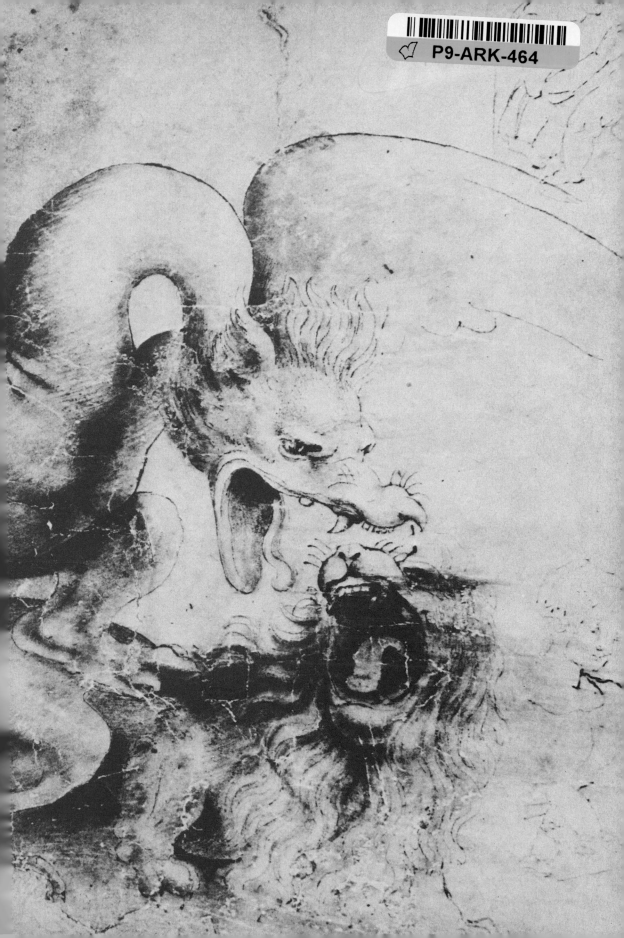

Leonardo da Vinci

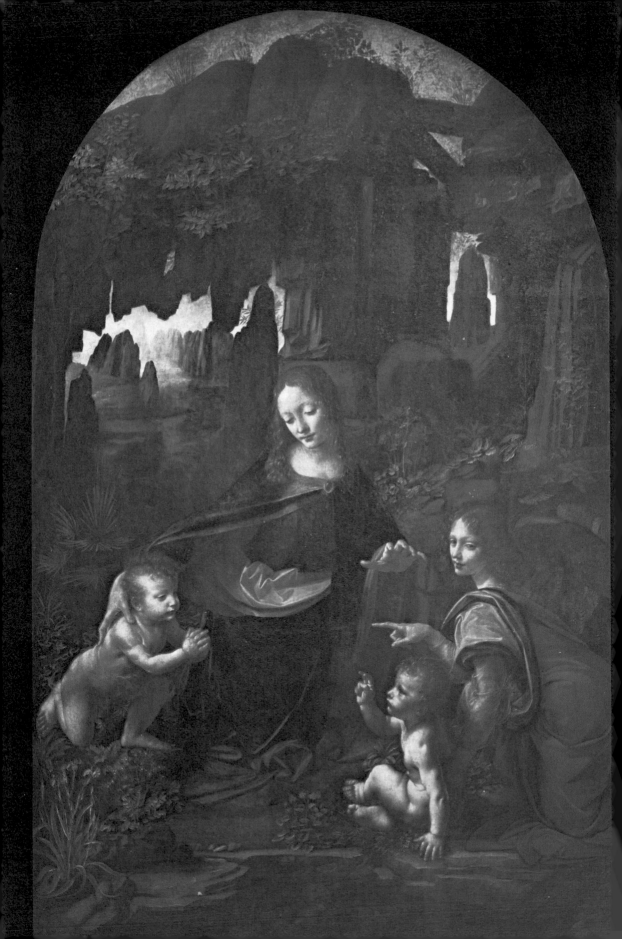

Leonardo da Vinci

Maurice Rowdon

Introduction by Elizabeth Longford

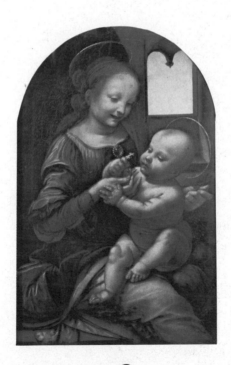

Follett Publishing Company Chicago

ISBN 0–695–80545–2
Library of Congress Catalog Card Number
74–21371

Printed in England

House editor Simon Dally
Art editor Tim Higgins
Layout by Sandra Shafee

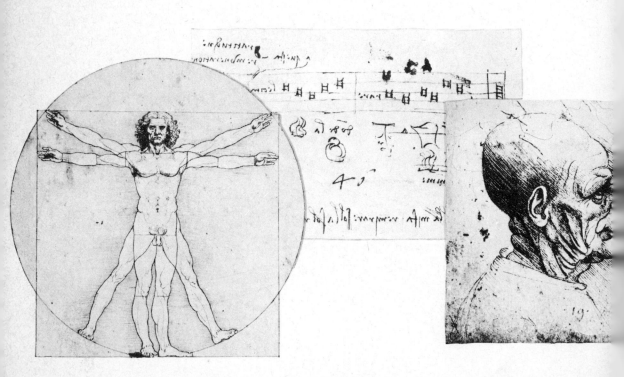

Contents

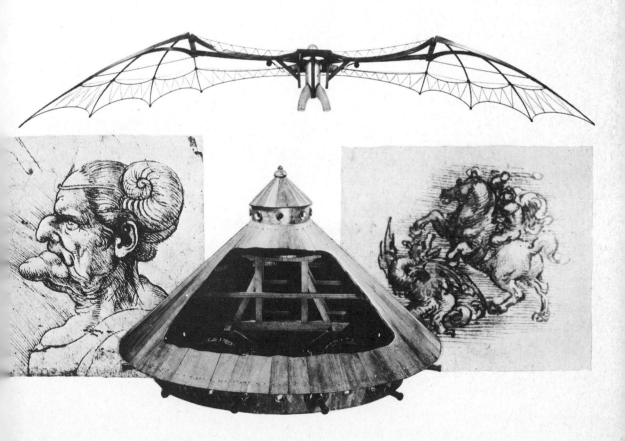

Introduction

AFTER THE PASSING of half a millennium, Leonardo is still the supreme example of multi-faceted genius. Weaponry, siege-engines, flying-machines, submarines; town planning, architecture, map-making, irrigation; botany, optics, anatomy, mathematics; music, sculpture, painting – he practised, invented or predicted them all. Yet despite his brilliance, he retains an intriguing opacity. He was a 'loner'. In the end he remains an enigma to which every generation will have its own solution.

This new interpretation of Leonardo presents us with certain paradoxes. To quote Maurice Rowdon, Leonardo was 'that most contradictory of all creatures – a recluse with all the court graces'. His detachment and charm were matched only by his creative energy. One thinks of the calm at the heart of those whirlpools which Leonardo so much enjoyed studying. Contrary to the views of Freudians, Maurice Rowdon does not believe that Leonardo's early 'homosexual scrapes' were of substantial relevance. He points to the famous portraits of women. These show that Leonardo's eyes did not see women as mere reproducing machines, whatever his intellect may have told him. As for his pictures of youths, these, says Maurice Rowdon, are 'androgynous', possessing characteristics of both sexes or neither. Nor does he agree that Leonardo was impotent. True, Leonardo considered the sex act ugly in so far as it was an assault on something wholly passive. Nevertheless he was no sexual casualty (even though illegitimate) but a fundamentally healthy being. Again, Maurice Rowdon holds that Leonardo was not 'Renaissance Man'. Far from promoting a rebirth of the past, he looked forward to a future scientific age. His painting became 'a new science of the visible'. Spiritually, he never felt himself to be 'the complete man' or accepted the classical dogma that 'Man is the measure of all things'; rather, he saw it as man's duty to measure all things. Or, as Kenneth Clark has put it, 'one can't imagine Leonardo painting himself as Christ'.

In probing Leonardo's 'dark side', we find a variety of clues. To begin with, he had a bit of a devil in him, like his favourite servant-boy, 'Salai'. Then, as an artist he was bound to paint *everything*: 'crumbling mountains, fearful and terrible places', as

well as the beauties of nature. These terrifying things had their effect upon him. Beyond that, Leonardo was an obsessive perfectionist. His eternal experimentation with materials and mixtures brought ruin upon his *Last Supper*. Finally there was the purgatory which he was bound to endure even if he had succeeded in inventing the best and most lasting materials in the world. Perfection is simply not attainable. On his death-bed Leonardo accused himself of 'not having laboured at his art, as he ought to have done, thereby offending God and man'. This was a reference to his unreliability, his many 'unfinished' masterpieces. Perhaps it had seemed better to break off than to fall short of the ideal. He suffered none the less.

If Leonardo was not 'Renaissance Man', his patrons were all Renaissance princes: Medicis, Sforzas, Borgias, popes, kings. The inner drive, however, behind all his inventiveness was neither greed nor rivalry with contemporary artists. It was insatiable curiosity. Today we pay our tribute to his genius in the same coin. For curiosity is precisely what Leonardo's life and character never fail to arouse in us. This original study will both stimulate our curiosity and help to satisfy it.

Elizabeth Longford

Prologue: 'Nature and experience

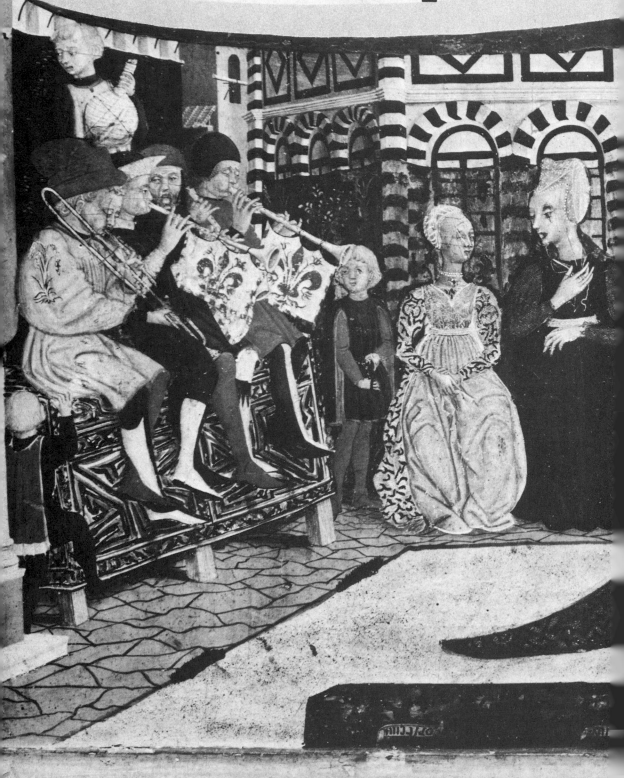

LEONARDO DA VINCI is everywhere regarded as a great artist – and, more than that, a great artist of the Renaissance. Yet he was not at all a characteristic Renaissance figure, or even much appreciated by his fellow-Italians. In Florence, where he was brought up, he was perhaps less valued than in most other Italian towns. His notebooks, published in English translation only towards the end of the nineteenth century, were unknown to most of his contemporaries, and in them lies evidence of an unbelievably restless and versatile genius that perhaps was never really satisfied with art. His paintings and frescoes were certainly admired, and to some extent his ideas about new painting techniques were too, but he was intolerably long finishing a commission (when he did manage to finish it), and even then he invariably found a way of applying a new technique which failed to come off, so that the paint cracked or faded.

Probably Lorenzo de' Medici, who ran Florence during his youth, was favourably inclined towards him at the beginning, when Leonardo was a promising apprentice in Verrocchio's workshop. The town council's decision to give him a commission in 1478, seventeen days after it had offered the same job to another artist, Piero del Pollaiuolo, may have been due to Lorenzo's sudden interference on his behalf. The favour did not last. Not many years later Lorenzo sent him to Milan, where the ruler Ludovico wanted a lute-player and a military engineer. In Rome, towards the end of his life, another Medici, Lorenzo the Magnificent's son, Pope Leo X, gave him the cold shoulder, and unashamedly preferred Michelangelo, who was twenty years younger, and Raphael, who was thirty years younger. Finally the Pope asked him to devise a scheme for drying up the Pontine marshes, after he had joked about Leonardo's failure to finish anything.

Leonardo simply did not fit in, particularly on home ground. Some see his homosexuality as the reason. But, more precisely, his homosexuality was just another aspect of his total singularity, which perplexed most of those round him even while they admired him. His lonely and bizarre mind, together with his remarkable beauty, his tenderness and courtesy of address, and his interest in the monstrous and deformed, made up too many seeming contradictions for people brought up on Plato and questing for harmony in all things to understand. The great theorist of the Renaissance, Leo Battista Alberti, whose ideas dominated Florence when the sixteen-year-old Leonardo arrived there towards the end of 1468, laid it down that a man who lacked 'letters' (by which he meant

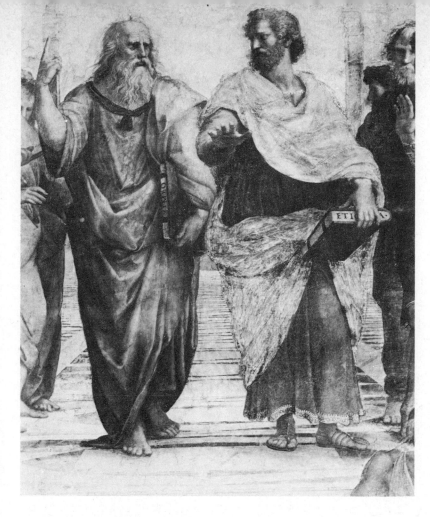

During the Renaissance there was a well-nigh obsessive interest in classical thought. Plato and Aristotle from Raphael's famous fresco in the Vatican, *The School of Athens*.

Latin and Greek) could only be considered a 'rustic', however noble. And Leonardo was not a lettered man. He was often made aware of the fact that he was no 'humanist', namely a thinker who saw a reawakening of Christian feeling in terms of the ancient world, a marriage of Plato and Christ (the former in his doctrine of 'the perfect man' and the latter in his personification of that 'perfect man' in the flesh).

Giorgio Vasari, whose lives of the Florentine painters created our first picture of an Age of Rebirth or Renaissance, in triumphant distinction from the Middle Ages, also created the Leonardo legend: his biography of Leonardo is perhaps his most careful. In his first draft he described Leonardo as of 'an heretical cast of mind', much more a 'philosopher' than a Christian. He cut this out of his final version, perhaps because he felt it was blind prejudice inherited from Leonardo's contemporaries, for he himself had never known Leonardo, being only four years old when the artist left Italy for the last time in 1515. Leonardo was often vilified as an atheist,

13

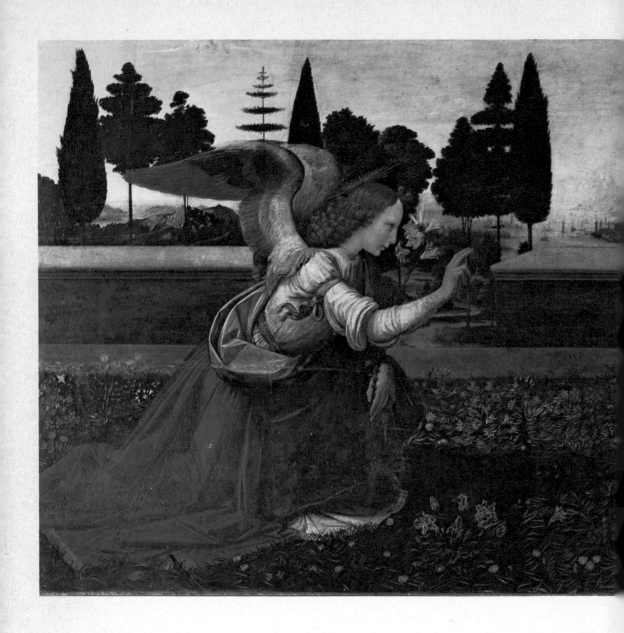

14

The Annunciation, the earliest
known work painted almost
entirely by Leonardo's hand.

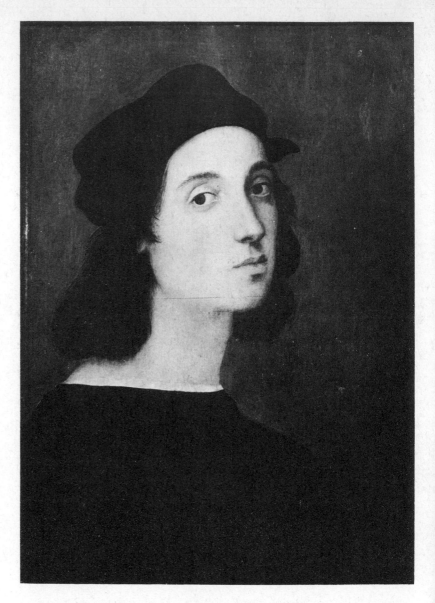

Two other great Renaissance artists.
RIGHT A self-portrait by Raphael, who was thirty years younger than Leonardo.
OPPOSITE Michelangelo, who was to show great contempt for Leonardo's slowness as a painter.

mostly in Florence. It seemed to go together with his dissection of corpses in the church hospitals in the dead of night, and his efforts to devise a flying machine, not to say in his peculiar sexuality which resisted the continual invitations of the lovely Isabella d'Este to paint her portrait and join her Court.

Above all, contrary to the picture we have of him today, he may have been regarded as rather old-fashioned. In ideas he was far more the climax of the Middle Ages than he was of that move-

16

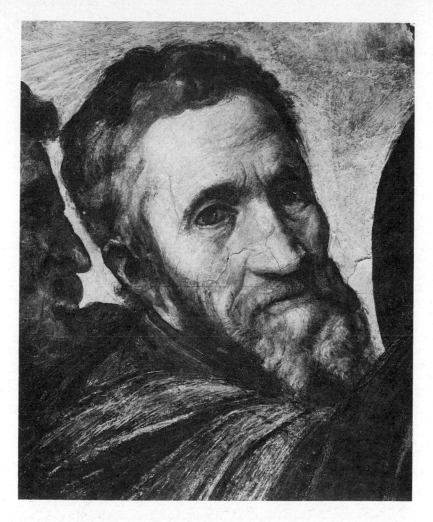

ment of rebirth which we call the Renaissance. His affiliation was
with Aristotle rather than with Plato or Plotinus. It was the
medieval thinkers who had laid down the importance of observing
nature and making experiment the basis of deduction. He read
Aristotle in the translation by the Arab thinker Avicenna, who
introduced him, as he had introduced the medieval mind, to Greek
thought. Many of the problems confronting Leonardo in his
researches, even in anatomy, had been cited by Aristotle too.
Certainly he heard the lectures of the Greek scholar Johannes
Argyropoulos or at least knew about them: Argyropoulos too
favoured Aristotle before Plato. It meant favouring nature, as
opposed to arguments from the spirit or what came to be known
as 'idealism'. It meant finding nature's principles or laws through

careful observation. It meant beginning with the 'concrete' and
not the 'spirit', which in turn meant beginning with the five
senses as the sole avenue to the certain truth. That was the basis of
all Leonardo's thought. Like the Aristotelian theologians of the
twelfth century (their thought galvanized into new activity by
the Arab discovery of the ancient Greek world), he maintained
that whatever doctrines of the soul there might be, the five senses
are our only valid source of knowledge, at least in the physical
world. It is here that the modern world seizes hold of Leonardo as
'one of us'. His notebooks, written in secret mirror-form, were like
the first rough blueprints of everything the nineteenth century
practised, from its streets of uniform houses served with the same
sewage systems and water-supply systems (Ludovico laughed in his
face at such an idea) to multi-firing guns, weaving factories, arm-
oured cars, aeroplanes and rationalized medicine, indeed the whole
paraphernalia of a production-obsessed society. He may well have
known the work of the 'Franciscans of Oxford' back in the thir-
teenth century, Robert Grosseteste and Roger Bacon, who stated
boldly that mathematics was the basis of truth, being, so to speak,
the very skeletal structure of the objective and the observable. It
took Leonardo far from the platonic thinkers of Florence like Pico
della Mirandola for whom *'mathematicae non sunt verae scientiae'* :
in other words, Pico meant by 'science' a much deeper knowledge
than what could be found by the five senses alone, or what was
measurable. And in our day, since Einstein defied the idea of
experiment and observation ('the theory decides what may be
observed'), and scientific 'fact' has been debunked to the position
of a synthesis, a mere 'possibility' formed by the mind, it is easier
for us to see that Leonardo was one of the most inspired materialists
who ever lived. It accounted for his perplexity, which turned now
and then into dark anguish.

For at the same time he was no atheist. His pictures were not
bathed in a mellow spiritual light like Perugino's, or given to
poetry like Botticelli's, or sweetly religious in mood like those of
the earlier Sienese school. But a tender and reminiscent mood
did play over the faces of his women and his boys, touching off a
smile which was best fixed in the famous *Mona Lisa* picture which
he sold to the King of France, and which the world has talked about
ever since.

The fact is that the five senses cannot prove the existence of the
soul. You cannot smell the soul or eat it or hear it or see it or feel it.
Yet you can be aware of it. 'The soul is an impossible thing to

18

demonstrate,' he once wrote. A strange conclusion to derive from medieval thought! But it was a conclusion the Christian world came to as well, by adopting the idea that, for all practical purposes, reality is strictly what we perceive, and nothing more. The Church all but collapsed under the weight of that doctrine during the sixteenth century, after the great Plato-adoring Medici of republican Florence were dead, and humanism was dead, and when 'spiritualists' and 'illuminated ones' were scorned by both Protestants and Catholics alike: it was no longer recognized that spiritual ecstasy, the reward for religious austerities, was 'real'. In sixteenth-century Spain, which set the tone for the rest of Europe, you were a Christian if you ate pork and observed Sunday, an infidel if you cut the fat away from your pork or, unthinkably, refused to eat it at all. For over a century Europe was at war with itself over definitions of words like 'transubstantiation'. Moralism took the place of faith: and the moralist can be a fearful inquisitor. Protestants and Catholics massacred each other, and even themselves. That was a century after the heyday of the Renaissance in Florence, when Lorenzo had commissioned Verrocchio and Botticelli and praised the child Michelangelo's work in Ghirlandaio's workshop. The 'rebirth' did not seem to have come about. Rome was sacked by imperial troops in 1527; Florence was sacked – at the instigation of another Medici, Pope Clement VII – three years later, and no more humanist talk was heard: the Christian civilization that had been planned and hoped for did not come about, though a great deal of war and empire-making did.

The fact is that Leonardo, a stranger to Renaissance feeling, was closer to the actualities of the times than the ardent scholars like Marsilio Ficino and Poliziano who turned the city of their youth into the liveliest place in Europe. For behind the platonic discussions between them and the Medici brothers in the forests of Calmaldoli were the financial operations of the Medici banks which were underpinning a state of war north of the Alps, and creating constant financial upheaval within Florence itself. At that time the social effects of that money-operation were even less understood than they are today. No one could explain why Florence – or, for that matter, Antwerp – was hit now and then by unemployment and bankruptcy. Expansion at whatever cost was an idea then at its embryonic stage (it took another four hundred years to bring it to fullness, and to make the bank virtually the key to economic life) but it was far more the real trend of the times than platonic ideas, which influenced Christian society only in the form

of the refinement of manners, from the sixteenth century on.

The Renaissance was nothing but the practical climax of the Middle Ages. In it a quest that had been going on in people's minds during the twelfth and thirteenth centuries was put into practice. Voyages to 'the two Indias' were undertaken. Ancient Roman roads which had fallen into disuse through lack of trade came alive again. Loans were floated, profit made. And in the end a 'modern' world was produced in which medieval society – localized and intimate and relatively immobile – its thoughts carefully copied out in manuscript form and passed from hand to hand – was no longer recognized. Printing was needed – hence its invention – in order to speed the circulation of thought, the thought that had crystallized in the medieval university and the medieval monastery. It was this 'modern' world of which Leonardo felt a part, with some anguish and misgiving, long before it came about, and which, far from being a 'rebirth', was a rejection of everything the humanists round him believed in.

There is one problem about Leonardo da Vinci which few have examined and no one has solved: how as a youth in Florence, an illegitimate son of a by no means wealthy father, he should have been able to maintain a household with servants and stables, and wear the finest clothes. At no time in his life did he want for food and drink and noble company. In Milan and in his last years in France he had virtually a Court of his own, and 'Leonardo' became a magic word. He seemed born for good fortune and lavish attention from others. Besides being remarkably beautiful, with a perfectly formed body, sound in health and limb, he was in his behaviour all that others, particularly women, would wish to watch – he walked well, he sang well, he played the lute well, he rode well, at a time in Christian history when shining as a human creature was not thought to argue arrogance. He was brave, he was strong, he was magnanimous. No one could help noticing him. God had clearly made a special endowment. Together with all these things, he was serious. He mastered whatever technique he applied himself to, so much that his mind was always diverted this way and that by its many facets, its inexhaustible curiosity.

1
The Marvellous
Apprentice

LEONARDO WAS BORN close to the town of Vinci, in a village called Anchiano, in 1452, the son of Ser Piero (the 'Ser' before his name denoted the traditional family calling of notary). His mother was Chateria or Caterina, and no one is quite certain whether she was a peasant woman or, as one of Florence's chroniclers, the 'Anonymous Florentine', says, 'a woman of gentle blood'. The fact that Ser Piero married someone else of gentle blood, Albiera di Giovanni Amadori, in the year of Leonardo's birth, seems to argue that Caterina was lowly enough to be disregarded.

Ser Piero, his father, was married four times in all, and had eleven children by his third and fourth wives. The farmhouse in Vinci, which local tradition insists was Leonardo's birthplace, was clearly of the most humble kind. He lived there in his mother's care for the first five years of his life. Then, when he was five, his mother married a local Vinci man, Attacabrigi or Chartabriga di Piero del Vacca, and Leonardo moved to his father's grander house in the town itself. There (since his father's first two wives bore him no children) he grew up as an only child. In the year he moved, 1457, his grandfather Antonio da Vinci made a tax return in which he described his household as consisting of his wife, his son Ser Piero (then aged thirty), another son Francesco (the uncle who according to local records 'did nothing' during the forty years he lived in the house, and who left his modest property to Leonardo), Albiera (Ser Piero's Florentine wife) and 'Lionardo', Ser Piero's illegitimate son.

The grandfather died in 1469 when Leonardo was seventeen, and the family moved into another house in Vinci as well as taking the ground floor of a house in Florence close to the Bargello or prison, in the little Piazza di S Firenze on the site of what is now the Palazzo Gondi (the Gondi were the owners in Leonardo's time, too).

Leonardo's father was no small man. In fact he attracted most of Florence's business, a fact which may partly explain the young Leonardo's luxurious habits. His schooling was modest. He showed immediate aptitude for arithmetic, so much that he confounded his teachers with the problems he set them. But Leonardo was largely a self-taught man. At times he was rather bitterly aware of the fact that he was considered 'unlettered', that is, unable to write in Ciceronian prose. It was partly this that threw him into the arms of the Aristotelians, with their emphasis on experience and the observation of nature, rather than the platonic idols of Florence who saw him as something of an outsider. He was left-

PREVIOUS PAGES The little Tuscan town of Vinci, which gave Leonardo his name. He was born nearby.

OPPOSITE ABOVE The farmhouse where by tradition Leonardo was born and spent his first five years.
OPPOSITE BELOW Leonardo's entry in the register of births.

24

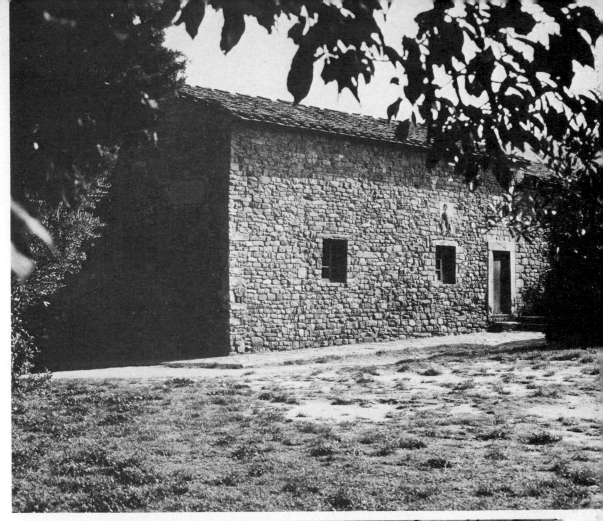

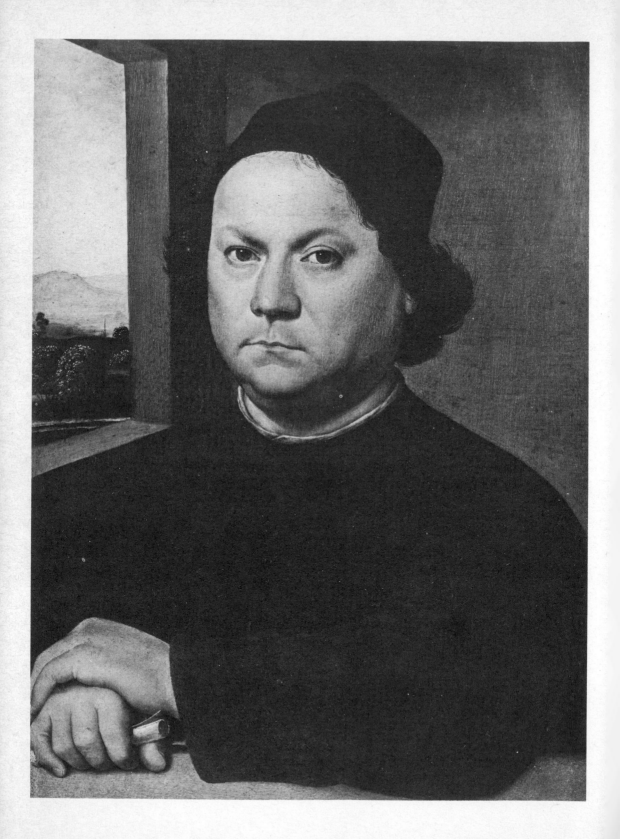

handed, and at first wrote from right to left in the oriental manner, a habit which he found useful later in life when he confided his secret thoughts to his diaries, in the famous 'mirror-writing'. He also learned to paint and draw with both hands. As he grew into a tall youth, with blond hair flowing down to his shoulders, with a sweetly mysterious and detached look in his eyes, it became clear that he was marked out for greatness of some kind. According to Vasari, it was his father who took some of his drawings along to Andrea del Verrocchio's workshop one day and showed them to the master, at that time Florence's most fashionable craftsman and artistic influence, being a goldsmith, painter, inlayer, sculptor and musician, a lion of the arts.

Verrocchio was astonished at what he saw, and agreed to take the youth in. That was where Leonardo's restlessness started, under the impact of Verrocchio's mind. Suddenly he was aware of the exhilarating powers open to a mind capable of delving beyond its own recesses of ignorance, as he worked in clay, in architecture, in perspective, in plans for mills and machines, in drawings of women and boys. He was fifteen, Verrocchio thirty-three. He worked side by side with Lorenzo di Credi. Other students in the workshop were Perugino (nineteen at the time) and Botticelli (twenty-two). Like Leonardo, Perugino never found particular favour at Lorenzo de' Medici's 'Court', being essentially a mystical painter (and in that, typically Umbrian). It was Botticelli, the most platonic and literary of Florence's painters, who became Lorenzo de' Medici's favourite and perhaps closest friend. Really Leonardo had little time for poetry. It was the materialist element of painting, the fact that it was visible and touchable, that put it on a higher level than literature for him, and made it the ultimate in all the arts, even music.

It was natural in fifteenth-century Florence for a boy who showed promise to be apprenticed to a workshop or *bottegha* after the age of thirteen, to learn all the techniques from the master in charge, and to take a hand in some of the paintings commissioned by the Church or a private patron. Six years was the usual period before a student could be considered a fully-fledged painter. And, if the date 1467 is the right one for Leonardo's entry (it was certainly not later than 1469), he remained under Verrocchio for nine years, until he was twenty-four. During this period the workshop turned out a variety of works in which he almost certainly had a hand. The first was the gilded copper ball that was placed on the lantern over the dome of the cathedral on 27 May 1471. The

OPPOSITE Andrea del Verrocchio, who was astonished by the drawings which Leonardo's father showed him. He immediately took the fifteen-year-old boy into his workshop. Portrait attributed to Raphael.

27

following year Verrocchio completed the imposing and rather gloomy tomb in red porphyry and green marble for Piero de' Medici (who died in 1469), to be placed in the Sacristy of the 'Medici church' of San Lorenzo. Four years after that, the bronze *David* was placed on the staircase of the town hall. In 1477 a relief of the beheading of St John the Baptist for the silver altar of the Baptistery was finished, and the year after that *Christ and St Thomas*, a group of bronze figures still to be seen today at the church of Or San Michele, was fired. It was a busy life. Leonardo reminded himself in his notebook to 'remember the solder with which the ball of S Maria del Fiore [the cathedral] was welded together'.

During those years too he met Paolo Toscanelli, the famous geographer, who was nicknamed 'Maestro Pagolo' and who charted Christopher Columbus's voyage west 'to the other coast of India', which turned out to be America. He it was who taught Leonardo the laws of stress and motion in machinery – for the Verrocchio workshop was the centre of ardent discussion and the exchange of curious information.

At that time a painter concerned himself with every branch of knowledge, just as he learned the techniques of the sculptor, the goldsmith and the architect too. It was not even unusual for him to be a military engineer. Vittorio Ghiberti, born a year before Leonardo, was a goldsmith, bronze-caster and architect, but his notebook was full of drawings for machines of every kind. A famous engineer called '*Il Cecca*' whom Leonardo must have met (and who was only five years older than himself) produced numberless schemes for the use of water for hydraulic purposes, the damming of rivers, irrigation systems, guns and earthworks and ramparts, all of which were regarded as methods of improving life quite on a level with frescoes and the new technique of oil painting which had been introduced from the Netherlands. Thus Leonardo was not at all pioneering new ground in his researches and studies. He was doing what dozens of men round him were doing, and had been doing for a long time.

Verrocchio too was fascinated by mathematics and alchemy and magic, by perspective and light-and-shade, and what was called 'the alchemy of lines', according to which one might paint or draw according to absolute scientific laws. Like Leonardo he was a musician as well.

At that time a workshop was a centre of ideas. It was also as near an artist got to belonging to a trade union. He became registered

OPPOSITE A self-portrait by Botticelli in his *Adoration of the Magi*. Botticelli was a fellow-pupil of Leonardo's in Verrocchio's workshop and seven years older.

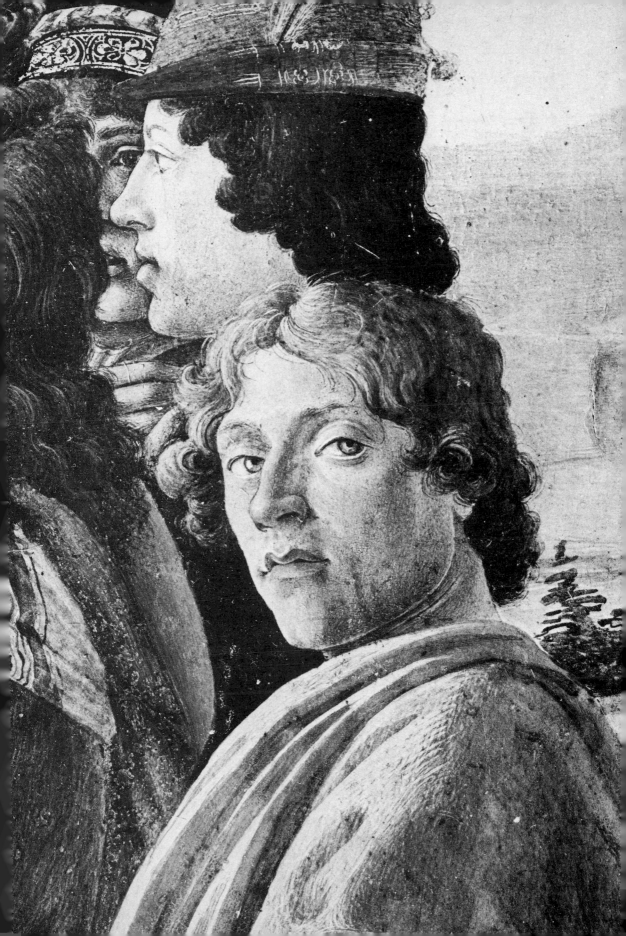

A map charting Columbus's voyage by the famous
geographer, Paolo Toscanelli; Toscanelli was one of the
first to think of reaching the east by sailing westward.

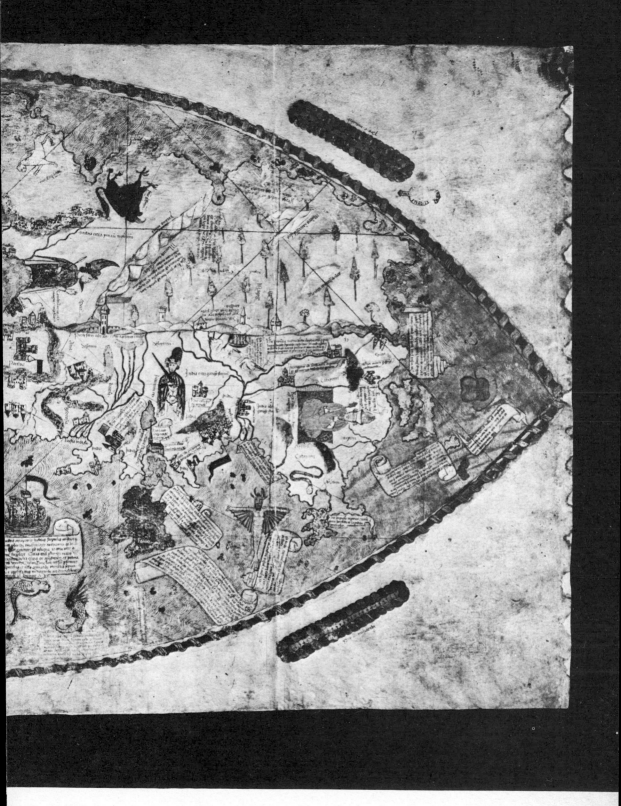

officially as a painter. When his apprenticeship was over, he became a member of the 'company of painters'. The Red Book, as it was called, registered Leonardo as a member of the Company of San Luca in 1472, and noted the fees due from him, though there is no record of his having paid them. A workshop also imposed fines if an apprentice took commissions outside. But it was much more than a trade union. It was a shop-window for the artist in his earliest years. Perugino worked ardently, and was soon known everywhere in Florence as a steady and reliable painter of church frescoes. Leonardo's development was quite different. He was by no means reliable, and anything but steady. He was too busy with his own thoughts, and with having a good time. The two went paradoxically together, in this strange and attractive creature who always seemed to walk apart while opening himself with the sweetest courtesy to the world round him. That world teemed with curious phenomena – peculiar faces and angelic faces and tortured faces, with nightmares and perversions and fearful storms, with all the appearance of a great harmony at work and equally an ugly principle of conflict.

Nature and experience were his schools, he always said, in reaction against the Ciceronians and *letterati*. Illegitimacy was no shame in Florence at the time, but it still tended to set a person apart, unless he came from one of the city's eminent families. And nature, in its violence and inexhaustible variety of creation, was his refuge from a society which never, even in his happy years in Milan, when 'Leonardo' was another name for felicity among the women of Ludovico's Court, satisfied him. As a child he had a dream which he remembered for the rest of his life. He lay in his cradle 'and it seemed as though a kite descended on me. It opened my mouth with its tail feathers and moved them about between my lips.' He took this as a sign that nature wanted to speak to men through his mouth. Nature awaited its mediator. 'And this seems to be my vocation, my fate,' he added.

His earliest known work, a pen drawing now in the Uffizi, shows a valley with a fortified town, possibly near Vinci, and is inscribed 'the day of St Mary of the Snow, 5 August 1473'. From the same period come those sketches of heads which are almost caricatures, said to be portraits of various members of the Vinci family. At this time too a painting was done in the Verrocchio workshop of a *Baptism of Christ*, where the more graceful of the two angels kneeling on the left of the picture (painted in oils, while the rest of the panel is in tempera) is said to show Leonardo's hand.

OPPOSITE A detail from Verrocchio's *Baptism of Christ* with an angel painted by Leonardo.

32

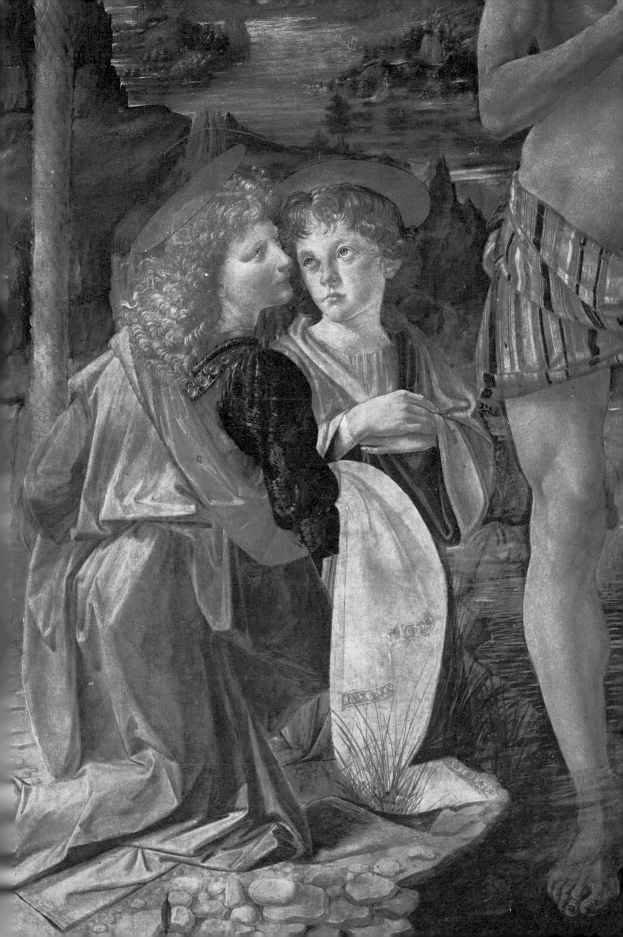

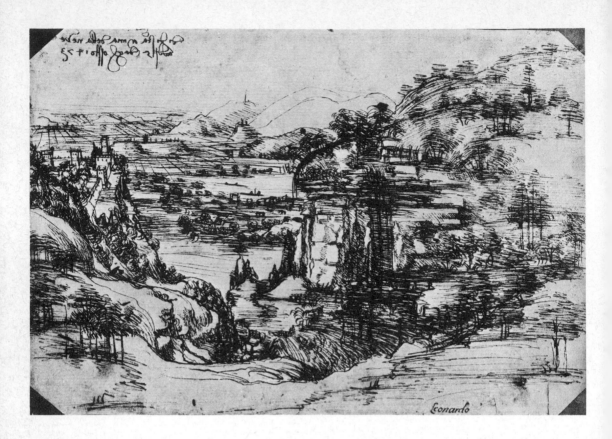

The earliest known work painted by Leonardo da Vinci, showing a valley with a fortified town and dated 5 August 1473.

According to Vasari it was painted as a commission for the monks of San Salvi just outside Florence. The general design is almost certainly Verrocchio's: in the angel Leonardo introduces an ease and naturalness hardly seen in painting before. Vasari believed that Verrocchio felt inferior to Leonardo as a painter from that time on. And it is true that Verrocchio never painted again, though this could equally have been due to his predilection for sculpture. Nor was Leonardo's angel the first graceful figure to have been painted in his presence, by any means. But in the angel's expression there is a certain longing, a disturbing mixture of doubt and detachment and ardour, that may have led the master to feel that in Leonardo he had formed the perfect pupil.

Not that grace was much of an objective for Verrocchio. He was first and foremost a craftsman, and his painter's hand was rather hard and heavy. His work included helmets and suits of armour for the Medici family, and numberless *ex-voto* pictures of which there is no trace today. About the time he finished *David*, he did a bell for the Vallombrosa monastery, the famous sculpture, *Boy*

34

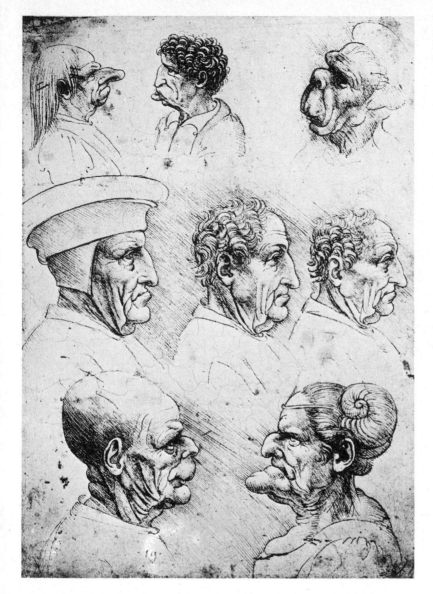

Eight grotesque heads illustrating Leonardo's fascination for peculiarities of the human anatomy.

and a Dolphin which Lorenzo de' Medici commissioned for the garden of the family villa at Careggi, and a marble well for the king of Hungary. His versatility entered Leonardo like a catalyst, and must have been one of the factors behind Leonardo's failure to finish anything once he had mastered its problems. Verrocchio invented the death mask, and shared Leonardo's interest in dissection. He must have provoked Leonardo to an interest in ceramic work too, as the youth's notebooks of the period talk a great deal

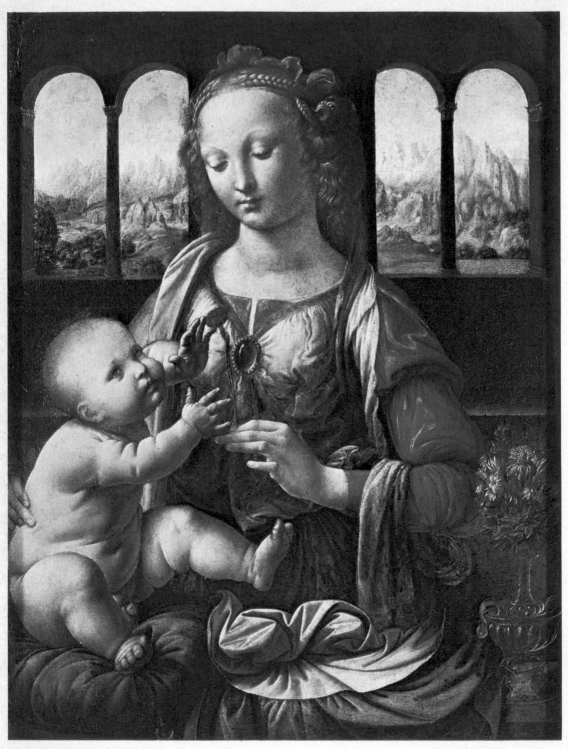

The Madonna with the Carnation; though badly
overpainted in places by other hands, in the modelling
of the hands and the drapery it shows affinities
with *The Annunciation*.

Lorenzo the Magnificent, the greatest member of the
Medici family, who ruled Florence from 1469, when
he was twenty-one, until his death in 1492.

about Luca della Robbia (together with, surprisingly, Botticelli, who was no imitator of nature). Verrocchio was almost certainly the author of the famous bust of Lorenzo de' Medici. For Florence Verrocchio was all that was modern.

Just as Florence was all that was modern in fifteenth-century Europe. It was what we in our day call a 'democracy', namely a society controlled by money-interests rather than military dukes like Milan or an aristocracy whose names were in a Golden Book like Venice or by the Church like Rome (with its satellite towns all over the Romagna) or by hereditary princes like Naples and the Two Sicilies or by clever, often cruel, usurpers like most of the other towns in Italy.

Florence was governed by parties, and these parties were families, which meant an army of cousins and in-laws who gathered at the family's town house to argue politics and to rig the next election. For there were free elections too, except that money and the promise of sinecures and tax-relief sweetened the vote in one direction or the other. The Medici were, in Leonardo's time, the top political family, with a network of banks all over Europe, the chief function of which was to lend money to other political families. Edward IV of England won his wars, and laid the basis of the English state, on Medici loans. The Holy Roman Emperor, Maximilian, borrowed plentifully, as his wife Margaret did too (between them they broke the Medici bank at Bruges). Yet in Florence the Medici were simply private citizens.

The Florentine did not like to be governed. He wanted to make money and be left in peace. He was in fact a most peaceful individual, in as much as he preferred hiring foreign soldiers to do his fighting for him. Not that Florence was politically a peaceful place. A city in constant financial crisis (it was modern to this degree as well) could hardly be that. Factions were constantly at mildly ridiculous war with each other, and the precious constitution, designed to stop any one family governing too hard, was changed as many times as there were elections. Revolutions, *coups d'état* and class warfare featured throughout Florentine history, yet for all that there was remarkably little brutality. The Florentine loved to argue. Rhetoric was his speciality. He no sooner had a government than he saw good reasons why he should have another one, even though it only meant shuffling round the names and leaving the richest family in charge. The remarkable thing is that the Medici managed to hold on to power for a century – which ended with Lorenzo's death and the virtual collapse of the city as an

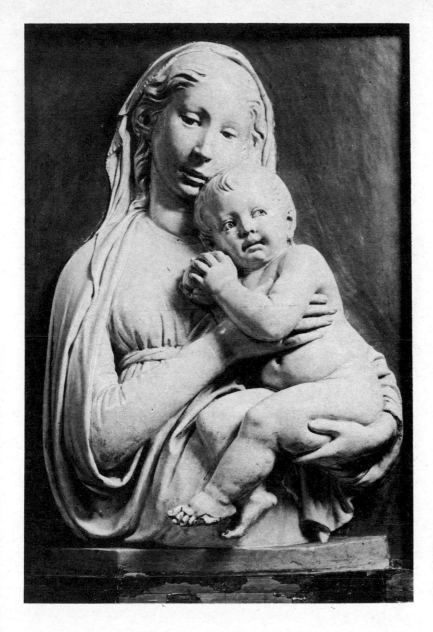

A Madonna and Child in ceramic by Luca della Robbia (1400-82), whose works Leonardo made frequent reference to in his notebooks.

independent republic. After that, Florence became a backwater, ruled again by Medici, but as Grand Dukes of Tuscany now, and without a shadow of their former power. During Leonardo's life that power was at its height, and there was hardly a prince in Christendom who had not benefited from a Medici loan or looked forward to getting one in the future.

39

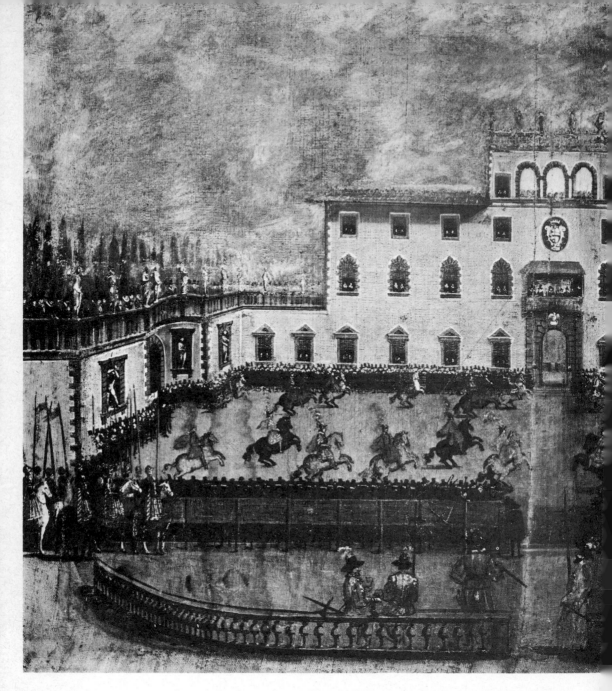

Yet the Medici were more than rich men too. They understood the modern role of money. They grasped the fact that the Church was traditionally opposed to usury, and the taking of an interest on a loan, and that until the fifteenth century business-life in Christendom had been strictly controlled by the theologians, in a prolonged argument with the merchants as to what constituted 'honest' practice. Now Florence had become rich. And the Medici

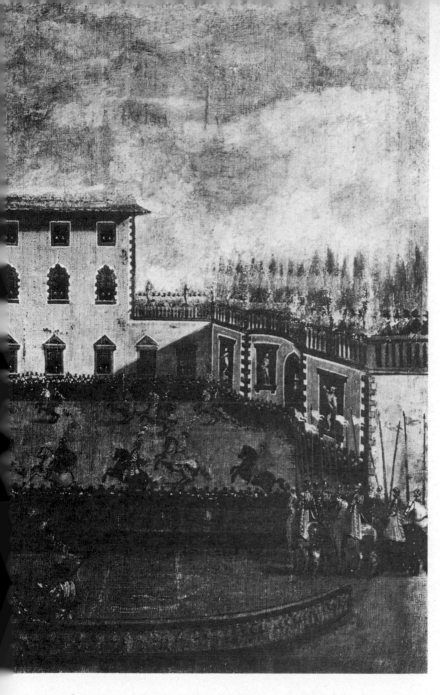

A tournament at one of the several villas which the Medici family built near Florence. The wealth of the Medicis grew out of their success in banking.

were clever enough to see that in Italy you could not get very far without the friendship of the Pope. The Pope had interests like any other prince. He wished to dominate Italy like any other state in the peninsula. And gradually the laws against usury were, if not forgotten, at least tempered with contrary practice. Loans were now disguised as straight trading transactions, and interest as some form of gift. Usury was as unthinkable as it had always

41

been. The Medici would have been horrified to hear the word attached to their name. But the fact remained that society had changed completely. And families like the Medici were the hub of that change – from a medieval world that tended to produce only the food and the goods it needed, to a society chasing wealth as hard as it could and producing as much as it could for the utmost profit.

Florentine wealth derived from the wool and silk industries. For centuries she had imported wool from Spain, France and England and exported it as cloth and finished garments to the opposite side of the world, to southern Italy and Constantinople and the Far East. Silk Florence imported from the East, and supplied the whole of Europe with silk products. There were nearly three hundred wool factories in Florence, eighty-three silk factories.

The Florentine florin was everywhere taken as a free currency, establishing with its value a kind of gold standard. In order to make trade possible, there were 'money-changers' too, who financed foreign transactions and exchange operations. In social prestige they came after the cloth-magnates and the silk-magnates. The genius of the Medici was that they saw to what extent their 'money-changing' activities were the key ones in this new society, and how they could climb to the highest thrones of social prestige while remaining simple (and ostentatiously simple) businessmen who bowed to others in the street and were never seen at the

The Florentine florin, which during the fifteenth century became accepted everywhere as a kind of gold standard and helped to ensure the stability of Florence's wool and silk trade, on which the city depended for its wealth.

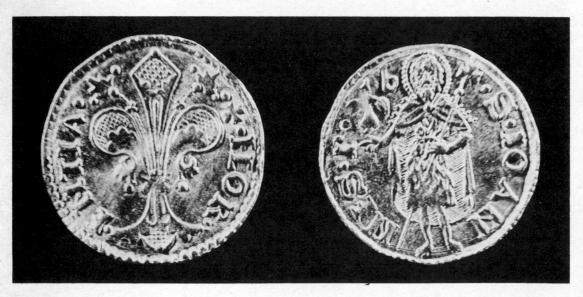

grand tournaments. They understood that the money-operation was the heart of modern society, and their collapse, like the collapse of their city, was due to factors other than their loss of astuteness: north of the Alps other states became powerful and rich enough to overlook the Medici banks. Florence became too small a unit.

In Leonardo's time it felt like the centre of the world. It was lively and gay, with some of the loveliest women in Christendom, who walked erect and lifted their heads high, and had a special provocative manner which distinguished them from other Italian women and gave them a reputation for being 'fast'. The Florentine had style. He was rarely a glutton. There was a measure to everything he did, and voluptuousness in pleasure combined with a keen intellectuality and a biting wit. Greek scholars, in flight from the Turks, took refuge more readily in Florence than in other Italian towns because of its atmosphere of freedom, and the fascinated audiences that listened to their lectures on ancient ideas. Under Cosimo de' Medici, Lorenzo's grandfather, an ecumenical council had been held in Florence in 1438 for the union of the Greek Orthodox and the Roman Churches. The union had not taken place, but many Greeks found their way into Florentine homes, dazzling everyone with their brilliant reasoning, and their hints of a civilization which the Christian world had not yet achieved. From that time there was a frantic search for manuscripts and anything else that bore witness to ancient Greece. Cosimo financed special journeys to lay hands on Chaldean, Hebrew, Alexandrian or Greek codices. Florence was a heady place in which to live – heady with dreams and quests and ardent talk. Pico della Mirandola, who came to Florence as a young man, flung himself into such feverish mental activity that he was dead before he reached middle age.

All this had the effect of making Leonardo dream of worlds far beyond the city. It was probably the dark side of his nature, the 'northern' side, that could not quite settle in this brisk yet spiritual city, far more than the lack of local encouragement. He soon had the reputation of leaving work unfinished. And commissions did not come plentifully to that sort of artist. He knew the Gondi family well – he had been brought up in their house after all. They were wealthy silk-manufacturers, and had family interests as far as Constantinople and Hungary. He listened avidly to Simone and Gianbattista when they returned from their travels. His pen-drawing of the Vinci valley, the one marked 'Maria della

43

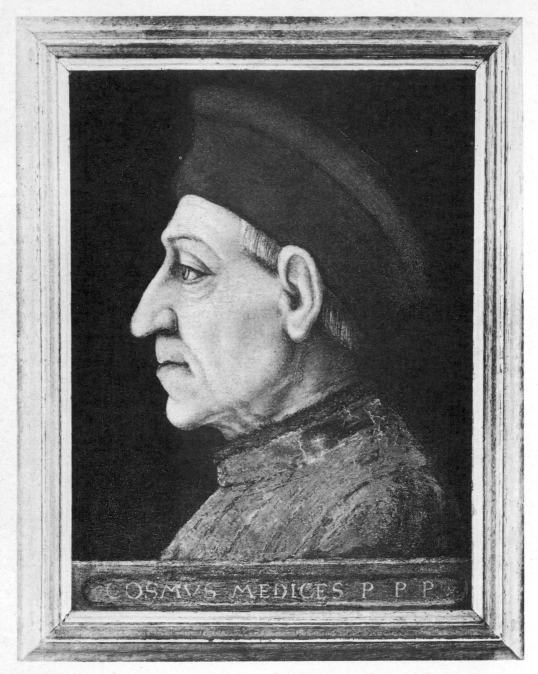

COSMVS MEDICES P P P

Cosimo de' Medici, grandfather of Lorenzo the Magnificent. The attempt in 1438 to unite the Greek Orthodox and Roman Churches during the Ecumenical council held in Florence while he ruled the city did not succeed. But under him Medici banks everywhere searched for ancient manuscripts, and Greek scholars were welcome in Florence.

RIGHT *St Jerome*, which over the centuries has been cut in two, lost, found in a Roman junk shop and finally bought by the Vatican.

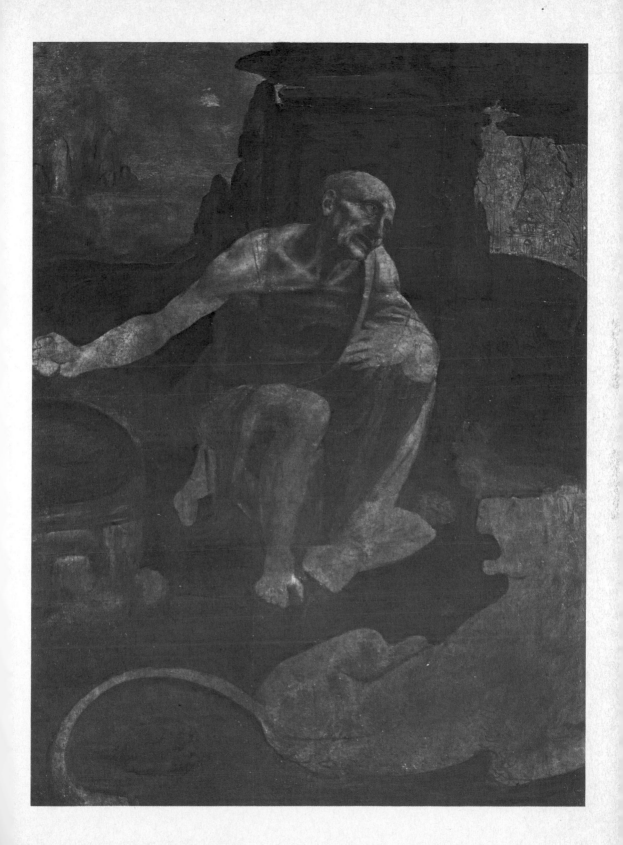

Neve' or 'Mary of the Snow', has a strangely oriental touch: Leonardo would feel at home where he was a perfect stranger. His detachment was of that kind.

One or two homosexual scrapes may have made him feel that he had local enemies, too. In Florence at that time it was customary for anonymous denunciations of citizens to be placed in a drum or *tamburo* at the town hall. The denunciation was called a *tamburazione* for this reason. On 8 April 1476, when Leonardo was twenty-four and in his last year with Verrocchio, a *tamburazione* was dropped into the box which notified the magistracy that a certain Jacopo Saltarelli, a goldsmith by trade, seventeen years of age, was indulging in 'sad' acts and had practised them with many dozens of people, one of whom was Leonardo Tornabuoni (from one of Florence's most eminent families – Lorenzo de' Medici's mother was a Tornabuoni), and another 'Leonardo di Ser Piero da Vinci'.

It is difficult to judge how homosexuality was regarded in the Florence of that time, since until very recently it was a rather forbidden subject throughout Christendom, however much it was practised. In Italy it is a fairly safe rule that whatever was permitted in the ancient world, in matters of the flesh, was permitted in the modern one too. But the fact that the four persons named in the *tamburazione* were arrested shows that it still was not regarded as pleasing, though the fact that they were at once released (on probation) shows that the offence was not taken too seriously either. But the *tamburazione* was repeated in June of the same year, when Leonardo was still in the Verrocchio workshop. Again the accused were released. There is a possibility that Leonardo was for a time in prison, but perhaps long before the *tamburazioni*. That was perhaps another reason why Lorenzo de' Medici did not welcome him into his 'Court' when he succeeded his father Piero on that invisible and nameless 'throne' of supreme power in 1469. And it may have been why Lorenzo suggested him six years later as just the musician whom Ludovico il Moro of Milan was looking for: perhaps he sent Leonardo off with a certain solicitude too, knowing that Florence was not for him.

Yet in that year of the *tamburazioni* Leonardo moved to a house of his own, and employed servants, dressed extravagantly, kept a stable and led a life of pleasure. There was something slightly effeminate about him which must have appealed to homosexuals. He had a surprisingly high-pitched voice too – surprising in a man so strong and forthright. Some say he was kept by a powerful

OPPOSITE Anatomical sketches from Leonardo's notebooks.

46

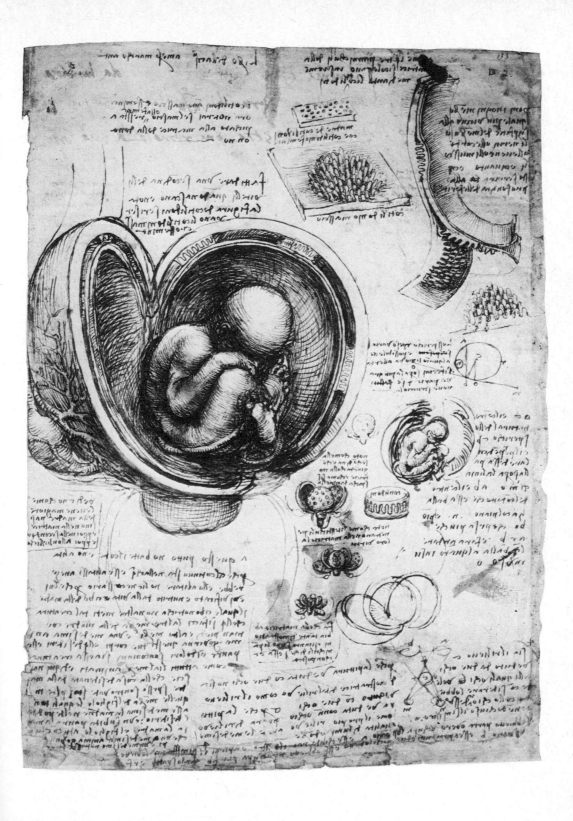

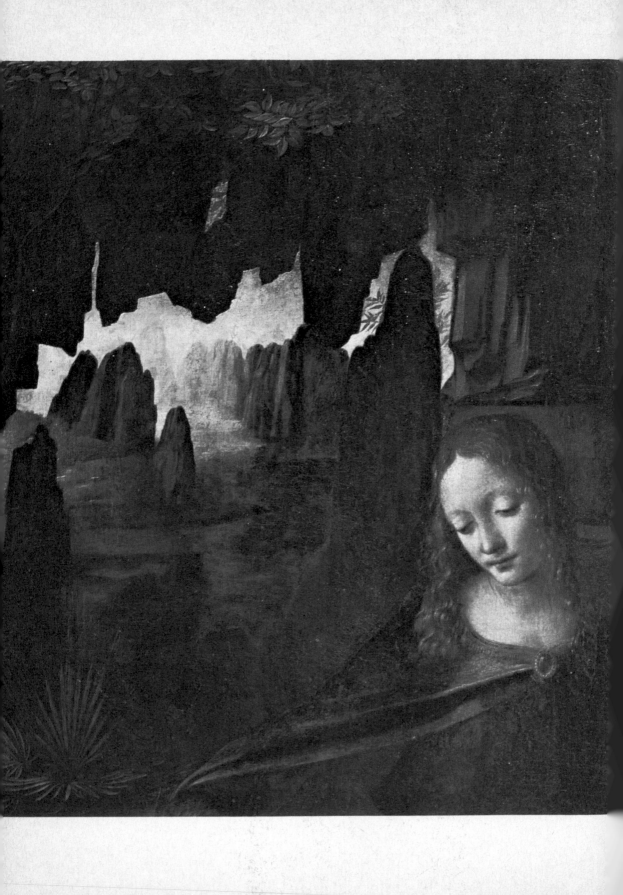

protector. Yet there is no evidence of how he practised homosexuality, or with whom. He was a fastidious man. He believed in great continence, and wrote that 'Whoso does not curb lustful desires puts himself on a level with the beasts.' The problem led Sigmund Freud and others to suggest that Leonardo failed to finish so much work because he failed in the primary sex act.

In Leonardo's time it was generally thought that the male erection was caused by pressure inside (deprived perhaps from a mistaken notion of what ancients had called 'vital spirits'). Leonardo, having studied the corpses of hanged men (which are invariably in erection) saw that it was blood that did the trick. That in itself was simply an anatomical observation on a level with his other observations about the liver, the gall bladder and the heart. Nor is there any sign in his drawings of coition that he flinched from the reality on the one hand or was obsessed with it on the other.

In a quite paradoxical way, Leonardo had a strikingly healthy mind, dark as it was at times. He always paid great attention to his own health, and was studiously clean. He believed in eating lightly and chewing thoroughly, and evacuating regularly. He felt that anger was bad for the nervous system, and must be avoided. He had no great faith in medicines. Later in life he became almost completely a vegetarian, perhaps eating fish now and then. And his attitude towards sex was on a level with his attention to health. At the side of his drawing of two figures in coition there is a note, 'Through these figures will be demonstrated the causes of many dangers of ulcers and disease.' This referred to venereal disease, no doubt, and the incidence of uterine growths and ulcers in women. But, more than that, the act of coition was ugly for him. He wished to concentrate on the beauty of the face, and its manifold expressions. That was what captivated him in the human creature, rather than voluptuousness ('the accompaniment of voluptuousness displeases love,' he once wrote).

And he felt that men 'maltreated' women, by sex domination. While all this was quite independent of his clinical observations, both belonged to a well-nigh oriental detachment, which found the sex-act rather distasteful in its pleasure-part and as fascinating as any other object of nature for its progenerative part.

He was exonerated from the charge of homosexuality. And there seemed to be no gossip at the time about his relations with boys: at least none has come down to us through the chroniclers.

Leonardo lived alone all his life, however much in company he

49

found himself. He was essentially a solitary, like thousands of other Italians in the monasteries of the time. That he was not greatly mystical as well created perplexity and anguish in him, far more than frustrated desires for what he did not find shameful or unmentionable: 'It seems therefore that this creature [the penis] has often a life and intelligence separate from the man, and it would appear that the man is in the wrong in being ashamed to give it a name or to exhibit it, seeking the rather constantly to cover and conceal what he ought to adorn and display with ceremony as a ministrant.'

There is one drawing by Leonardo which is singularly unclinical compared with the others, and that is a sketch of the vagina in an open state, done when he was over fifty. The labia majora and minora are glossed over, so to speak, in a vague muscular rim surrounding a dark cavity, and the clitoris is simply not there. And the whole is larger than life. The sketch is perhaps connected with something he wrote about the 'incompatibility of the sexes':

The woman commonly has a desire quite the opposite of that of a man. That is, the woman likes the size of the genital member of the man to be as large as possible, and the man desires the opposite in the genital member of the woman, so that neither one nor the other ever attains his interest because nature, who cannot be blamed, has so provided because of parturition. Woman has in proportion to her belly a larger genital member than any other species of animal.

Now that is a strange statement of coital desire, not to say performance. It really says that sexual satisfaction is out of the question. But more important than what it sets out to establish, is the fact that it demonstrates first an ignorance of the act and secondly a solicitous concern for the two participants in a mistaken enterprise. In his sketches of coition it is the male figure which is boldly shown, with its anatomy, while the female is a ghost hovering, an outline: she in her essential self is not there.

Leonardo's remarkably unanatomical sketch shows a passive, patiently receiving organ, and this patience – serene and long-suffering – is in the smiles of all his women, most notably the Mona Lisa.

And this attitude of Leonardo's is far closer to the hermaphroditic condition than the homosexual. The homosexual often sees the woman as a highly active, indeed dangerous, captor of the male organ; her own organ is equipped with intricate ensnaring parts. Leonardo's women are not practical, husband-desiring creatures on the whole. They are far from Ghirlandaio figures, farther from

50

voluptuous Botticelli goddesses and muses. They create a time of their own. Although much has been made of his drawing and painting of boys, it is his women who convey his basic predilection, with their reflective sweetness and repose, their serene detachment which is miraculously full of rapture and concern, their utter self-reliance which makes them all madonnas, in what will look to some like a mood of frigidity, to others like a victory over the body.

He did not seem to find that victory in the male: his boys have been found 'feminine' perhaps because he found the frankly male disturbing. His women were essentially spiritual creatures. The act of sex was (essentially again) an act of assault by the male. That was how little he felt like a homosexual. An assault from the front or behind is equal, and the 'ugliness' is not diminished by changing position. Men were *nature* for him. That is perhaps why they are depicted anatomically in his sketches of coition, while the woman remains an outline, a mere universal receiver. Here perhaps lies the origin of his aloneness, and the reason why he is said (quite falsely) not to have had real friends, outside his 'family' of Salai and Francesco Melzi and Fra Luca Pacioli. He had close friends all his life, and many of them. He was not good, apparently, at bearing malice or quarrelling. The lawsuit he was involved in against his brothers, over the property he had inherited from his uncle Francesco, did not prevent him from being friendly towards them afterwards: his sister-in-law wrote to her husband Giuliano (Leonardo's brother), when he was in Rome, after the lawsuit, asking to be remembered to Leonardo, '*vuomo excellentissimo e singhularissimo*' ('the most excellent and curious man').

But gossip found an easy victim in him, during those periods of his life when he was without the protection of a powerful prince. In Rome, where he failed to fit into Leo x's Court, the denunciations started again, not overtly on the subject of homosexuality, but the whispering campaign – directed against his dissection of corpses – must have included that. As he wrote once, calumny is more powerful than the sword. 'Men will always fight among themselves and do each other great injury. . . . There will never be any limit to their evil nature.'

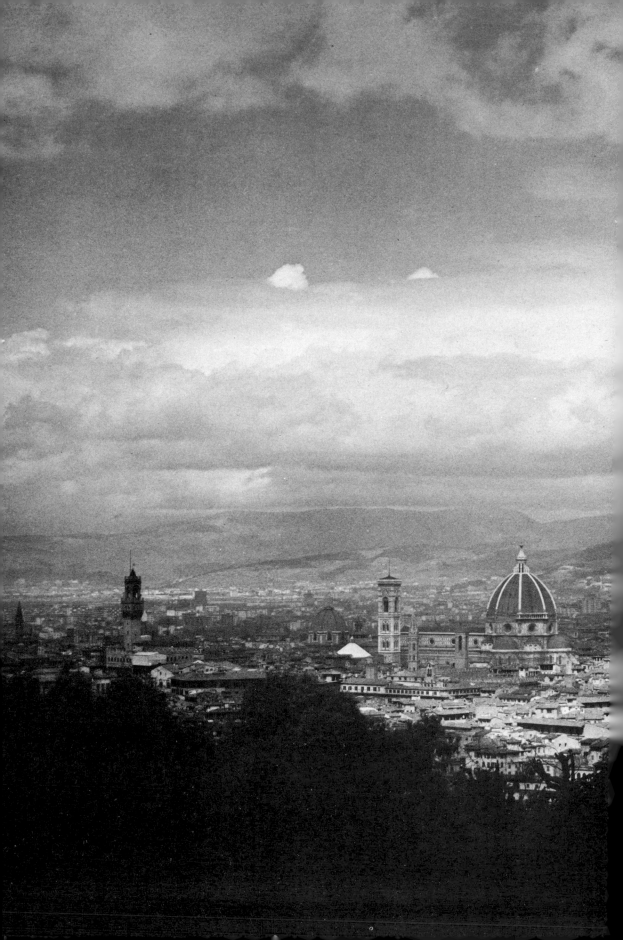

2

A Misfit in
Medici Florence

FOR LEONARDO there was a thoroughness in nature, even in the matter of evil and destructive forces, that dazzled and bewildered the mind, and he was determined to imitate this 'divine craftsmanship' in the application of his own powers, whatever he did. It was about this time, when he had finished his apprenticeship (though he continued to work with Verrocchio), that he became interested in machines of war, after he had read *De Re Militari* by Volturius, a famous manual of the time. He read massively in every field of study known to him, from optics to hydraulic engineering. Here too he was following the ingenious blueprints of previous centuries. None of his inventions was original in the proper sense. Some, like his plan for firing metals, were more original than others, but all had their origin in hard medieval work. During his life he projected dozens of ingenious schemes for air-pressure gauges, drainage machines, cranes, drills, weight-lifters, mechanical ventilators, movable bridges, rampart-scaling ladders on wheels, sawing machines, double-bottomed boats, parachutes, helicopters, gear-boxes, printing machinery that could be operated by one man, river locks, armoured cars on wheels operated from inside by means of cranks, hand-driven horseless vehicles, devices for separating the husk of the wheat from the kernel, and – centuries before the 'age of steam' – a vapour-fired gun. His various guns, multi-firing or on vertical and horizontal traverses, or buried in the earth to spray shells over ramparts, conformed to ballistic requirements.

The whole theory of a 'modern' world that suddenly burst into action around the fifteenth century does not bear examination: the moment we look into the background of all these 'inventions' we realize that each epoch invents precisely what it needs, to the extent it needs it. The interest in a higher rate of production is demonstrated by Leonardo's printing machine, which saved on manpower. But at that time manpower and production were not at all the problems they became in the nineteenth century with its population-increases and higher volume of demand, hence his idea was not taken up.

Leonardo was a peaceable man but found no difficulty in conceiving machines of war since war in his time was a sporadic and localized matter more like the diplomacy of our day. War machines were not yet manifestations of that 'evil' of which Leonardo was aware inside peaceful Florence between one man and another. They were simply a necessary defence, and 'evil' in time of war lay outside the town-gates. He was so peaceable indeed that he

54

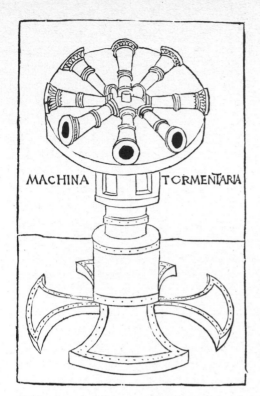

MACHINA TORMENTARIA

Two illustrations from
Volturius's *De Re Militari*,
a famous military manual
of the day.
ABOVE An early idea for
a quick-firing cannon.
BELOW A battering ram
supported by a beam,
much more powerful
than the usual
shoulder-supported one.

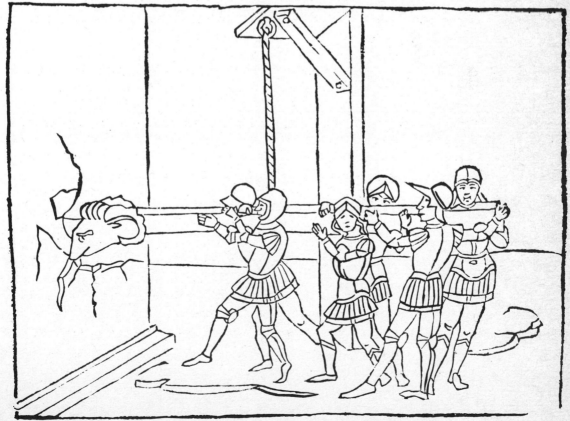

Although Leonardo was a peaceful man, his imaginative interest in engineering was as readily diverted to conceiving war machines as to hydraulic and sewage problems.

ABOVE An Archimedean screw.

BELOW A device enabling soldiers to attack a fortified town and remain protected.

OPPOSITE Ideas for multiple-firing cannons, perhaps a prophetic vision of machine guns.

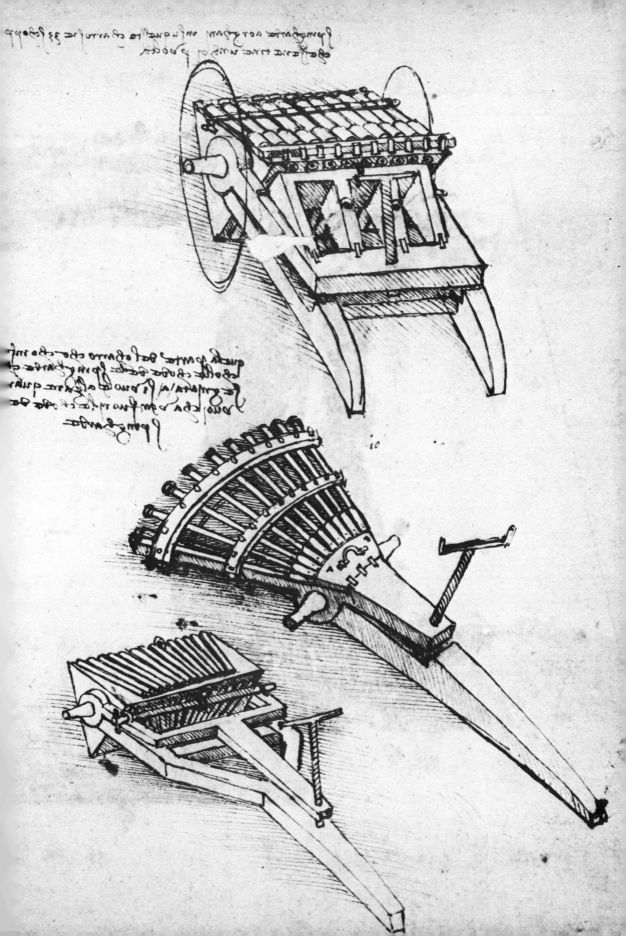

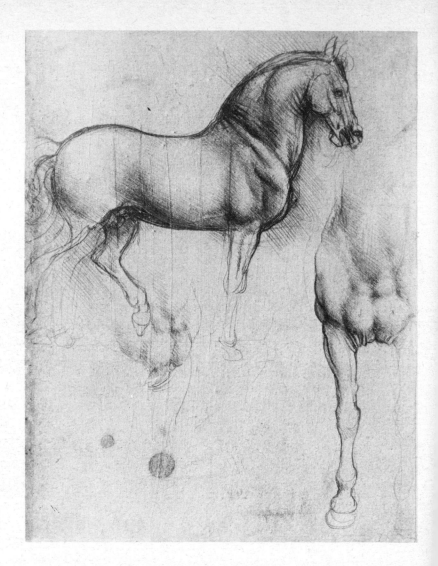

According to Vasari Leonardo 'greatly delighted' in horses.

OPPOSITE Pope Sixtus IV with a cardinal. Sixtus IV was Pope from 1471 to 1484 and connived at the famous Pazzi conspiracy to murder Lorenzo and Giuliano de' Medici because he was angered by Lorenzo's refusal to advance him a loan and agree to his takeover of the town of Imola.

was well-known for buying caged birds from peasants and setting them free, for the joy of seeing them fly away after the first moment of hypnotized disbelief. He understood animals, even envied them – especially the birds – for their marvellous powers of movement. According to Vasari he 'greatly delighted' in horses, and looked after all his own animals 'with the greatest love and patience'.

The evil he saw between men, the destructive force latent in nature, was suddenly manifest in Florence in the famous Pazzi murder-attempt on Lorenzo de' Medici, when Leonardo was twenty-six. It is safe to say that Florence never really recovered

58

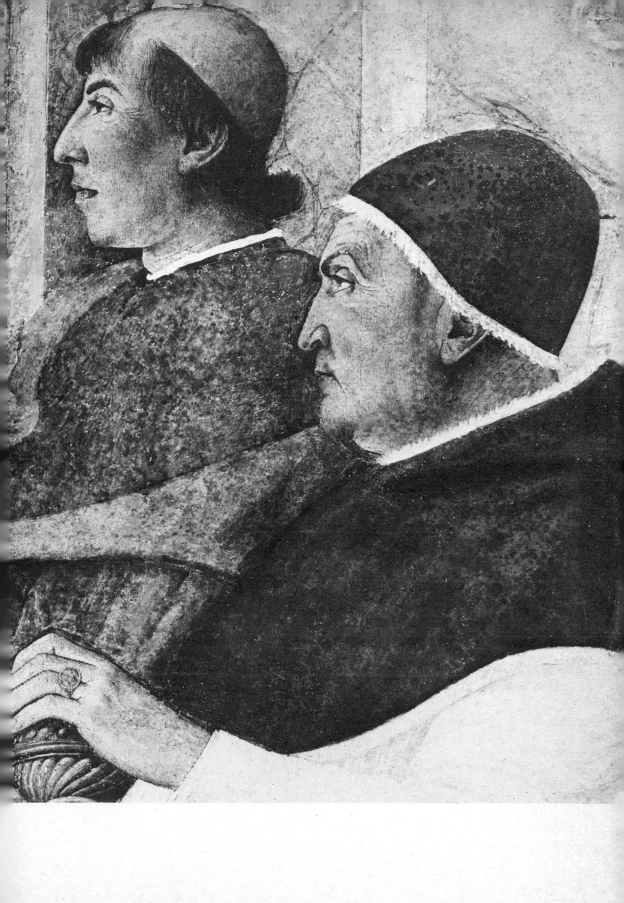

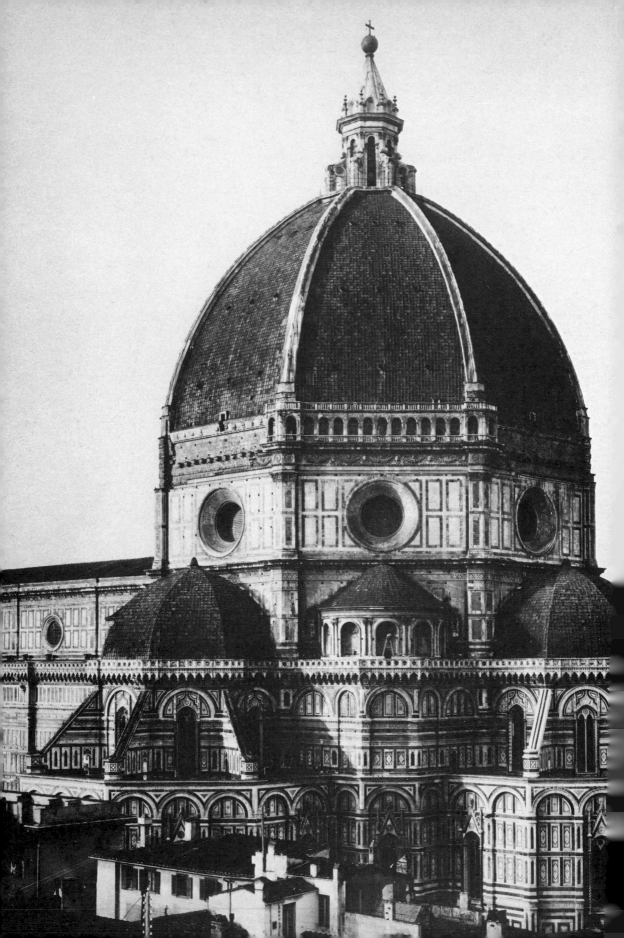

from this. It dragged her into war, near-bankruptcy (not to say near-starvation) and, finally, after Lorenzo's death, eclipse. The Pazzi conspiracy of 1478 involved the Archbishop of Pisa, a mercenary captain called Montesecco, two priests, a number of local misfits and the Pope himself. For Lorenzo de' Medici, *Il Magnifico*, had angered the Pope by refusing him a loan with which to buy the town of Imola. Lorenzo had his eye on that place for himself, and gave instructions to Francesco de' Pazzi, head of the Pazzi bank in Rome, not to advance Sixtus IV any money. Francesco saw that this was a good chance of bringing Lorenzo down in the papal favour, and instead of following Lorenzo's advice offered to advance three-quarters of the sum he wanted. The Pope transferred his account from the Medici to the Pazzi bank. Now this alone might have been insufficient to bring the two families to an open clash. But Lorenzo, following Florentine tradition in meddling with the tax- and inheritance-laws for political ends, put a new retrospective law through which said that in the case of a Florentine dying intestate, the preference was to be given to collateral males over the daughter of the deceased. It meant that the vast Giovanni Borromeo inheritance would not go to Borromeo's daughter (wife of Giovanni de' Pazzi) but to his nephews.

Even Giuliano, Lorenzo's brother, thought this was a silly thing to do, given the business war between the two families (the Pazzi network of banks throughout Europe was almost as important as the Medici). The plot itself was the work of Francesco, the madcap of the Pazzi family, and Girolamo Riario, a nephew of the Pope's. It was all worked out in Rome. Jacopo, Francesco's uncle, another restless individual who had the habit of dashing his dice-board over the head of his opponent if he lost a game, gave the conspiracy a final touch of improbability, and a double assassination was planned to take place in Florence's cathedral. Both Lorenzo and his brother Giuliano were to be killed. Two years before the Duke of Milan had been murdered as he entered the church of San Stefano. That ended a remarkable period of peace in Italy when, according to a Ferrarese chronicler, only 'battles between birds and dogs' were to be seen. Now it looked like war and assassination for the whole of the peninsula as rivals began to compete for the most important ducal throne in northern Italy.

The plot failed, but Giuliano was killed. Lorenzo got away with some of his retinue to the sacristy, and barricaded himself in, with a cut in his neck which a young aide sucked in case the knife had been poisoned. The city was in a state of frightened hysteria.

OPPOSITE The cathedral in Florence, with its famous dome designed by Brunelleschi, where the attempted double assassination took place in 1478.

61

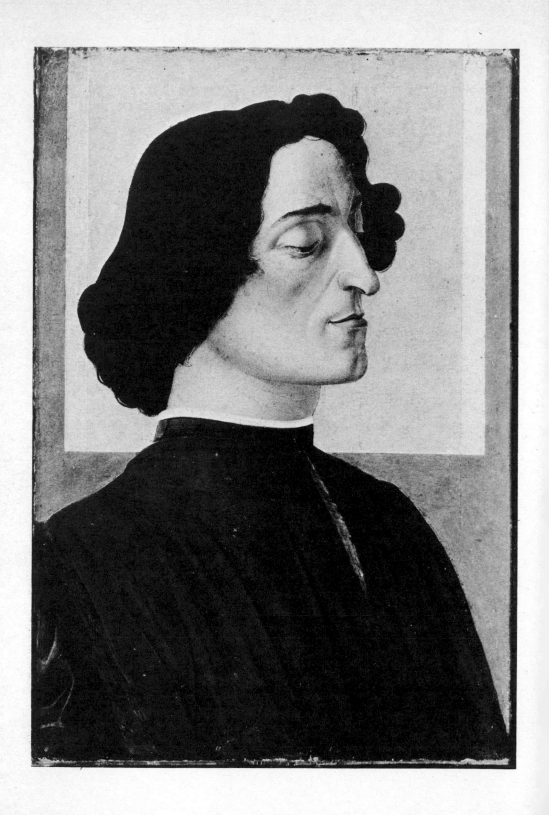

Horsemen dashed here and there. Jacopo de' Pazzi galloped into the main piazza shouting 'People and liberty!', but the answer from the crowd was 'Balls!', meaning the six balls of the Medici house. He turned tail and fled with his retinue to the Santa Croce gate, and the waiting army outside fled too. The other conspirators, with the exception of Bernardo Baroncelli and one of the two priests, were rounded up and hanged. The Archbishop of Pisa was thrown out of a Signoria window on a rope just after Francesco de' Pazzi, and managed to bite Francesco in the chest just before they died. Not one man in the square below had cried *'Marzocco!'* which, referring to the lion of the Florentine coat-of-arms, would have meant support for the Pazzi. Lorenzo appeared on the balcony of the Signoria with a bandage round his neck, and asked everyone to disperse quietly. From that time Florence was in an unsettled

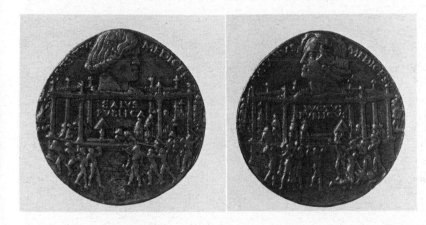

OPPOSITE Giuliano de' Medici, who disapproved of the new inheritance law which was initiated by his brother Lorenzo and which sparked off the Pazzi conspiracy. Ironically it was he who was murdered.
LEFT The two sides of a medal struck to commemorate the Pazzi conspiracy. (Left) Priests celebrate Mass in the choir of the cathedral while the conspirators attack Lorenzo. (Right) The murder of Giuliano.

state. It was clear that the Pope would never forgive Lorenzo for hanging an archbishop, and above all for failing to get murdered himself. Sooner or later Florence would be at war.

On the day of the conspiracy Leonardo went round the city drawing people's alarmed and excited faces. When Baroncelli was finally caught and brought to Florence the following year, he drew him hanging, and carefully noted every article of his clothing. He had such an inquisitive turn of mind – was so helpless before anything new or unusual that caught his attention – that it was a wonder he ever settled to work in the concentrated way he invariably did. At this time, when they were both in their twenties, Perugino – already successful and sought-after by the patrons – felt that Leonardo's restless curiosity was dispersing his genius; and more than one person must have felt this as Leonardo turned

Leonardo's sketch of the
hanging of Bernardo
Baroncelli, who was caught
a year after the Pazzi
conspiracy. With a detached
eye Leonardo notes the
details of the corpse's
clothing.
OPPOSITE A sketch of
a beggar's head.

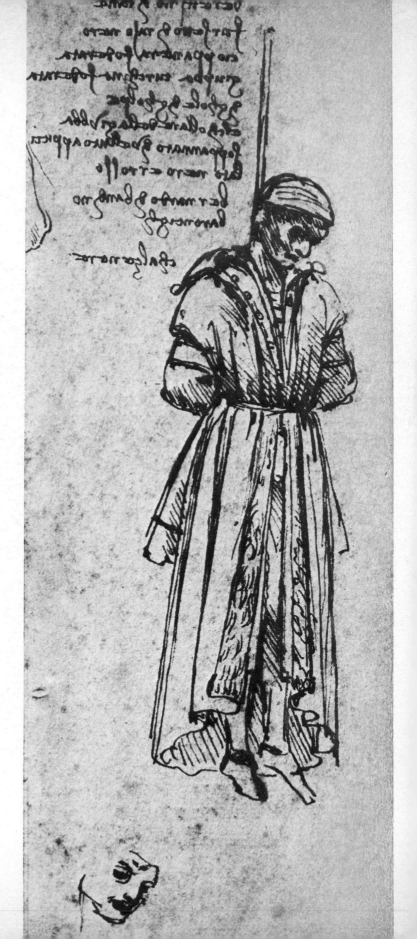

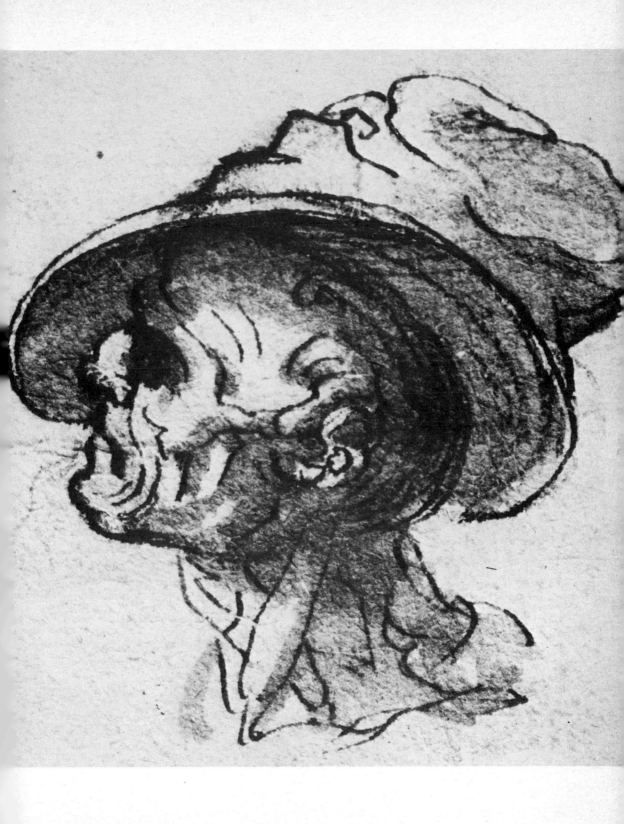

from painting to designing new musical instruments and from that to water clocks. He would follow a man with an interesting or quaint face through the streets all day in order to get his likeness down on paper.

His unpunctuality was now so talked about that the friars of the San Donato a Scopeto monastery pinned him down to a strict time-limit for a fresco they wanted, an *Adoration of the Magi* which survives today only as an under-drawing in umber and terracotta (in the Uffizi). Even a contract failed to hurry him, and the commission was eventually given to Filippino Lippi. He began this between 1480 and 1481, having agreed to do it in thirty months. In August 1481 he received a consignment of wood and faggots from the San Donato friars – but not for the *Magi* picture: he had painted their clock, or perhaps the tower. How many of the three hundred gold florins offered by the friars for the picture reached him we do not know, but he certainly did several drawings for the project, some of which are in Paris. And the friars sent him a keg of wine and various provisions. They simply could not understand why, as a painter, he did not paint the picture as Perugino would have done, and draw his earnings.

The fact was that for Leonardo the painting of a subject was never enough. In a sense, everything he touched had to be an invention of some kind. And it is doubtful if the friars would have liked his picture, since it was as restless, to judge from the cartoons, as he was himself. When people came to Verrocchio's workshop to look at the work in progress and, as classicists, found the picture over-crowded, he replied, 'I don't follow the classics, I follow life.'

For sheer dynamic choreography and variety of facial expression in a crowded composition, nothing like his picture had been seen. The cartoons burst with action – rearing horses, a dark and seething crowd round a marvellously reposeful and isolated Madonna with her Child, and clever architectural suggestions behind. On the left of both the Uffizi and the Louvre cartoons there is an old man standing, quite withdrawn, simply gazing at the scene which, apart from the illuminated figure of the Holy Mother and her Child, is dark and dense with a not altogether wholesome curiosity and adoration in the crowd. In the Uffizi cartoon there is (on the right side) a young man (some say it is a self-portrait) gazing reflectively out of the picture – quite as if Leonardo himself had already tired of the subject, which he had 'solved'. There were too many other things to solve in life to stop too long in the execution of one: his mind leaped on to the next problem. For

66

The Adoration of the Magi, commissioned by the friars of San Donato for three hundred florins but left unfinished.

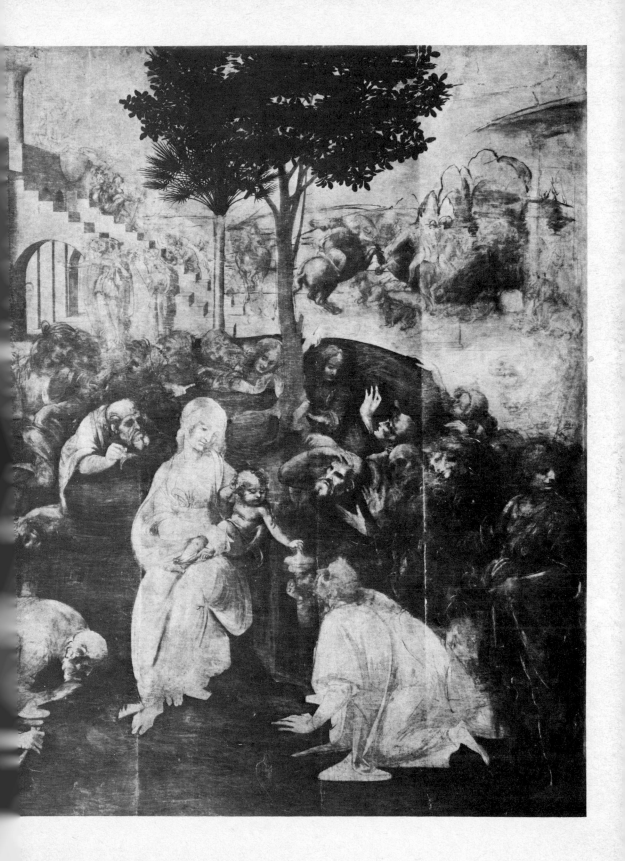

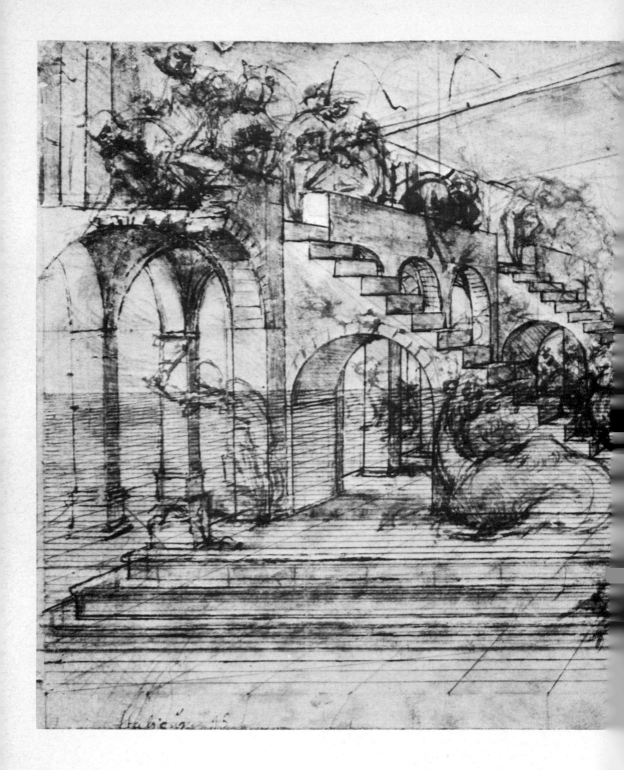

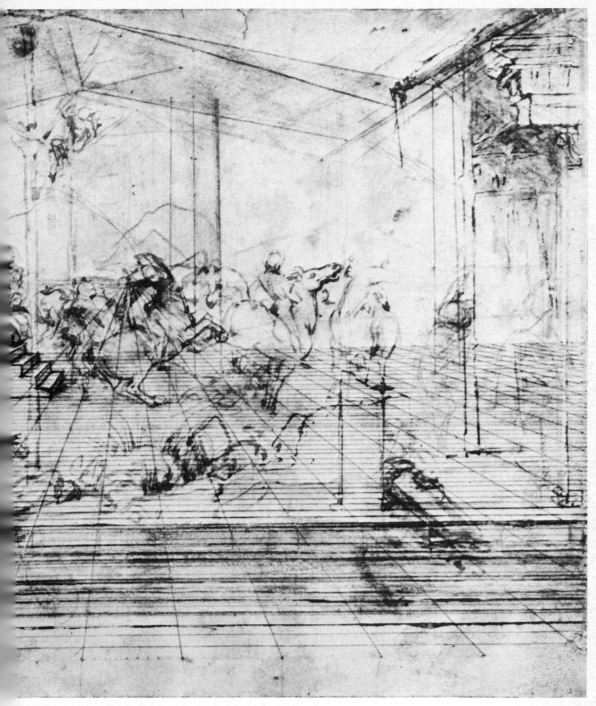

This preparatory sketch for *The Adoration of the Magi* shows Leonardo's careful study of perspective.

a painting – a mere successful painting – could be done by any proficient artist. People came to the workshop and marvelled at what they thought only the beginning of a great picture. But for Leonardo they had already seen the marvel, in the cartoon, in the composition. One mind could hardly undertake a revolution in every picture – and also paint the picture itself! Perhaps too the friars showed a distaste for what he was preparing to give them. The smallest sign of indifference was often enough to make him turn to new quests – provided that the problems had been solved.

Few of Leonardo's admirers have been prepared to see that he was not interested in art so much as in the act of painting. The two are very different. Painting was on a higher level than the other arts for him because it described physical nature. And of course art is not simply a description of the physical. The physical is only the medium of painting as sound is that of music. But what Leonardo did was to try to render the physical not only with the utmost workmanship but also with the closest anatomical study (and where necessary the closest study of the anatomy of the emotions), in order to make the plainly physical, the unashamedly physical – untouched by any revising or instilling hand – a sufficient tribute to the spiritual in itself. In this sense the act of painting was what preoccupied him, not the narration of events as in Ghirlandaio, nor the poetry of events as in Botticelli, nor the mystery of events as in Perugino. Leonardo asked only to be a

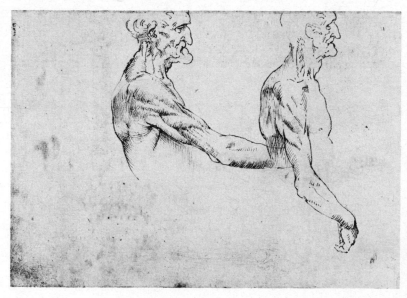

Leonardo's anatomical sketches demonstrate the painter's fascination with the workings of the human body and the processes of growth and decay.

practitioner. And to be a practitioner of nature meant for him to penetrate to its inner formulae – possible if you were diligent enough. Whether he really felt that his method was the right one in the end is another matter. He hoped for so much from mathematics, even in his painting, which it did not give him.

It is precisely this power of his, shown from his earliest years, that makes the so-called *Benois Madonna* doubtful, although it is now generally attributed to him. The ear is simply too gauche, too wrong for Leonardo of all people to have been able to paint, with

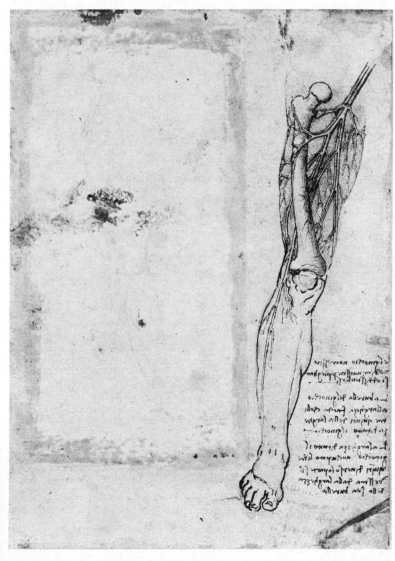

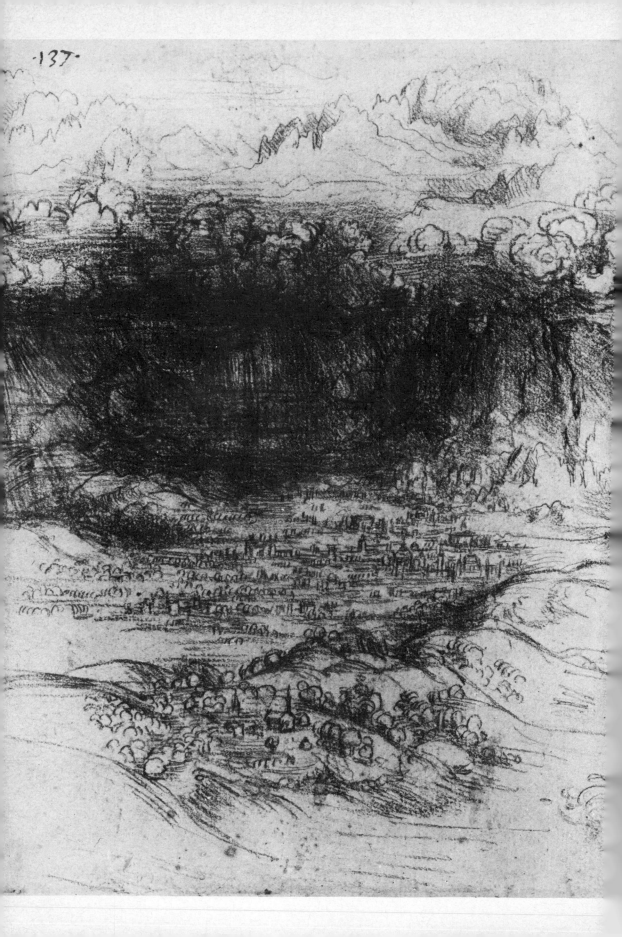

his consistent and meticulous attention to anatomy. The Child sits too floatingly in the Madonna's lap. The Virgin's smile is too open, too momentary, too impressionistic, while the rather careless gaiety of the piece does not fit into any of Leonardo's moods as we know them. In the *Madonna and Child* cartoon where the Child plunges his hand into a bowl of flowers, and another where the Child plays with a cat, and certainly the 1475 *Madonna with the Carnation*, where the Virgin is reflectively holding a flower for the Child to play with, we have the true – the untiringly truthful – Leonardo. There is a great attention to drapery, and to landscape, which in Leonardo's work is nearly always stirring and strange, offering blazing vistas of chasms or giddy peaks or slender, spiky-leafed trees or grottoes with still blue water. Invariably 'excitement' is the word for even his least mobile pictures, but not excitement overtly displayed in the subject. It is there in the *Carnation* picture (oil on wood panel), outside the windows, in the Madonna's hand and the cushion on which the Child sits. In the 1478 *Annunciation*, immobile and fixed as it seems at first sight, in a careful balance of forms, there is an altogether new relationship between the Virgin and the Angel. Leonardo felt that in most pictures on this subject the Angel seemed to have just arrived in the room with terrific force, and the Virgin seemed to want to get rid of him as quickly as possible. In his version her eyes settle on the Angel with a sweetly serious and girlish expectation, yet with complete dignity, as she raises her hand in a sign, to answer the Angel's hand, as he kneels holding a lily. There is again the vast landscape behind, and the superb detail, the attention to perspective that will not allow any short cuts, and the usual superbly tactful combination of colours.

All this added up to an excited – sometimes an over-excited – concern with inventiveness, in subject, in technique, in perspective, in colour, in facial movement and indeed in the whole manner of sitting or kneeling or standing. His *Ginevra Benci*, sometimes attributed to the year 1475, when he had been with Verrocchio about eight years, invents an altogether new kind of portrait. There the quality of feminine spirituality which has nothing to do with any individual bent in the sitter herself, is like a divine universal quality seated in the woman as naturally as her womb. It has nothing to do with the tradition of chivalry either: that in any case had little importance in Italy compared with its social role in Provence. There is nothing idealized in the portrait. It simply explores characteristics which are beyond the sitter and

OPPOSITE A sketch in red chalk of a storm over a valley and town; possibly a preliminary sketch for the strange, deserted landscape of *St Anne, the Virgin and the Infant Christ with a Lamb*.

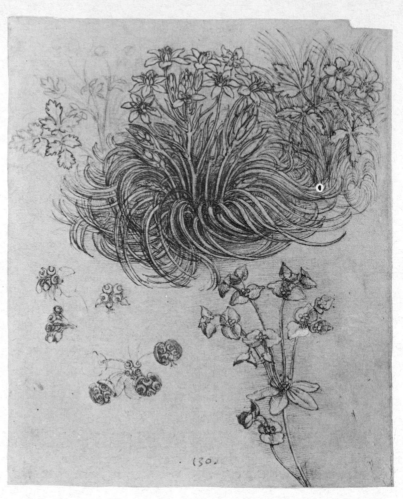

A study of plants in red chalk and ink for the first version of *The Virgin of the Rocks*.

yet latent in her, giving her eyes – simple and even rather plain as they are – a reflective cast, and her skin something of the smoothness of polished marble, and her hair a shining articulated quality like that of the juniper trees behind her (perhaps chosen because in Romance dialect they bear her name). And there is the same hint behind of an awful landscape, full of a strange light, reflected in water, and primitive in its stillness, quite unlike the husbanded olive groves and vineyards of Tuscany. When one climbs the hill from Vinci to the village of his birth today, up a narrow road that winds between numberless olive trees, with industrial Italy left suddenly behind, one sees that the shadowy dips, the sudden broom-covered cliffs, the endless vista towards Empoli and the sea beyond, and the hills so densely wooded that they seem to swallow up the sunlight and give nothing back,

74

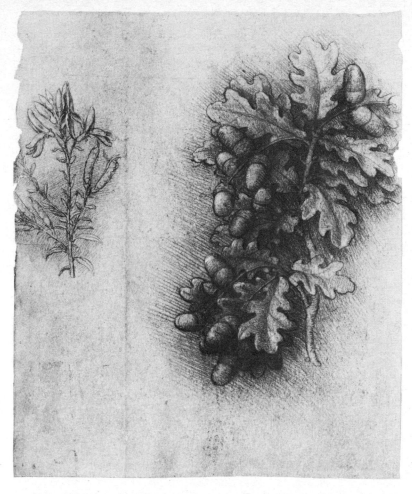

A wild plant and an
oak branch.

interested him as much more than a scene. There is a local story that
he was fascinated by a grotto below the house where he was born,
but was afraid to enter it. He overcame his fear. And the fear, the
fascination – the excitement at overcoming the fear in order to
indulge the fascination, remained in his pictures.

While he was interested in every kind of posture in the human
figure, there was little posturing in his work, indeed none in the
finished paintings: there is stiffness in the unfinished *St Jerome*
(1480-1), and bad draughtsmanship in the sketches for *The Last
Supper* now in the Accademia in Venice, if indeed that is his work.
But the hallmark of the Leonardo composition is an utterly authori-
tative and reposeful ease, in line, in colour, in pose. Why then
do we have no story in pictorial form – no series of paintings that
mark his development as an artist? Let us suppose that Lorenzo

75

had less advanced tastes in painting than he had in poetry, and failed to recognize Leonardo as more than an accomplished artist, one of several in Verrocchio's workshop, and a musician with a pleasing voice. Why then under Ludovico of Milan was there no such development? Why was Leonardo forever trying to fly, and devising new hydraulic systems, and ardently prophesying the world after his death? How could he have been diverted constantly from art if art had not been in some way an insufficient medium for him? It was not a matter of his failing to finish a picture. For finish pictures he did, though these were not always the commis-

A section of *The Annunciation* which shows the superb detail of Leonardo's vast landscapes.

sioned ones. He worked best in secret. He believed strongly in being alone: 'The painter or draughtsman should be alone, so that physical comfort does not impair his intellectual progress, and in particular he should be alone when he is concerned with observation or reflection.' Again, *'Se tu sarai solo tu sarai tutto tuo'* ('If you are alone, you will be all your own'). Communication was not his aim. In that respect it was never enough for him to be an artist. Art means the communication of spirit — the sound or the paint or the clay or the words are simply the medium incidental to that communication. He had an altogether different objective. He was

so powerful a creature that he could with the slightest touch convey art where others dedicating their lives to it were left behind. His sleight of hand, dealing with rocks or flowers or the most precious religious subjects, was such that he always seemed to be questing beyond the picture itself – as if too much had already been achieved for him to say anything new. Thus, however much spirit he happened to convey, in his *Annunciation* and his *Ginevra Benci*, in his later *Lady with an Ermine*, not to say his *Virgin of the Rocks* and his *Mona Lisa*, and his madonnas, that achievement belonged to only one of his moods of discovery, and discovery as an end in itself remained for him the most fascinating

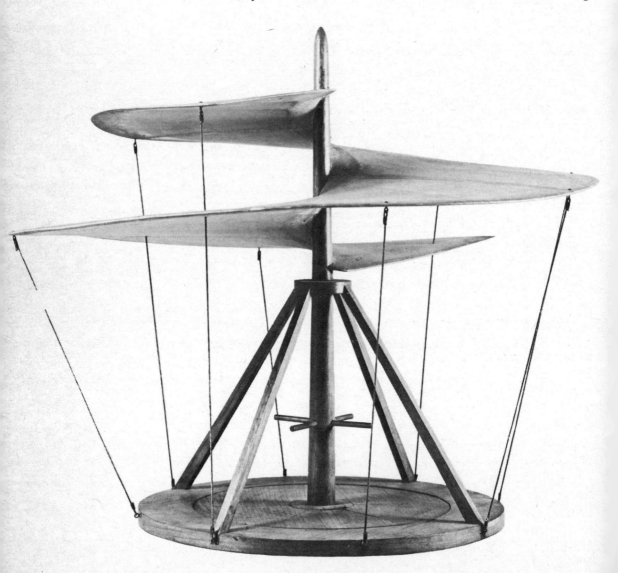

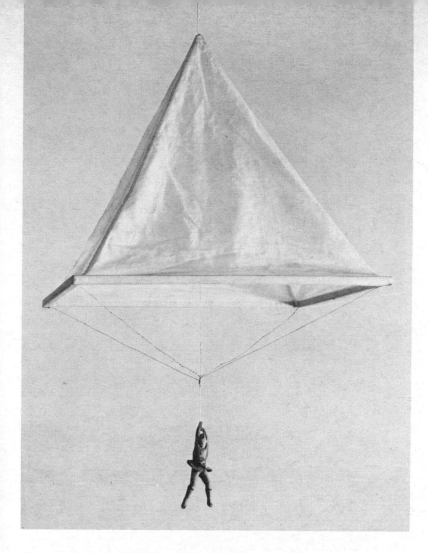

Two reconstructions from Leonardo's designs foreshadow the modern helicopter and parachute.

of all human enterprises. His passion to fly, which gripped him more and more deeply after he left Florence and could as an individual really 'take wing', far from calumny and familiar report, was not simply one more bid to wrest open the future – to give something to the world – in a long list of such prophetic researches based on medieval aspirations. It was deeply personal, an anguished desire for greater power. This was not power for future generations. The fact that one day an aeroplane would certainly be invented was of little consolation to him. He yearned for the flying sensation – of the kind that mystics have in dreams. He yearned for levitation of a material kind. And art – from the spirit and back to the spirit – was like religion, not enough. The most ardent materialist who has ever lived, naturally he felt deeply that religion had somehow become separated from nature – that in nature lay so many keys and dazzling mysteries that account had to be taken of it once

79

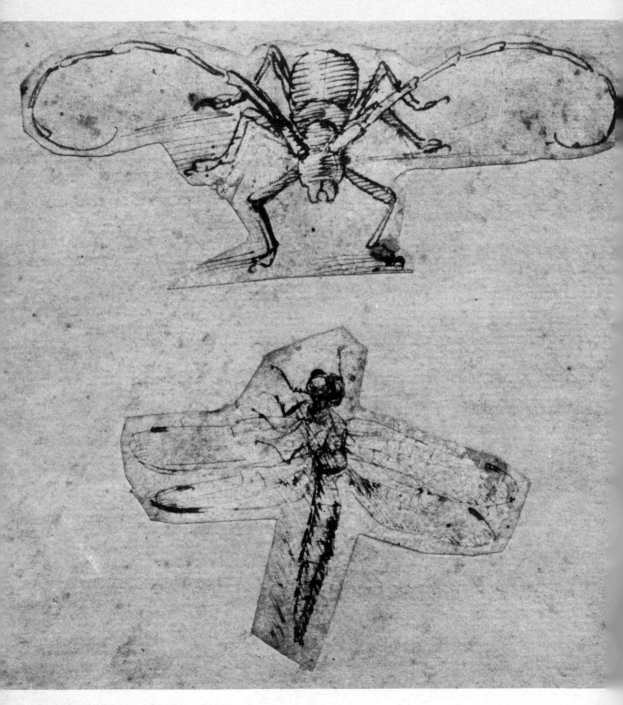

Leonardo's obsession with flying led him
to examine everything which moved
through the air: studies of dragonflies.

more, at the expense of the spirit which turned its wheels, and if necessary at the expense of his art. He was incapable of leaving nature. He was tugged back again and again. And towards the end of his life he saw, with a certain dismay and perhaps surprise too, that his fellow-countrymen had no real grasp of the quality of his mind, because they lacked tangible evidence of it. Two great frescoes that were already peeling on their walls – an unfinished equestrian statue in Milan which had never got to the firing stage, and which French troops had used for target practice: what evidence was there of the great man? He had gone from one fascinated quest to the next – until life was suddenly over. Did nature with her alluring play of veils entice him too successfully?

Even in his gentleness there was more than personal aptitude. It derived from his rapt awe of living nature. His St Sebastian is without the usual arrows piercing his flesh, as if Leonardo could not allow his brush to be the vehicle of brutality even for the imagination. This was certainly not squeamishness, in a man who dissected corpses. Sometimes it seemed that he yearned for a more universal religion than Christianity was at the time, with its overbearing doctrine of heaven and hell, and personal immortality, and original sin, and its sometimes well-nigh Albigensian rejection of matter as evil. He was looking for both a more boldly realistic and yet more gentle experience which he perhaps could have realized only in an eastern religion, which saw God in everything. Thus, like the neo-platonists who were so different from him, he strove to give in his work a hint of the greatest craftsman of all – in the smiles of his women, in the gazes of his boys, in his Virgins and his angels and, for all we know, in the charcoal portrait of that Florentine friend who gave his name to America – Amerigo Vespucci, 'a most beautiful head of an old man', according to Vasari, who saw it. Only in this way could a man fascinated by strange animals and distorted faces and pickled glands and guts be reconciled with the man who recoiled from any hurt to the living flesh. He looked for a deeper attention to nature than Christianity gave, and a deeper detachment from it.

As he neared the age of thirty he may well have begun to feel impatient to move away from Florence, quite apart from the fact that his 'master' (and in that his protector) Verrocchio went to Venice to do an equestrian statue of the mercenary captain Colleone. He needed to attach himself to a great prince, and there was clearly no chance of that in Florence. Possibly the Medici party

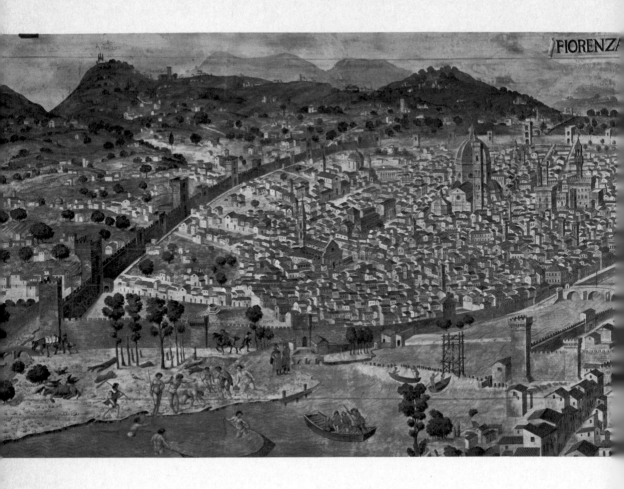

ABOVE A view of Florence showing the
cathedral, the town hall (Palazzo Vecchio)
and the Arno valley.
RIGHT The burning of Savonarola in the
main square in front of Palazzo Vecchio.
OPPOSITE ABOVE The deathmask of Lorenzo
the Magnificent, probably made
by Verrocchio.

82

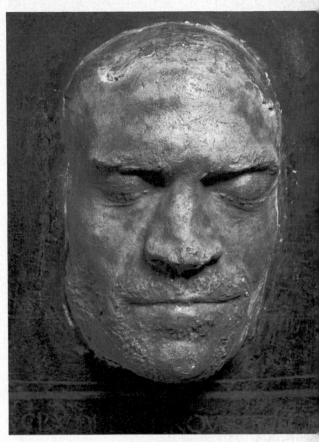

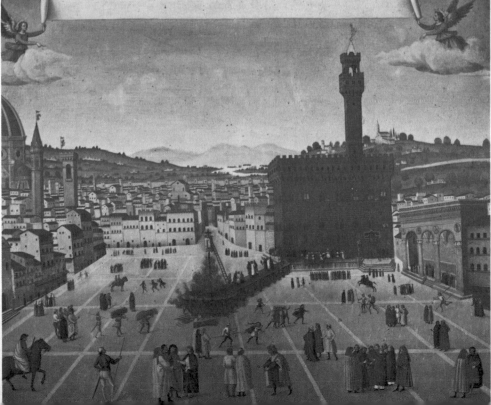

was cool towards the Verrocchio workshop – some say because of a homosexual stigma. But equally the workshop's political loyalties may have been suspect. The Medici party had been going through a bad time since the attempt on Lorenzo's life. Between 1478 and 1482 Lorenzo had little time to devote to artists. He had been excommunicated by the Pope, and the expected war had come, with Rome and Naples in alliance against him. Florence had not simply been beaten in the battle-choreography of the time: it was in financial crisis, since it depended on trade for its survival, and its road- and sea-outlets were cut off. The demand on the Pope's side was that Lorenzo 'give himself up', and leave Florence to find itself another leader. As a last desperate bid to save himself,

84

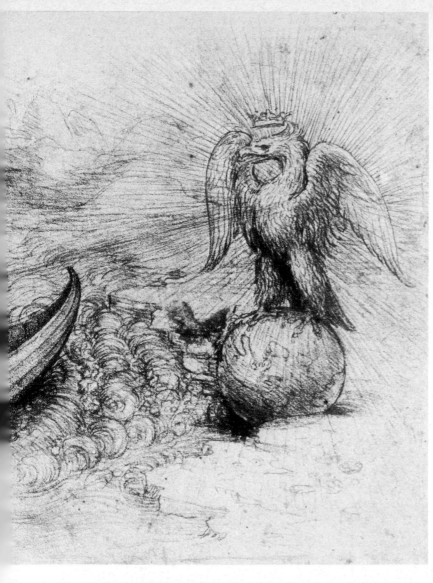

An allegory of state illustrating Leonardo's ability to blend naturalism with a wild imagination. Traditionally the wolf represents the papacy.

he went alone to see King Ferrante in Naples, from which journey, as everyone knew, he would either return triumphant or never return at all. He returned, and Ferrante agreed to peace in February 1480. Almost certainly Lorenzo had threatened him with the Turks: later that year, when the Pope once more threatened war, the Turks besieged Otranto, possibly at a sign from Lorenzo: and the Pope was forced to climb down. There was a second attempt on his life, this time without support at the Vatican – and the plot was scotched in time. But his party leaders were uneasy and suspicious. It was not the best atmosphere for artists. And Verrocchio's journey to Venice may have become a holiday from vicissitude.

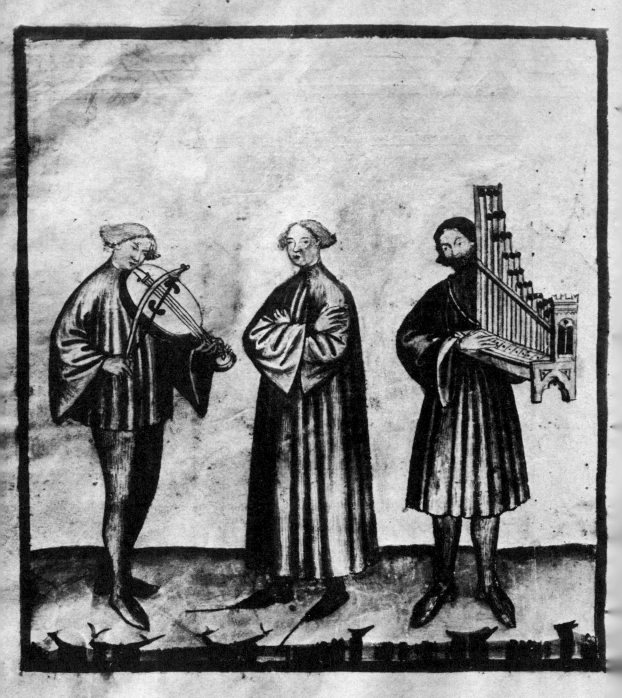

Natura. Quedam in uita uel cantus uiolentus melior creis. qd est ppor
tionatus xordit cu uoce Juuameti. qn cantant suauiter mo festinat
nocimeti. qn discordit cantant qr ipoz alter uix audietur oculte canti
re remoto nocimith cu pportionaliter ocordantur.

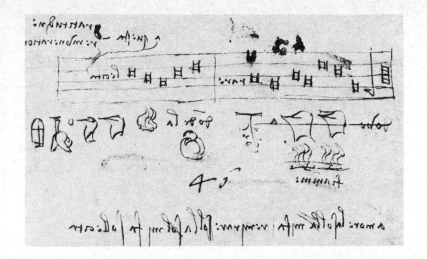

The Renaissance introduced
new techniques into music
and Milan had one of the
finest music academies
in the world.
OPPOSITE Three minstrels.
LEFT Music composed
by Leonardo.

Ludovico Sforza (or 'the Moor' as he was called because of his
dark complexion) was now firmly in the saddle in Milan. Brother
of the murdered duke, he now styled himself the 'protector' of the
heir to the ducal throne, the young Galeazo. Bona of Savoia, the
murdered duke's widow, looked on anxiously, as everyone knew
that one day Ludovico would declare himself duke. He began to
form a Court round himself. He began looking round for artists
and musicians (Milan had one of the finest music academies in
Italy at the time) and military engineers. Lorenzo de' Medici
suggested Leonardo as just the musician Ludovico wanted, apart
from the fact that he would be able to do a fine equestrian statue
of Francesco Sforza, the *condottiere* founder of the Sforza family
and Ludovico's father: and Leonardo was known to have his head
full of new ideas for machines of war.

He left Florence in August 1482 with his old friend Atalante
Migliarotti, a fine lutanist, and Tomaso Masini who called himself
Zoroastro de Peretola and was interested in magic. For all we know,
Lorenzo and his party chiefs may have been glad to see the backs
of all three, at a time when security on the home-front was the
first consideration. Equally, Lorenzo needed Milan's friendship,
and it was a mark of his regard for Leonardo that he sent him.
There was a negative and a positive side to the decision. As
Leonardo once said, 'The Medici made me, and the Medici broke
me.'

3
Milan:
Peacocks and
Water Lilies

LUDOVICO COULD NOT HAVE NEEDED a man like Leonardo more. He meant to make himself the ruler of Italy, and he meant to create the finest Court in Europe. A great artist and military engineer in one man, and a perfect courtier, gracious and attractive to the women without embroiling himself with any one of them – Leonardo's assets could hardly have been better. Like many another usurper Ludovico boasted. The Pope was his 'chaplain', he once said, the Holy Roman Emperor his 'condottiere', the King of France his 'courier'. In Boltraffio's portrait of him he looks tolerant yet determined, his haughtiness not of the brutal kind. And there is a touch of hesitation in him – not humility but deference. And indeed he was by no means sure of himself. He was certainly tolerant of Leonardo, even indulgent towards him (the horse for the Sforza statue took him sixteen years, enough to try the patience of the most deferential patron). Ludovico was intelligent and discerning, but not at all trustworthy. Leonardo found the man he could deal with. He understood a usurper (perhaps every artist, climbing suddenly to thrones of fame, has a touch of it in himself). The two men liked each other. And, after all, Leonardo was none too dependable either.

Milan was a very different city from Florence. But the things that would have made another Florentine feel homesick fascinated Leonardo. The mists, the hazy plain all round the city, the mountains in the farthest distance, the lack of Tuscany's intimate and crowded hills, with its terraces of vines and blazing willow-trees, its warm and soothing checkerboard *poderi* hugging hilltop farmhouses: Leonardo took long walks outside the city, fascinated by the mysteriousness of distances lost in mist and mountain peaks. Florentines looked down on Milan. More than one Medici had made himself unpopular by befriending this 'barbaric' military state which always seemed in need of money, and where usurpers murdered their way to the top. Milan was hardly an artistic city either. Ludovico was strongly aware of this. Some of the finest-looking streets in the city were in fact simply façades: behind, there was nothing. The cathedral was still being built. There was none of that busy and exhilarating traffic in new ideas that went on in Florence, and little of its freedom, let alone its language, that sweet and clear-sounding Tuscan that, moulded by Dante and Petrarch, became the basis of an Italian literature and a national speech. There was a lot a Florentine could feel superior about.

Yet Milan was a lovely city, lost in the most exquisite way in orchards and clear streams, with the smell of blossom in the air.

PREVIOUS PAGES Milan cathedral, surrounded by a forest of pinnacles; the building began in 1385 and was still in progress when Leonardo arrived in the city in 1482. He submitted some designs for the cupola. The façade was not completed until the nineteenth century.

OPPOSITE Ludovico Sforza 'The Moor'. Intelligent and discerning but above all ambitious, Ludovico hoped to create the finest Court in Europe by gathering men of genius around him. A detail of an altarpiece.

OVERLEAF Castello Sforzesco, the magnificent centre of Ludovico's great city, where, in luxuriously carpeted and perfumed rooms, he held court.

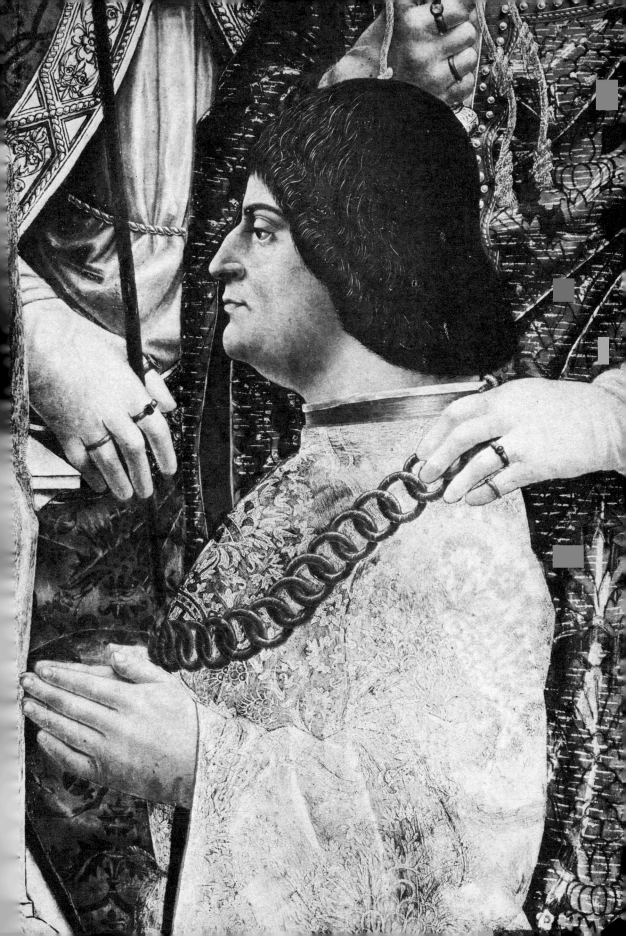

It was on the great trade-routes of the Lombardian plain, and had a wide canal called the Artiglio, with subsidiary canals radiating from it. The princes of Europe passed through it on their way south. The Lombards were a proud race, and Milan had defied Barbarossa in the twelfth century: her granaries had been set on fire and her enemies – Como, Pavia, Cremona – had joined in the looting. It was a vulnerable place, and its nearness to the Alps was not always a blessing (though the threat to invite the king of France or the emperor to squash an Italian enemy was invariably effective). Ludovico wanted to establish a great city in the Florentine sense, and like all of Milan's rulers, he was thwarted by the insecure nature of his throne, rooted as it was not in commerce and fiscal strength but in an army. There were too many powerful neighbours, not least among them the Venetian republic.

Like Venice, Milan had an oriental flavour, due to the Levant trade that passed across the Lombardian plains. That too was an allurement for Leonardo. His earliest landscapes hint at such a predilection, even the first pen-drawing known to us, of the Vinci landscape. The houses and palaces of Milan were pink and red, like its roses which were the finest and most perfumed in Italy. Its pink castle was a town in itself, with its open pavilions and luxuriously carpeted and perfumed rooms, famous everywhere in Europe. Inside its walls were cloisters and gardens and fresh, smooth lawns. It had a tower, and at its centre the Rocchetta, where Ludovico had his Court, with nearly two hundred servants. Peacocks strutted about the courtyards, there were dovecots in the gardens and still ponds with water-lilies floating. The voluptuous felicity of it all made Medici commerce seem far away: there was no sense of a republic here, no party politics or the endless argument about constitutions and tax benefits and electoral rights. A Court – a real one and not the makeshift and unofficial kind that Florence's great families cautiously permitted themselves – was just what Leonardo needed. Ludovico's bed was made of sardonyx and gold, and was covered with every kind of silk and brocaded cushion imaginable. His walls were brilliant with tapestries, his floor piled with Persian carpets. It was the kind of thing Leonardo liked, not simply luxurious but bizarre and curiously thorough in its hedonism. In one of the rooms a wall had been frescoed. The subject was dancers in the sunlight, quite undevotional, and inscribed above it Ludovico's worried motto, *Post tenebrae spero lucem* (after the shadows I hope for the light), which Leonardo made a note of.

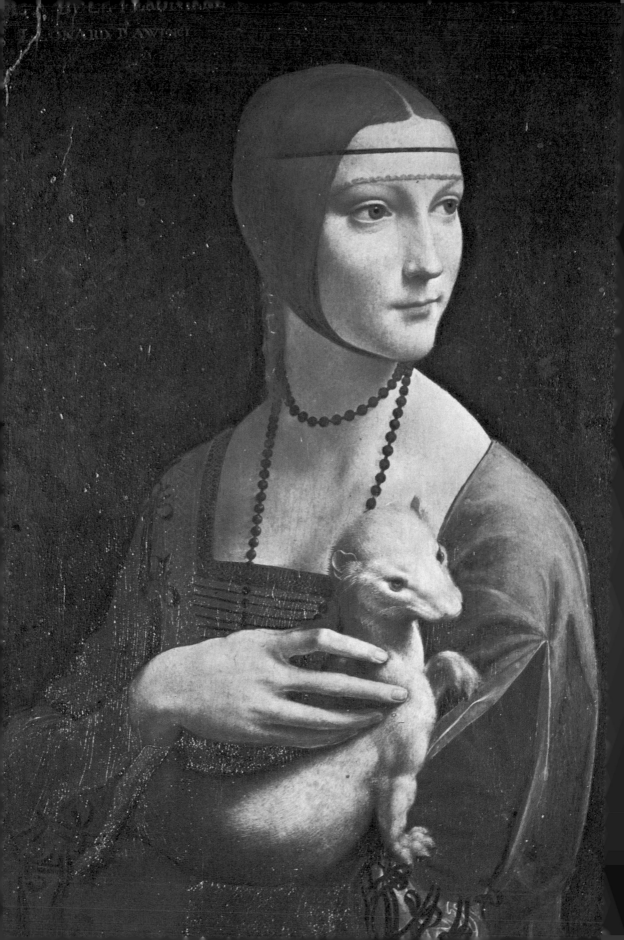

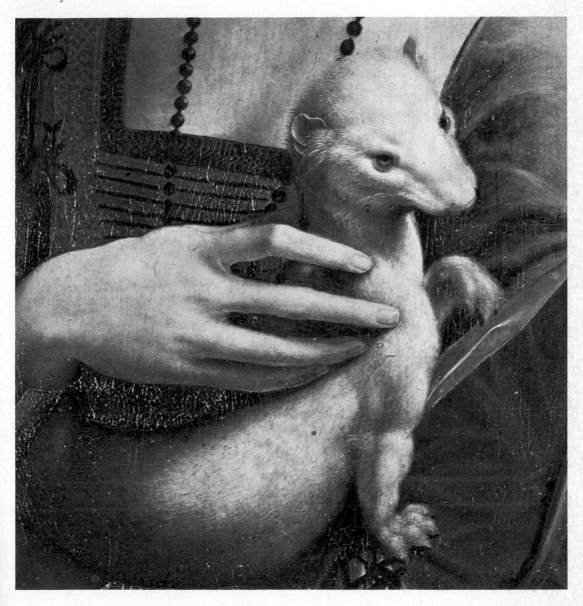

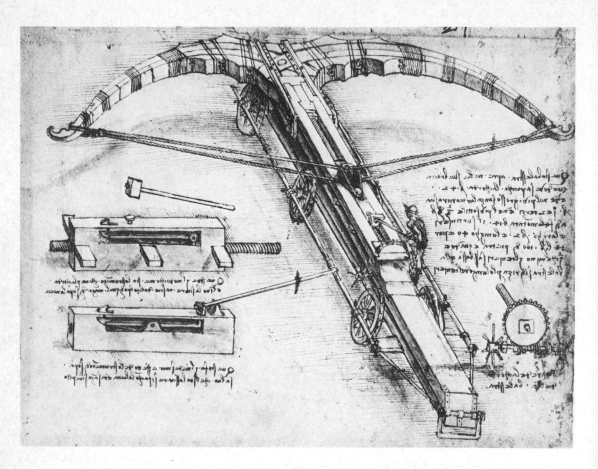

He presented himself at the workshop of Ambrogio da Predis, whose family studio (they were miniaturists and illuminists) was near the castle. There he met Milan's other artists, and it was arranged that he should work with Ambrogio and his brother Evangelisto. He stayed with them too, and prepared a long letter to Ludovico, after which he expected an audience.

Having, most illustrious Lord, now sufficiently seen and considered the essays of all those who proclaim themselves masters and inventors of warlike instruments, and that the invention of these instruments, as regards their operation, differs in nothing from those in common use, I will attempt, without denying the merit of others, to make myself understood by your Excellency, by laying open my secrets to you, and afterwards offering them to you at your pleasure, as occasions permit, to put them effectively into operation, as well as all those things, which for the sake of brevity shall be in part set forth here below.

He had invented 'very light and strong' bridges, and machines for drawing up water from outside the castle walls during a siege, and battering rams, scaling ladders, smoke shells, shrapnel-firing guns, mine-digging apparatus that was noiseless, armoured cars, 'bombards and mortars and field-pieces of the most beautiful and

Leonardo recommended himself to 'The Moor' not only as an artist but also as a military engineer. He drew up designs for a variety of ingenious projects covering every aspect of warfare. A design for a giant crossbow; a model of a light portable bridge 'offering the means of pursuing the enemy and also, if necessary, of fleeing from him'; an armoured car operated manually from inside to avoid the use of animals which could easily be wounded.

useful forms, and out of the common use', and armaments for ships: in fact, all the things we can nowadays see in model form at the Leonardo Museum in Vinci. Few of them were ever tried out. But that was not the point. Ludovico was not sufficiently a military man, nor Leonardo sufficiently a field-engineer, to carry out the new ideas. The list was simply a recital of his powers of invention (which would be used to devise the most ingeniously spectacular celebrations and fireworks-displays and processions Milan had ever seen). At the end of the letter Leonardo wrote,

In time of peace, I believe that I can very well give satisfaction, in rivalry with any other, in designing both public and private buildings, and in bringing water from one place to another. Moreover I will execute in sculpture, whether of marble, bronze or clay, and likewise in painting, whatever may be done, and in rivalry with any other, be he whom he may. Also I shall be able to put the work of the horse into execution, which will be to the immortal glory and honour of the prince your father, of happy memory, and of the illustrious house of Sforza. And if any one of the above-named things seem to any one to be impossible, and not to be done, I am prepared to make a trial of it in your park, or in whatever place may please your Excellency, to whom I commend myself with the utmost humility.

As usual, when princes received letters from those who were not princes themselves, there was no reply. Leonardo went on working, and produced a number of madonnas of which the *Madonna Litta* may be one. It was not likely that Ludovico would disregard him. The Sforza family had every reason to be grateful to the Medici, since Ludovico's father Francesco had largely owed his dukedom to the diplomatic support of Cosimo de' Medici, who openly backed him against two royal pretenders. Ludovico may also have felt that Florence was rich and influential enough to be a useful ally while he was preparing to bend the whole of Italy to his will; after that he could turn her into a satellite. It is doubtful if Ludovico's obvious ambitions worried Leonardo (as a Florentine). Like popular piety, patriotism had little meaning for him. He found them both the emanations of ignorance. Number and the laws of flight and the pressure of steam were the same wherever you went. He wanted only to serve – with his imagination. It was why he ended his life in a foreign country, happier than he had ever been: he had found the ideal prince. 'Rather death than weariness,' he once wrote. 'There is no work which can weary me. I am never weary of serving.'

In Ludovico he saw a prince already well disposed to the kind

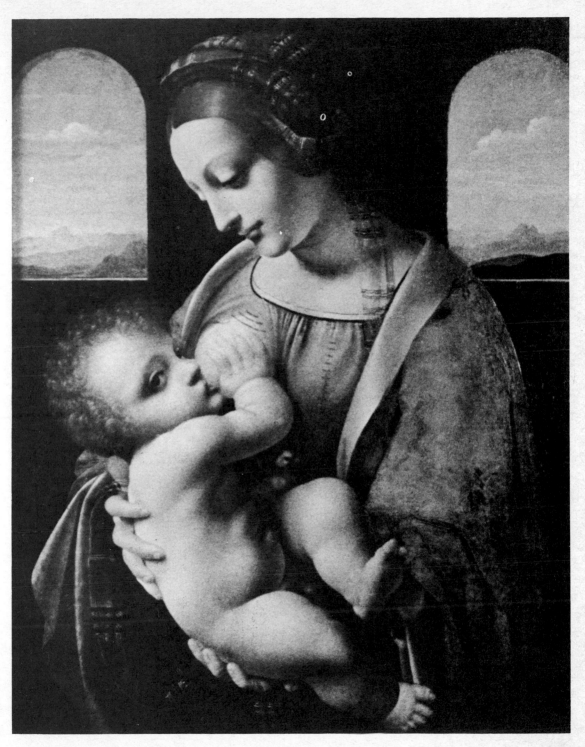

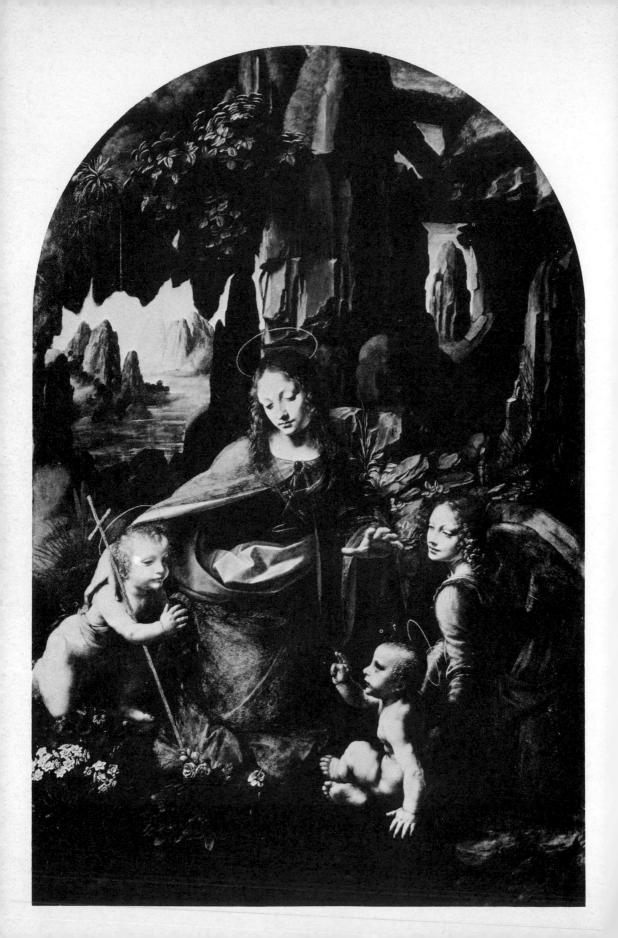

of practical research he enjoyed ('Mechanics are the paradise of science' was one of Ludovico's perplexing remarks). The Prince was erudite without those platonic tendencies which had divided Leonardo from Lorenzo and above all he was rich (Milan's income from her wool industry was greater than England's at the time). The signs were good. There was a Court poet called Bellincioni who wrote stilted allegories for performance on state occasions. The usurper-duke was fond of music, and Leonardo had invented instruments, among them a special viola that worked with stops. Some say that he took to Milan a lute in the shape of a horse's skull. He had a superb voice. Yet Ludovico kept his priceless visitor waiting. Perhaps he wanted to see how Leonardo got along with other Milanese artists – and whether the homosexuality he had heard about would show itself in a scandalous fashion. He never trusted Leonardo, as Leonardo never trusted him. It was precisely Leonardo's detachment which had brought him to Milan, and which was his most suspicious quality.

Meanwhile he worked with Ambrogio and Evangelisto on a new altar-piece for the church of San Francesco. Whether or not the monks had heard of Leonardo's powers of delay we do not know, but they set up a contract in which he was to paint the central panel in less than eight months. The contract was dated April 1483, and the painting was to be ready in December. The price was to be eight hundred lire (though 'three valuers' could raise the fee if they thought fit), and a hundred lire was to be advanced right away; the rest of the sum would be paid from July onwards in the form of a monthly salary of forty lire.

Leonardo's subject was the *Virgin of the Rocks*, of which we have two versions today, one in the Louvre and the other in the National Gallery, London. As to which one was painted for the Brotherhood of the Immaculate Conception in Milan, the art historians are inclined to argue among themselves. But of the two, the one in the Louvre has a warmth, a mellow and dusky sunset colour, an ease that connects it with the earlier Florentine period, around 1482-3. Leonardo may have brought it to Milan, or finished it in his first months there, using it as an example of his work for the friars. The Milan picture, namely the commissioned *Virgin of the Rocks* (in the National Gallery) is an altogether different piece of work, though the subject and the positions taken up by the Madonna, the Child, the Angel and St John are identical. Only the Angel's enchanting hand, pointing lightly towards St John, has been omitted from the earlier picture, and St John's cross is

OPPOSITE The second *Virgin of the Rocks*, commissioned by the Brotherhood of the Immaculate Conception in Milan and now in the National Gallery, London. Leonardo's painting was to form the central panel of an altarpiece and the contract stipulated exactly what he should paint and when it should be completed. The painting is altogether more forthright and less sensual than the earlier version. (See frontispiece for comparison of the differences.)

OVERLEAF A detail from the National Gallery *Virgin of the Rocks*. Here again Leonardo combines architectural precision with haunting imagination to create a landscape of apparently infinite depth.

101

no longer resting on his shoulder. But these differences do not constitute the real change from one period to another. The light is quite different. It is Milan's light, the product of sunlight on mists and vast plains, rather than the warm and rosy Tuscan twilight. The figures are less in repose. The touch of sensuality in the first version has gone altogether in the second – and at all times Leonardo was the least sensual of painters. The faces shine with the pale light, and are non-committal now. In view of the arguments that went on over the next decades between Leonardo and da Predis on the one hand and the friars on the other, it may be that the friars liked what he did for them less than the original. In this new Milanese work there is a climax of craftsmanship. It is more forthright than the first version. But there is a new frigidity as well.

He began to intrigue and puzzle the Milanese, and it was no doubt curiosity as much as need that made Ludovico summon him to Court one day. It is said that he received Leonardo standing up (he was, after all, a year younger than Leonardo, apart from being a usurper). And it is also said that of the two Leonardo was the less nervous. That was typical of him. He loved luxury but lived simply; he believed in princes but felt superior to them. But then he felt superior to almost everyone in the matter of intelligence. He was prepared to demean himself for his ideas, but in his style of life never. And Ludovico realized that he had in his midst a kind of natural prince. The women of the Court began flocking round him. He got the commission to do the Sforza horse, but little else. Perhaps Ludovico wanted, as Lorenzo the Magnificent wanted, a great artist who was also a friend. There was no wittier conversationalist than Leonardo, nor a more interesting one – his mind brimmed over with fantastic schemes and jokes and anecdotes he had picked up from his reading (mostly in anthologies), but his mind claimed him back the moment his back was turned, rendering him that most contradictory of creatures – a recluse with all the Court graces. He had few ardent moral concerns, as Michelangelo had. He was never much worried about whether the Church reformed itself or not. His mind went on working as if society did not exist, but, more than that, as if people did not exist either. Yet he delighted in people. He delighted in his young servant boy whom he picked up in Milan at the age of ten and called 'Salai' or 'little devil'. But it was a strangely uninvolved delight. It noticed all the more for that reason, and no powerful moral principles came to darken his charity or com-

passion. Salai stole, swore and lied – and remained in his service almost to the end of his days. Michelangelo would have thrown him out long before.

Some of those who knew both Leonardo and Ludovico felt that they each had 'a snake' in their natures. It was perhaps what attracted them to each other, and made them distrust each other without abandoning each other. Ludovico was frightened of the conspirator's dagger. And Leonardo was safer at the Court of a frightened man than at a settled Court with its fixed intrigues which could cold-shoulder an enigma, as he himself was. He took long walks, of which the reclusive (and enigmatic) landscape of rocks and water in the second *Virgin of the Rocks* was the result. He went on dissecting at night in Milan's hospital. In one sense at least he was an ideal friend for a prince – for his extreme reserve was never coldness, his understanding of princely problems was without familiarity, his love of processions and balls and fireworks and melodramas (as the musical plays fashionable at courts came to be called) never tipped over into licence. Solitude always claimed him back. It revealed the future. He predicted the least predictable aspects of the modern world – air travel, space travel ('many creatures of the earth shall mount up among the stars'), the telephone ('men from the most remote countries shall speak to one another and shall reply'), nuclear physics. He had no interest in wealth, though he preferred to be surrounded by it. Probably he could have amassed a fortune out of his commissions had he tried. He never bothered so much as to prove himself reliable – and patrons like to know if the work they finance is going to get finished. His delays, especially in Milan, during his most fertile period, were due to an over-full mind: he simply could not prevent ideas rushing pell-mell into it – for scythe-armed chariots, air-burst shells, brothels with three entrances to secure anonymity for visitors. The friars of the Immaculate Conception would find him gazing at the half-finished picture from a chair, or walking in the fields, or poring over a book, or drawing something fantastic. Above all, he was rarely moved by a theme so deeply that he felt it had to be completed as soon as possible, by sheer sustained concentration. Really spiritual matters perplexed him. Why talk about things that were so 'uncertain'? It was experience that counted. What he did not see was that these spiritual matters too derive only from experience, not from argument. And clearly he lacked the experience. In arithmetic and geometry, 'One does not argue if twice three makes more or less than six, or that the angles of a

Perhaps one of Leonardo's most horrific military conceptions were these armoured chariots, fitted with enormous revolving scythes designed to cut down the enemy.

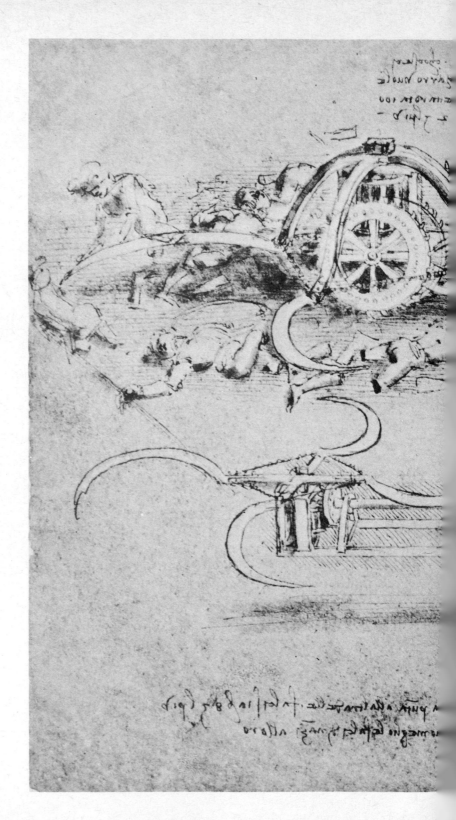

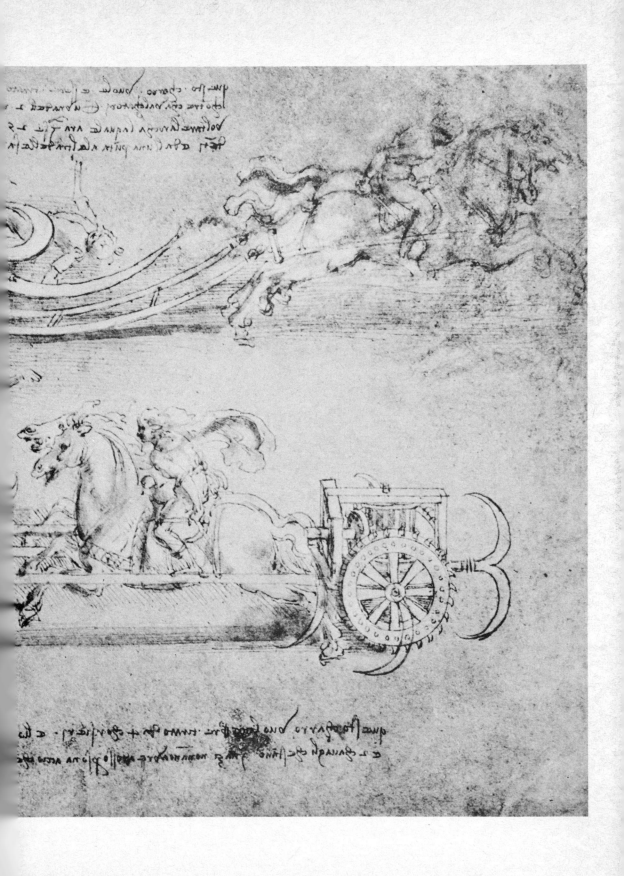

triangle are less than the sum of two right angles; all argument is reduced to eternal silence, and those who are devoted to them can enjoy them with a peace which the lying sciences of the mind can never attain.'

Among his notes there is a reference – one of the most significant he ever made – to the fact that 'everything has already been done'. Far from feeling that he was a blaze of light after the prolonged darkness of the Middle Ages – for these historical fictions had not yet been invented – he felt that he was arriving late on the Christian scene, even last, and could do no more than touch up what had already been achieved, in painting as in thought. The note goes on to compare his condition to that of a man who had arrived late at market, after the best things had been sold, and was obliged to confine himself to picking up a few useful things that other people had overlooked.

There is no sign there of a sense of 're-birth', nor of his feeling 'the complete man' of the Renaissance, as he is sometimes called. Only our modern concept of the 'artist' – which really means a visionary – makes us 'post-imagine' Leonardo (as he himself would have said) in this false way.

Far from being thought a visionary at that time, the painter was classed rather low even in the 'mechanical arts' (by tradition painting was not included in the seven canonical Mechanical Arts). That was why any painter, not simply Leonardo, was interested in the mechanics of other fields. In his *Treatise on Painting* (compiled by an unknown editor from his notebooks) he was concerned to raise the painter higher in the hierarchy not by making him a 'visionary', which would have had no meaning in an epoch when the Church, and the Church alone, looked after that sort of thing, but a true 'scientist'. Now this word did not, as it does now, imply a rejection of religious subjects, much less religion, but the very opposite. Leonardo saw the painter in God's image. The painter could survey the whole of nature as no one else could, by depicting 'the essences of animals of all kinds, of plants, fruits, landscapes, rolling plains, crumbling mountains, fearful and terrible places which strike terror into the spectator', as well as sweet places, meadows with 'many-coloured flowers bent by the gentle motion of the wind which turns back to look at them as it floats on'. Painting was an immensely serene art for him, with something of the detachment of the divine eye. That was its spiritual side. And the painter should prove himself a 'scientist' by painting all these things with the most precise knowledge of anatomy – that

OPPOSITE Sketches of monstrous animals and flowers. Leonardo held that painting was the highest of the arts because only the painter could depict nature in detail.

109

of bodies, that of plants, that of mountains. It is for this reason that we find in Leonardo that enigmatic combination of the utmost materialism with mandarin detachment. And for this reason too, he painted with unremitting care and polish. It was in his workmanship that his originality as a painter lay.

Certainly this was what caused the admiring attention of the Milanese from his first days in the city. Their own art was provincial, compared with that of Florence. During his first period in Milan he painted *The Lady with the Ermine* (now in Cracow) which many people have accepted as his portrait of Ludovico's mistress, Cecilia Gallerani. If it is her, she must have been about seventeen at the time. Bernardo Bellincioni, the Court poet, wrote a sonnet on her portrait ('*Sopra il retracto de Madonna Cecilia quel fece Maestro Leonardo*' was the title) in which he said she 'seemed to listen and not to speak', which is an exact description of the sitter's mood in this picture. Bellincioni died in 1492, so the portrait must have been done before then. She was Ludovico's mistress from about 1481 onwards. Also the ermine was used as a heraldic figure by Ludovico. The workmanship is certainly Leonardo's, and its colours belong to his style of the time, namely to the first years of his stay in Milan. In 1498 Isabella d'Este at Mantua wrote to Cecilia Gallerani asking for the portrait on loan, as she wished to see a specimen of Leonardo's art. Cecilia replied on 29 April, saying she would have sent it with even greater pleasure had it been more like her, but she begged the Marchioness not to suppose that this was the fault of 'the master', for indeed she did not think that there lived his equal in the world, but the portrait was painted when she was quite young, and since then she had changed so much in her features that no one would recognize that the picture was meant to be her. This is further evidence of the picture's date. The background has been repainted, but the face, and the animal, are intact. The animal is one of the most remarkable *tours de force* in painting; Leonardo's care and observation of its every aspect, the claws and fur and mouth, hint at the work of his last stay in Milan under the French, when he was in his fifties. The young lady herself was known for her grace, combined with determination and understanding, and these show in the frank and questioning cast of her eyes, the slightest hint of a smile on her lips. Apart from this portrait Leonardo did several madonnas, one of which went to the King of Hungary, in 1485.

There are disagreements about where Leonardo spent the four years between 1483, when he got the *Virgin of the Rocks*

OPPOSITE Animal sketches now in Windsor Castle.

110

commission, and 1487, when the record of his work under Ludovico is taken up again. According to his 'anonymous' chronicler he returned to Florence, after fulfilling Lorenzo's mission (essentially a musical one). But it is possible that he went to Syria on an engineering mission, since in his notebooks there are letters to the Devatdar of Syria and the Sultan of Egypt which refer to certain official duties, in the employ of the Sultan, in Armenia. There are also drawings of rock formations near Mount Taurus, and a sketch-map of Armenia. Equally, these drawings may have been taken from books of the time, but there are no records of his being in either Milan or Florence during those years, or indeed in any other Italian city. Had he returned to Florence, the 'anonymous Florentine' would have known about it. And he was sufficiently celebrated among princes, even at this time, for his presence in another Italian town to have been noticed and recorded.

From 1487 he definitely worked under Ludovico, receiving a Court pension in return for services as painter, engineer and 'general artificer to the Court' for the arrangement of musical plays, processions and holidays. He was certainly used as an architect during this year. The council responsible for the building of the cathedral began making him payments in August for a design of the cupola, and this was ready as a model on 11 January of the following year. This was returned to him in May for a revision if he thought it necessary, and on the 17th of that month he received more money. But the commission finally went to two Milanese architects, Omodei and Dolcebuono, two years later.

Ludovico was less interested in his many schemes than he would have liked. Even the military ones failed to excite him, probably because he was already spending enough on conventional weapons without subsidizing research. 1486 had been a bad plague year for Milan, and some estimates put the number of dead at fifty thousand. The Court removed to its country seat of Vigevano while it raged, and Leonardo went with it, devising plans for an ideal plague-free city as he went. He guessed that plagues were caused by bad sewage systems, or rather the entire lack of them. Even courtiers were unwashed, and covered the stink with perfume. People tended to squat down wherever it was convenient, in dark alleys, and to tip their refuse into the street. There were foul stenches of which only the lawn-swathed Rocchetta was free. Leonardo's idea was that houses should be built high on the banks of rivers so that both houses and gardens should get a plentiful supply of water, conveyed to them underground by pipes. So

OPPOSITE Offering his services to Ludovico of Milan, Leonardo wrote 'I believe myself able to acquaint myself as well as any man in the designing of public and private buildings.' While acting as advisor on the building of Pavia Cathedral he produced some ingenious ideas for centrally planned churches.

113

Francesco Sforza, Ludovico's illustrious father. In 1489
Leonardo was asked to undertake the great commemorative
equestrian statue of Francesco with which Ludovico
intended to impress all Europe.

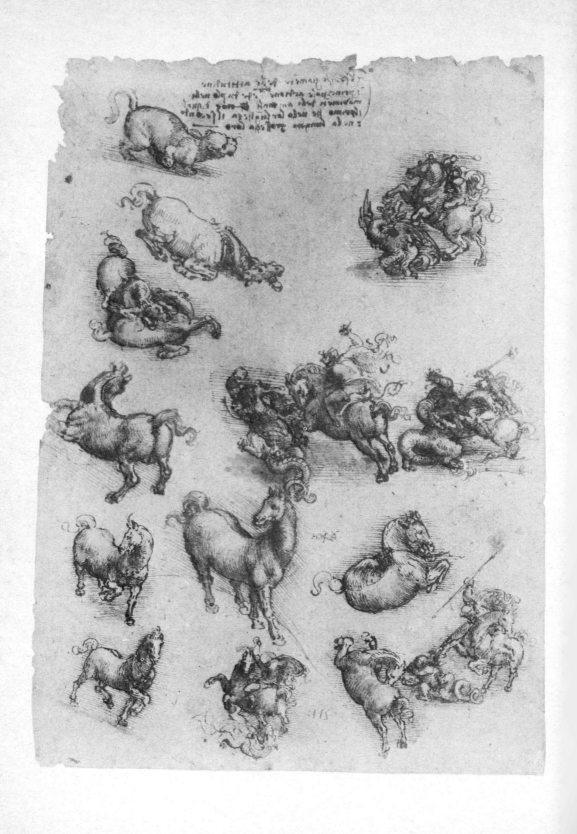

prophetic a materialist was he, that the houses he designed were in series, and to be prefabricated. That indeed was a mathematical concept of life, and one which came to appeal to the money-operated society of later epochs, though it was the scheme that Ludovico laughed at most. Also planned in this ideal city were interlocking symmetrical canals, two-way and two-level roads (one for pedestrians and the other for traffic) and windmills to supply fresh air in the dogdays and also power for household appliances.

Then in 1489, six years after he had first arrived in the city, Ludovico asked him to do the equestrian statue of Francesco Sforza. He began making drawings of the horse in every position, and typically divided the animal into nine hundred theoretical parts, so that his work would be as perfect as God's when it was finished. The studies for this monument – again they threatened the completion of the monument itself – are dated 1489-90 (Windsor Castle).

Ludovico also sent him to Pavia to restore the Visconti castle there, and at that town's university, with its superb library of manuscripts, Leonardo made many new friends, and once more spent hours of his time in talk. The town was a haven for him, in many ways his ideal setting, as it had been for Petrarch and Christopher Columbus. There he wrote his notes on optics (turned into a treatise after his death) and was consulted, together with Amadeo and Francesco di Giorgio, on the completion of the cathedral there. As far as we know, his designs came to nothing, but it may be that, as in Milan, his contribution was an advisory one in 'engineering' problems, which included calculating the stress and proportion in architectural work. He certainly worked on the Sforza castle in Milan, though his name is not connected directly with it as the designing architect. Drawings in his notes show moats, trenches, bastions and escarpments, and a kind of double-purpose tower high enough to be used for observation. In Pavia he worked on his *camera obscura*, to demonstrate his theory that all vision is determined by the angle at which the light falls on the eye: the upside-down image thrown on the wall from the camera's pinpoint of light was a more graphic argument than words, and it was little wonder that he got the reputation of being a sorcerer and alchemist, though he thoroughly despised both callings.

In January 1490 he organized the festivities for the unfortunate duke Galeazzo, who looked as if he would not live to inherit his

OPPOSITE Leonardo's many preliminary sketches for the Sforza 'horse' are remarkable for their accurate study of the animal in motion long before the assistance of the camera.

throne. Some courtiers whispered that he was dying of slow poison – and that Ludovico (who called himself the Duke of Bari) was dispensing it. Leonardo devised a marvellous celebration just the same, and called it 'the holiday of heaven'. He had 'Tartar' horsemen with mirrors on their shields and peacock-eyes on their gilded saddles. This was where Leonardo really shone – and it was perhaps why so few of the city's big commissions came his way: it was considered enough that he made a world – indeed a Court – of his own, which was more than a mere architect or military engineer or even a painter was expected to do. Not that Ludovico always kept his temper. He naturally wanted to know how the equestrian statue was getting on, and was told that Leonardo spent whole days at the stables sketching. He sometimes suspended Leonardo's income. He also disliked hearing Leonardo described as a heretic. The mutilation of corpses was forbidden in Milan, but still Leonardo went out at night to do his dissecting. A certain doctor from Imola, Galenus, was the great authority on anatomy at that time. His book argued that the human being had thirty vertebrae. Leonardo showed that there were thirty-one. He discovered how the eyes absorbed light, and for the first time pointed out the cavities that led to the nose. Galenus did not know that the blood flowed. He also claimed that the heart was a tissue and had two chambers. Leonardo argued that it was a muscle and that its beating was nothing but the opening and closing of its valves to discharge blood. And he found that it had four chambers.

For a patron who wanted an equestrian statue of his father to impress all Europe (at a time when only saints were thought really worthy of being commemorated), all this was bad news. He urged Leonardo to apply himself to the statue, knowing with what concentration he worked when he wished to. A studio was reserved for him in the 'old palace', close to the Rocchetta, and he had plenty of assistants (whom he promptly used for his researches). In his book-keeping notes the names Giulio and Tomaso crop up. Tomaso made six candlesticks for him, Giulio worked for fifteen days on some springs, and later on some locks. Giulio was in fact German, and years later, in Rome, he proved to be no friend. He and others no doubt carried alarmist stories to the servants of the Court about Leonardo's efforts to fly. And his experiments in steam caused wondering perplexity.

Ludovico sent him to Pavia a second time, and there he made one of the closest friends he ever had, Father Luca Pacioli, who came from Borgo San Sepolcro near Florence. Pacioli was fascinated

by Leonardo's mathematical researches, and held that 'science' was essential for both priest and layman. He was one of the finest scholars of his time, a Franciscan who wandered from university to university. His humanism caused sharp discussions between them. Leonardo was much closer to what most people today wrongly think of as humanism, namely a vague positivism with humanitarian overtones. In this he greatly represented the world that was coming, a world disturbed by more or less permanent

Gian Galeazzo Sforza. In 1490 Leonardo was employed in organizing the lavish festivities for his marriage to Isabella of Aragon.

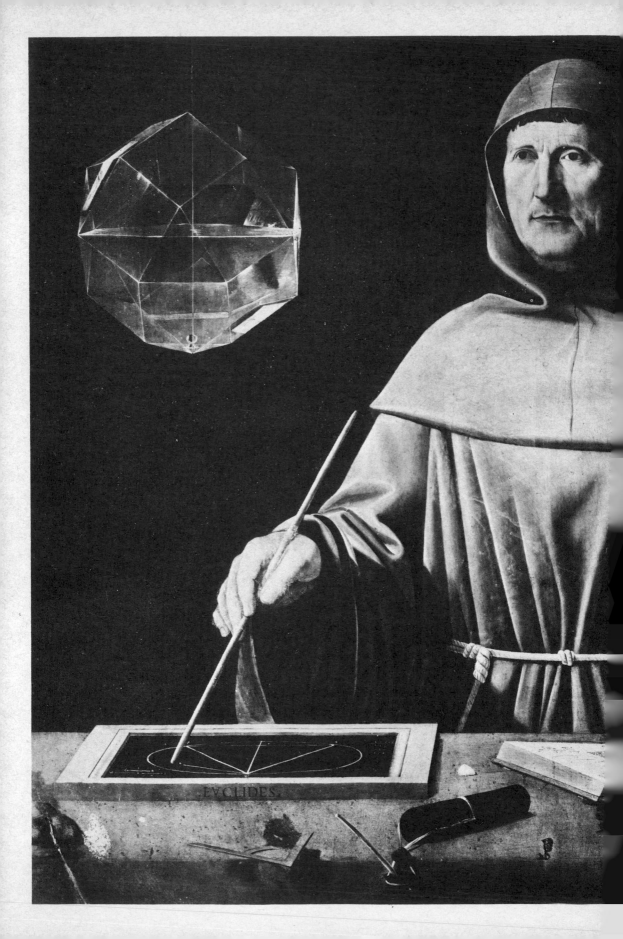

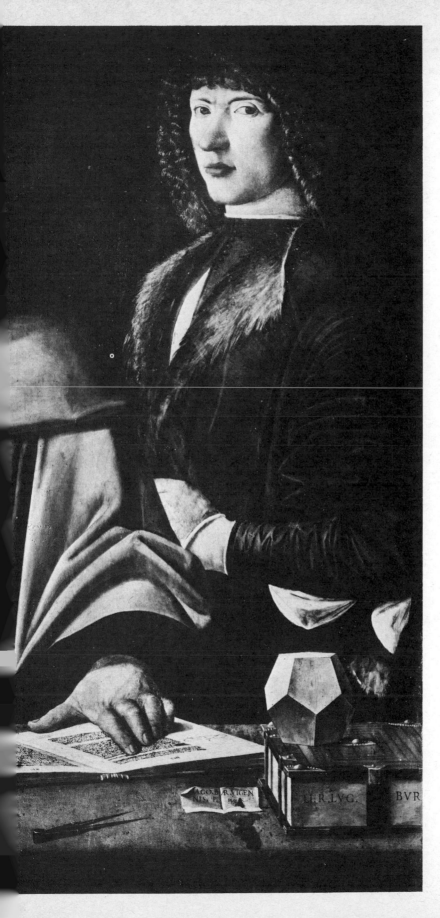

Fra Luca Pacioli, one of the
finest scholars of the age,
became a member of
Leonardo's 'household'
for a time. Leonardo
illustrated Pacioli's
treatise on geometry
De Divina Proportione.

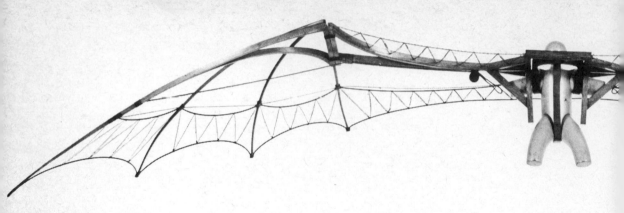

A model of Leonardo's flying machine, shaped like a vast bat, which he considered to be the perfect design for flying.

war, revolution, terror systems and financial crisis. These things are all present in his notes and drawings, culminating in his tireless depiction of *The Deluge*. 'The things of the mind that have not come to it through the senses are futile and generate no truth, only fiction.' There could have been no franker definition of the doctrine that underpins the turbulent world we have today. And nothing could have been further from the humanism of the time, which was really a spiritual search for 'the perfect man' within, based on Christ – here was the departure from ancient Greek thought – as the model and inspiration, the perfect man Himself. Something of this did exist in Leonardo: no more fervent – or rather obsessive – perfectionist ever lived. But 'the sublime master' was how he saw God. It was an intellectual concept, more than a direct spiritual experience. When, later, the Church virtually collapsed as a universal power and as the spokesman for everyone's intimate life, people no longer felt the need to carry this concept around with them. For them, too, as for Leonardo, the actual experience of God, the direct experience, collapsed, and they were left with the mind on the one hand and the senses on the other (the two tending to make war on each other). Leonardo, like the mass of the people that followed him, the pundits of a great new future that was going to be based on 'science' (meaning the mechanical doctrines of the Middle Ages, basically), was not really happy. Something was missing. 'O Leonardo,' the notebook says, 'why so much suffering?' In that one sentence lay the anguish of the generations of the fifteenth century who had the job of putting into practice the thought of the Middle Ages, from medicine to physics. He had a passionate need to serve. He never spared himself – which was perhaps why he looked venerable at the age of fifty. Sleep was for him 'like death'. And he held to another callow and characteristically 'modern' belief, that works of art

122

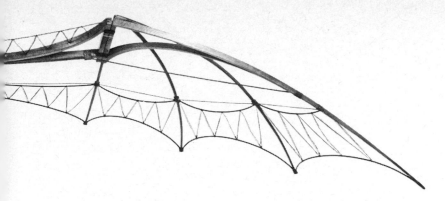

made their creator 'live' after death, 'just as much as those actually alive'. For the anguished need for personal immortality was precisely the result of no longer believing – no longer experiencing – immortality during life.

When he heard, in April 1490, that Ludovico was threatening to find another sculptor, he took up his horse-researches again and decided that his model was to be one of the horses in Ludovico's bodyguard. He was faced with certain problems of balance in his preparation of the clay model. But at least he was actually working on the thing itself, instead of on thoughts about it. People began to talk about 'the Leonardo horse' – and paradoxically (for he had no respect for the sculptor's art, which he regarded as noisy and dirty and sweaty) it was what gave him a reputation throughout Italy. Again, it was the unbelievable workmanship that did it.

His house was always full in those days (some say it was 'a centre of homosexuality'). His servant and pupil 'Salai' (the thief, liar and glutton in Pucci's famous *Morgante Maggiore*, which everyone literate had read at that time – the work of Lorenzo de' Medici's closest 'nocturnal' friend) had marvellous flowing hair and a quite undevilish face. Leonardo doted on him, and reprimanded him tenderly. Being something of a devil himself, he had an unashamed admiration for devilish behaviour that stopped short of the downright criminal. In this he was no different from any other Italian before or since. Salai helped him with his experiments, and received splendid clothes and jewellery in return.

There was a flying machine on the roof of the house, shaped like a vast bat – for Leonardo regarded bat-wings as the ideal design for flying. A pilot's cabin was slung under them, with handlebars and stirrups for the feet. He made instruments to measure wind-pressure, and humidity. He was possibly more productive under Ludovico than at any other time in his life. He

became more of a vegetarian than before, though fish seems to have been included in his diet. He designed dining-rooms and table-utensils for the great banquets, but hated the occasions themselves, with their endless succulent dishes. He declared that the killing of animals was criminal. Far from his house being 'a centre of homosexuality', it is possible that he was becoming less and less sensual in his habits. He dreamed of an 'androgynous body', where the needs of sex – which he regarded as the key to the individual nature – no longer existed.

Yet he was surrounded by sensual people whose company he enjoyed and who found him delightful. In January 1491 Ludovico married Beatrice d'Este, sister of Leonardo's most untiring admirer, Isabella, and only fourteen years old. Leonardo was responsible for the festivities, and the setting of the scene for the joust at which the Marquis of Mantua, Count della Mirandola and Annibale Bentivoglio of Bologna took part. There was a gorgeous ball, and for days the castle echoed with laughter and fireworks and music and the tap of feet. The Duchess Beatrice wanted Leonardo's attention too, and he was as sparing with it as he was with her sister. But he did design a heating system for her bath, and a special pavilion for her garden. During the exciting months of the 'new' Court, his boy stole constantly, and Leonardo's notes about it have a helpless tone. He designed the set for a play called *Dafne*, as he had Bellincioni's allegory *The Paradise* during the Duke Galeazzo's wedding festivities. He also designed a pavilion for Ludovico's 'labyrinth'. Like that for the Duchess's pavilion, the design has survived in his notes. On that page there is the date 10 July 1492. He attended the Duchess Beatrice almost daily. She was a fascinating handful. She had the clever Cecilia Gallerani packed off with a husband. She gilded her hair in the sun like a Venetian woman, and did not seem at all afraid of Ludovico. She rather disliked Leonardo (the portrait of Cecilia was nothing in his favour). Her sister in Mantua went on clamouring for a portrait of herself, and was put off with charming promises. She never got it.

Ludovico was again getting impatient. He wrote to Leonardo that the statue must be ready by November 1493, as he needed it for the marriage of his illegitimate daughter Bianca to the Emperor Maximilian, whose wife had died (leaving a vast debt at her local Medici bank). Leonardo replied that he could guarantee the clay model, but not the bronze. Rather surprisingly he kept to his promise, though the commissioners of buildings at Piacenza had

124

been told that the bronze doors for their cathedral could not be designed by the only man capable of doing them, namely Leonardo, because he had 'work that will last his whole lifetime, and I fear that it is so great an undertaking that he will never finish it'. A letter from the Florentine agent in Milan, Piero Alamanni, to Lorenzo de' Medici, about four years earlier, had asked for one or two masters capable of making a statue to be sent, 'for although the duke has entrusted this commission to Leonardo da Vinci, he does not seem to me to have any great confidence in his capacity to carry it to completion'.

It was all the more surprising, then, that it was ready to be unveiled ceremoniously during the wedding celebrations. It was erected in the Court of the castle of the Visconti, and Baldassare Taccone described it:

> Vedi che in corte fa far di metallo
> Per memoria del Padre un gran colosso
> I' credo fermamente a senza fallo
> Che Gretia e Roma mai vide il più grosso,
> Guarda pur come è bello quel cavallo!
> Leonardo Vinci a farlo sol s'è mosso.

[See, he has had a great colossus of bronze made in the courtyard to the memory of his father. I firmly believe that Greece and Rome never saw a bigger. Just look how beautiful that horse is! Leonardo Vinci did it all alone.]

It seems that there was a figure on the horse as well, though naturally the rearing animal was what caused delighted astonishment. Ludovico met the Emperor at the Sforza country seat of Vigevano, and sent off his daughter with a dowry of 400,000 ducats, which Maximilian needed badly. Ludovico was buying imperial protection, though Maximilian's slender resources, nothing like those of his son Charles v when he later became emperor, were not enough to save Ludovico's throne or person from capture by the French, when the critical time he had always expected came. He heard that Isabella, his sister-in-law, was pressing her grandfather, the King of Naples, to challenge his right of succession to Milan. He needed French support too, and contacted the French King Charles VIII to tell him that he would support his claim to Naples. He began to arm. And the casting of the Leonardo horse (which Leonardo wanted cast in one piece, an unprecedented operation) was the first thing to be jettisoned, now that every scrap of metal was required. Ludovico was in a tough spot, trusted

The Holy Roman Emperor Maximilian I, who married Ludovico's illegitimate daughter Bianca and badly needed her dowry of 400,000 ducats. Portrait by Dürer.

by no one and suspected of intending to kill his young nephew. Charles VIII could certainly use his support in claiming Naples, but what Ludovico did not know was that he wanted the throne of Milan as well. He entertained the French King at Vigevano and Pavia, having met him at Asti, and found him 'absurd', with his mouth that hung open and his stammer and trembling hands. But outwardly things were going well for Ludovico. Probably only he himself could see the trouble ahead.

By October of that year Gian Galeazzo was dead. Some say that the Duchess Isabella in Mantua connived in the murder, but this

127

CAROLVS VIII GAL REX

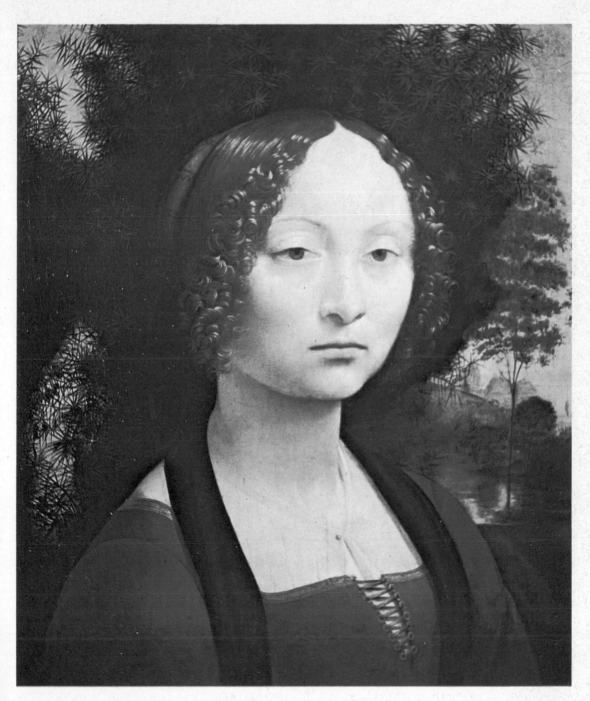

OPPOSITE Charles VIII of France.
Ludovico supported his claim
to Naples without facing the fact
that he wanted Milan as well.

ABOVE *Ginevra da Benci*, painted *c.* 1475. It is probable that almost
one-third of the painting has been cut off, perhaps because the lower
part was unfinished, and the sides were trimmed
in order to keep the rectangular shape.

is hardly borne out by her invitation to the King of Naples to seize Milan. Ludovico now declared himself officially Duke of Milan, the least wise and popular thing he ever did. He kept up a fabulous mode of life. He had a cloaked magician called Ambrogio da Rosate whom he consulted on all matters of state. Rosate even decided what ambassadors he should receive. Milan's goldsmiths and jewellers constantly had ducal orders to fulfil. The famous scholar Filelfo, whose wife was Greek, came to Milan from Florence after Lorenzo de' Medici died in 1494. Leonardo was virtually a minister of culture now. He supervised everything from the music to be played at dinner to the design of the ladies' fans. Characteristically he seemed not to notice Ludovico's dangerous situation. Back in 1491 he had been sent to divert the River Ticino from its course so as to irrigate the surrounding fields, and had met a nobleman called Girolamo Melzi who had a villa at Vaprio on the River Adda, and liked nothing more than to have thinkers and artists at his table. Leonardo soon became one of his household, and conceivably it was in the Melzi villa that he finished the *Virgin of the Rocks* from his Florentine days, while leaving the one for the Friars of the Immaculate Conception unfinished. In fact he and da Predis petitioned Ludovico (between 1491 and 1494), asking him to intercede with the friars on their behalf. They described how the 'three appraisers' mentioned in the original contract had had a disagreement among themselves about the value of the 'picture in oils'. Their valuation of twenty-five ducats was too low. The figures should be at least one hundred ducats, as this price had been quoted by several people who now wanted to buy the picture. In view of the fact, the petition went on, that the friars were not competent to judge matters of art, two more expert appraisers should be appointed. In all the artists wanted three hundred ducats (a lot of money for a monastery). It seems possible that the Duke cleared the matter up, since the picture did remain in the friars' hands (it was sold by their successors to an Englishman, Gavin Hamilton, in 1787: hence its existence in the National Gallery in London). It is possible too that Leonardo sold the earlier version to Ludovico, who then presented it to the Emperor Maximilian on the occasion of his daughter's marriage. It then passed into the French royal collection, perhaps through Francis I or Louis XII before him.

Ludovico was greatly attached to a certain Dominican monastery in Milan, Santa Maria della Grazia, and for some time had been asking Leonardo to do a *Last Supper* for it. In 1495 he got his way.

By 1497 the work was almost finished. The first notes on the design of the picture in Leonardo's manuscripts are dated between 1494 and 1495, so that he must have known that he would one day accede to Ludovico's request (which after the superb execution of the Sforza horse may have become a ducal order).

This picture too created early astonishment as it developed. Boccaccio's brother, Matteo Bandello, later Bishop of Argen and a writer, was at that time receiving instruction at the monastery, where his uncle was Prior. He described what he remembered of Leonardo's working there:

There were in Milan in the time of Ludovico Sforza Visconti, Duke of Milan, certain gentlemen in the monastery of the Grazie, which belonged to the monks of S. Domenico, who were occupied in contemplating the wonderful and most famous *Last Supper* of Christ with his disciples which the excellent painter Leonardo Vinci the Florentine was then painting, and he liked that each on seeing his work should freely express his opinion about it. It was his habit often as I have frequently seen and observed to go early in the morning and mount upon the scaffolding because the *Last Supper* is some distance from the ground. It was his habit I say from sunrise until dusk never to lay down his brush, but forgetful alike of eating and drinking to paint without intermission. Then two or three or four days might pass without his putting a hand to it, but he still remained there for an hour or two hours of the day merely looking and considering and taking counsel with himself and judging the figures. I have also seen him, as the caprice or whim took him, set out at midday, when the sun was in Leo, from the Corte Vecchia [the old palace], where he was at work upon the clay model of the colossal horse, and go straight to Le Grazie; and having mounted the scaffolding, take up his brush and add one or two touches to one of the figures and then abruptly part and go elsewhere.

In those days Cardinal Gurk, who was then old, was lodging in the Grazie and happened to enter into the Refectory to see the said *Last Supper* at the time when the gentlemen I have spoken of were assembled there. When Leonardo saw the Cardinal he came to do him reverence and was graciously received by him and much complimented. . . . The Cardinal enquired what salary the painter had from the Duke and Leonardo made answer that his ordinary salary amounted to two thousand ducats apart from the gifts and presents which the Duke was constantly giving him. To the Cardinal this seemed a very large sum and he departed from the *Last Supper* and returned to his own apartments. It was on this occasion that Leonardo proceeded to tell the gentlemen who were there assembled an excellent story by way of showing them that capable painters were always honoured.

Vasari's story, in the second edition of his life, is that the prior

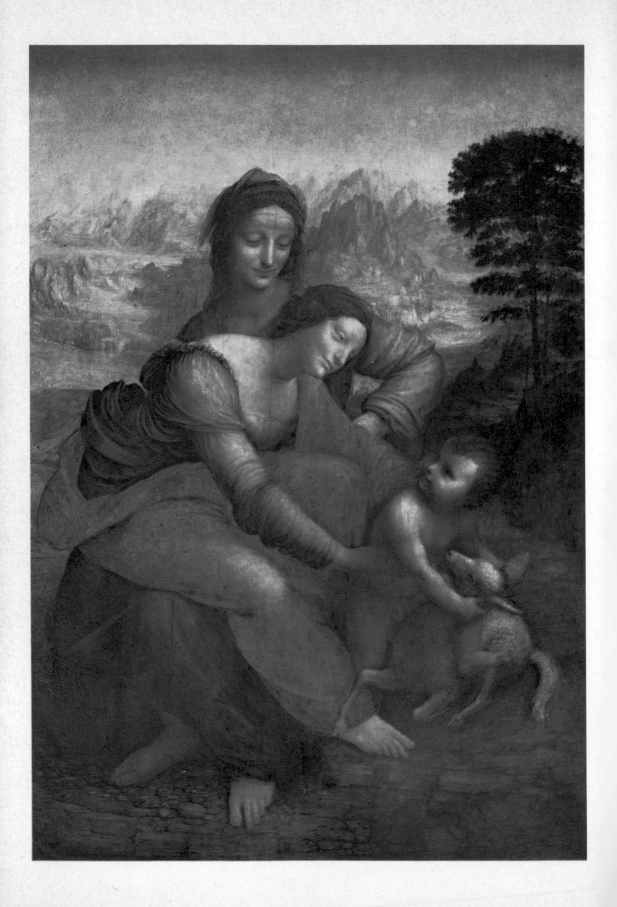

of the monastery pestered Leonardo again and again to finish the work, as the faces of each of the disciples developed, showing anger, fear, love, sadness at the thought that one among them would betray Christ. The faces of Christ and Judas did not develop. The prior seemed to feel that a painter should paint continuously rather 'as if he were digging in a garden'. He twice went to Ludovico about it, and the Duke summoned Leonardo. 'Leonardo, knowing the intellect of that Prince to be acute and discerning, began to discourse at large with him upon this matter, a thing which he had never done with the prior, and arguing much about art made him understand how men of lofty genius sometimes produce the most when they work the least.' He added that there were still two heads for him to paint – Christ, 'which he was not willing to seek on earth' and which he did not think it possible to conceive in the imagination, and Judas, who was unthinkable for quite opposite reasons. However, he would certainly go on looking for a Judas-face (apparently he went every morning and evening to the Borghetto, Milan's bad quarter, in search of it): but if in the end he failed to find it, could he not paint the prior? This made Ludovico laugh, and the prior is said to have been chastened by the whole interview. However that may be, and however true or false the story is, Leonardo finished only the Judas. Christ remained a shadow.

In his notes, usually dated 1494-5, Leonardo described the disciples:

One who was drinking has left the glass in its position, and turned his head towards the speaker [that is, to Christ, who has just said, 'Verily I say unto you that one of you shall betray me']. Another, twisting the fingers of his hands together, turns with stern brows to his companion. Another, with hands spread open and showing the palms, shrugs his shoulders up to his ears, and makes a mouth of astonishment. Another speaks into his neighbour's ear, and he who listens to him turns towards him and lends an ear, holding a knife in one hand and in the other the bread half cut through by the knife. Another in turning, holding a knife in his hand, upsets with his hand a glass over the table. Another lays his hand on the table and is looking. Another breathes hard from full mouth. Another leans forward to see the speaker, shading his eyes with his hand. Another draws back behind the one who leans forward, and sees the speaker between the wall and the man who is leaning.

In what remains of the fresco only the disciple 'shading his eyes with his hand' is missing (though it is found in the Windsor drawing). Most of the other references can be more or less

OPPOSITE *St Anne, the Virgin, and the Infant Christ, with a Lamb*, in the Louvre, which won the astonished admiration of Leonardo's fellow artists from every part of Italy.

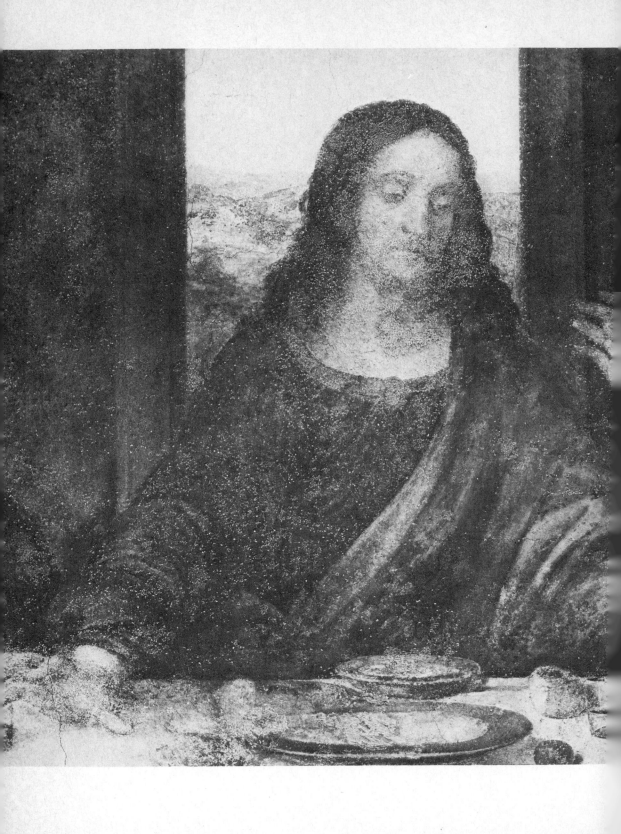

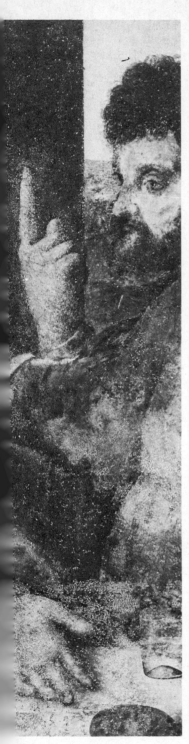

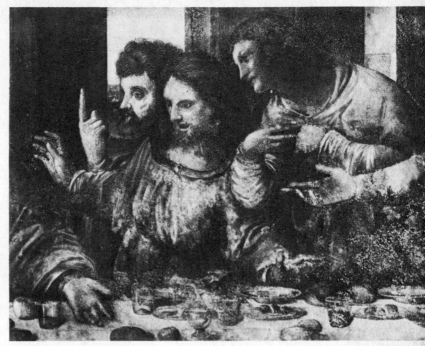

Three details from *The Last Supper*.

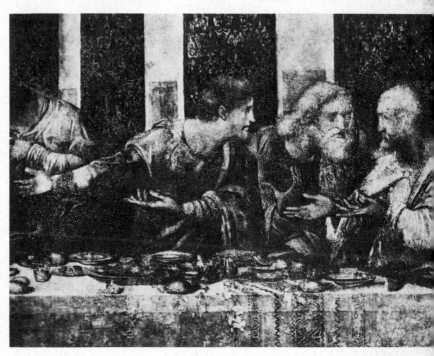

recognized, even though hardly an inch of the ruined fresco has not been retouched by more than one restorer's hand. The colours are unrecognizable. They began to flake from the wall soon after the picture was painted, certainly in Leonardo's lifetime. Yet those who saw it felt that it was the climax of his work, and that no finer painting on the theme had ever been done. His itch to experiment and try new methods was the cause of the deterioration. He painted the wall in an oil medium instead of the usual tempera on a lime base. He also prepared his surface with a mixture of pitch, mastic and other elements laid on to the wall with a hot iron, and covered that thinly with white lead mixed with yellow clay. It was apparently the clay that made the whole peel. When the oil dried, it began to crack, and then the dampness of the wall (which could not damage the usual lime and tempera to anything like the same extent) seeped through and began its work of discoloration. As early as 1517 there is a record of its beginning to spoil. In 1584 it was described as totally ruined. In 1652 the friars opened the wall to make a door, and a lower portion of the fresco was lost, including the feet of Christ. The following century the fresco was restored at least twice. And in 1796, despite Napoleon's strict orders that no damage was to be done, the refectory was used as a stable by French troops (who also pelted the apostles with clay). Later it was used for storing hay. As if to realize in full measure Leonardo's reluctance to finish a work of such devoutness, in 1800 a flood covered the whole fresco with damp mould. Goethe saw it when it was in better condition, after a damp course had been built: it was he who described Leonardo's preparation of the wall. There were two attempts in the nineteenth century to remove the work of the eighteenth-century restorers, though probably that work had been useful in preserving Leonardo's original colours. And since then the plaster has been falling away steadily.

So there is little to tell us what Leonardo painted. The extraordinary thing is that the work, where the outlines of the apostles are still visible, unlike their facial expressions, has a strangely convincing movement which altogether escapes the theatrical, that posturing which marked so much later baroque work. The figure of Christ is separate from the others, surrounded by his own light, in serene detachment from a world to which he never belonged. It makes Veronese's *Last Supper* – that ultimate absurdity, with its dwarf and other features to add 'interest' – look blasphemous, which is how the Inquisition in Venice felt about it too. Leonardo was never content to show off in painting – either

136

with tricky light-and-shade effects or with what he called 'la bellezza dell'oro e dell'azzuro', 'the beauty endowed by blue and gold'. He demanded of himself the most thorough craftsmanship not only in his brush work but his conceptual preparation of the figures, their expression, their clothes, their meaning for the picture as a whole. There is no wastage in those dim figures of his *Last Supper*. And there is no doubt about who the central figure is, and how solemn the occasion is. Yet the central figure remains unfinished. For his Christ, Leonardo was clearly unable to accept the somewhat stylized figure of the Byzantine artists, or that of the early Florentine and Sienese schools. But more than this, the whole matter of what spirituality 'looked like' was perplexing for him. He had no 'certainty' in that field. He could realize detachment, in the Christ figure, because he was a lonely and detached creature himself. But he had to leave the expression of Christ's face to the imagination – or rather to oblivion, since a creature so perfect could not even be imagined. So far had the religious experience, which is always simple and immediate, removed itself in him to the level of speculative philosophy.

Beatrice, the Duke's wife, after dancing all night during the rather wild New Year celebrations of 1497, had a miscarriage and died the day after. For two weeks Ludovico remained in his room, seeing no one. She had amused, provoked him, tenderly ruled him. He now became more devout than ever before. And her death was taken by the Milanese people as a bad sign. He urged Leonardo to finish *The Last Supper* so that it could be a votive offering on behalf of Beatrice.

Its unveiling caused a deeper astonishment than his horse because of its theme: 'This work, remaining thus almost finished, has always been held by the Milanese in vast veneration,' says Vasari. Now there was no Court in Christendom which had not heard of him. Painters came from everywhere in Italy, from Burgundy and France, to see the work, and probably no one was rated higher as both a painter and a theorist of painting than Leonardo at this time. The picture spoke so eloquently. Never before had an artist made an urgent dramatic moment spring so convincingly from still forms, yet without any deliberate narration. For the painter was a thinker too, and believed that you could not be one without the other. The disciples in the picture think too. The sketch in Leonardo's notebooks of James the Elder shows this with remarkable delicacy, in the absorbed look of the eyes, the slightly pained set of the sensitive mouth, the nose which argues discernment and

MERCVRIO E PIANETO MASCHVLINO POSTO NELSECONDO CIELO ET SECHO MAPERCHE LA
SVA SICITA EMOLTO PASSIVA LVI EFREDO CONQVEGLI SENGNI CH SONO FREDDI EVMIDO COG
LI VMIDI ELOQVENTE INGENGNIOSO AMA LESCIENSIE MATEMATICA ESTIVDIA NELLE DIVI
HASIONE A ILCORPO GRACILE COE SCHIETTO ELSV SOTTILI ISTATVRA CHONPIVTA DE
METALLI A LARGIENTO VIVO ELDI SVO E MERCOLEDI COLLA PRIMA ORA Φ ☿ IS EZZ
LANOTTE SVA E DELDI DELLA DOMENICHA A PERAMICO ILSOLE PER NIMICO AVENE
RE LASVA VITAOVERO ESALTATIONE EVIRGO LASV MORTE OVERO NVMILIASIONE
E PISCE HA HABITASIONE GEMNI DIDI VIRGO DINOTTE VA E IZ SENGNI IN ☿
DI COMINCIANDO DA VIRGO IN ZO DI EZ ORE VA VN SENGNO ☜

selfless judgment. Many artists copied the work, among them Andrea del Sarto, in Raphael's workshop, though he entirely missed the tact of Leonardo's grouping, the relation between each figure and the feeling of the whole, and his disciples are separate figures who seem to have little to do with each other. And the urgency of that moment, when Christ mentions a betrayer among them, has gone. 'Nobody who is not a mathematician will be able to grasp the basis of my work,' Leonardo wrote. 'Proportion is found not only in numbers and weights, but also in sounds, scenery, time, movements and every possible kind of phenomenon.'

The word mathematics meant a good deal more at that time than it does to us. It was no specialized study but the science of knowledge itself. Working through compasses, and precise mathematical calculations, Christopher Columbus and indeed every seaman since Vasco da Gama had proved its importance in the most spectacular way. It was no less important in the matter of light and shade, and in 'perspective', by which the fifteenth century meant more or less everything that made a picture convincing to the eye, including therefore colour and shadow and not only the exact measurement of distance in its effect on the proportions seen by the eye. 'Shadows have their boundaries at certain determinable points,' Leonardo said. 'He who is ignorant of these will produce work without relief; and the relief is the summit and the soul of painting.' The men and women in his painting had to be studied in the same way. He first decided the human type he was after, then he went to the places where such types could be found. He studied not simply their faces as a composition of lines, or light and shade, or colour, but every aspect of their person, from the way they stood or walked or argued to the way they did their hair. He would possibly have liked to find a set of rules for all this, some mathematical principle that would guide him as surely as the science of 'perspective' did. But there mathematics remained what it started as – measurement. *Everything* could not become clear to the mind. Hence the unfinished Christ. All his observation could not help him with that. But here he insisted that painting could concern itself only with 'the observed. That was why all of Italy flocked to him. The kind of observation to be found in Mantegna and Piero della Francesca, who were also highly conscious of 'perspective', became in Leonardo so complete as to constitute a new science of the visible.

It seems that during the early stages of *The Last Supper* he imposed portraits of Ludovico and his wife with their two children

LEFT Mercury from the Planets series, *c.* 1460, showing a number of different fifteenth-century occupations including sculpture, fresco painting and the grinding of colour, the goldsmith's art and the use of books.

139

Massimiliano and Francesco on a *Crucifixion* painted by Giovanni Donato Montorfano in the same year. Only their outlines remain today. After Beatrice's death Cecilia Gallerani returned to the Court and became Ludovico's mistress again, together with Lucrezia Grivelli (one of Beatrice's ladies-in-waiting), of whom Leonardo's portrait has apparently been lost. The portrait in the Louvre once called *La Belle Ferronière* (more simply *Portrait of a Woman*) has been called both a Leonardo and his portrait of Lucrezia. But it has also been called a portrait of Ann Boleyn. Some historians argue that this was the work of Boltraffio, in Leonardo's workshop. Cecilia and Lucrezia became friends, and were in the habit of consoling Ludovico together. Cecilia even became the godmother of Lucrezia's son by him.

Leonardo continued work on the Sforza horse while working on *The Last Supper*, probably in order to prepare it for casting, which would have been a difficult enough operation even had he not insisted on casting it in one piece. Such a thing had never been done, and probably never has since. The steps of casting require that a plaster mould be made of the original clay model (this has to be in sections) so that a wax figure can be formed inside it. What Leonardo was demanding for the last and most difficult part of the process was that the huge wax should be given its mould of plaster and baked clay powder as a whole, no longer in sections, and that this should be placed complete in the oven (for the wax to pour out, melted, and the bronze to be poured in). The oven required would have had to be huge, but above all the danger of breaking would have been maximized. There is really no drawback to casting in sections. But for Leonardo the last process of soldering together those sections would have destroyed the detail of his work, conceived with such thoroughness. To divide the anatomy of the horse into nine hundred parts and then to watch sections of it being clumsily soldered together – the proportions, so carefully defined, would surely be lost! But then sculpture is not painting. A painter can be as meticulous as he wishes. He lays the paint on with his own hand. A sculptor cannot, by the nature of his medium, interest himself with such tiny effects. He has to achieve his perfect proportions another way, at least in bronze. For better control of his medium, Leonardo would have had to carve the horse in stone with his own hand, like a Michelangelo. But – so evasive is nature for a mind tortured with the idea of perfection – nothing like the detail achieved in the wax and bronze process could be achieved in stone.

OPPOSITE The *Mona Lisa,* arguably the most famous painting in history, and the only portrait by Leonardo whose authorship has never seriously been questioned.

140

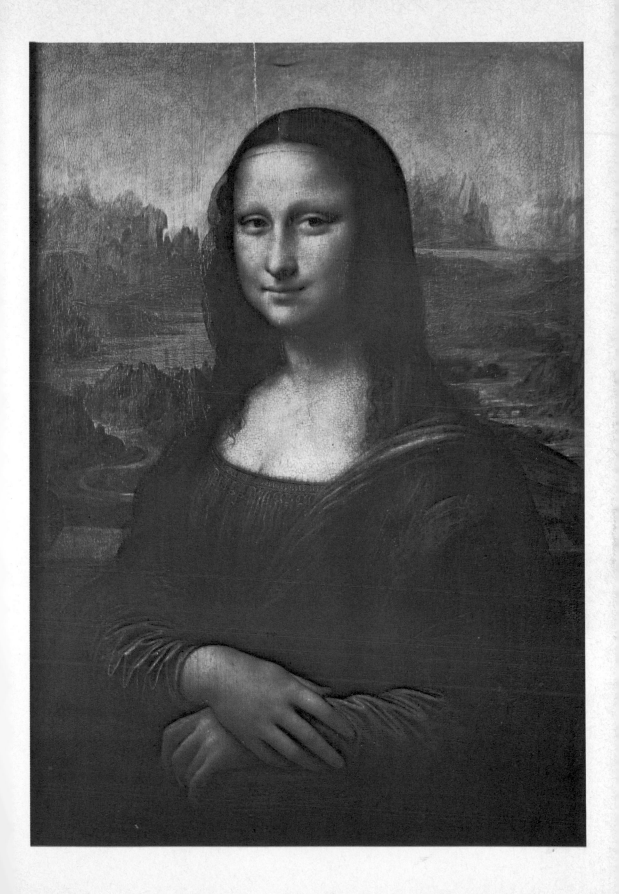

His love of doing something not only great but new was again responsible for a tragic loss. The horse was never cast. Ludovico was going through a bad patch, and could not afford the expense, apart from the fact that ovens and bronze were needed for more war-like castings now that Italy was closing round him and it looked as if France and Venice might soon be forming a military alliance against him. He could hardly pay his servants. Some say that he had quarrelled with Leonardo. In its dedication to Ludovico, the book by Fra Luca Pacioli (diagrams by Leonardo), called *On Divine Proportion*, mentions that 'a praiseworthy and scientific duel' took place on 9 February 1498, with Leonardo and Ludovico present, so presumably they had made it up by then. These 'duels' or discussions were a usual thing at Court, and it was by no means the first one they had had: Leonardo's treatise on painting is said to have been based on discussions he had had with the Duke. Some time between 8 November 1497 (eleven months after Beatrice's death) and the date of the 'duel' mentioned by Fra Luca Pacioli, Leonardo wrote Duke Ludovico a letter complaining of 'arrears in salary'. The letter has been torn down the middle – by an angry Duke? Only fragments of it are decipherable. Leonardo starts by saying that he realizes how occupied the Duke is at present, but he wishes to remind him 'of my small matters and the arts put to silence'. It seems that he had not spoken to the Duke for some time, as in another sentence he wonders if this 'silence was the cause of making your Lordship despise' – the rest of the sentence is lost. He points out that he has spent his life in Ludovico's service. He is ready to serve him always. 'Of the horse I will say nothing because I know the times'. And he then mentions the two years' arrears of salary, and the fact that he had to pay 'two skilled workmen' out of his own pocket. A later sentence – 'works of fame by which I could show to those who shall see them that I have been' – may refer defensively to the Duke's impatience at his delays, which was perhaps the cause of their quarrel. 'I having been taken up with gaining a living' – was this why he had not seen the Duke? However that was, the Duke did pay up in full, in March 1499, by which time the Franco–Venetian alliance was a fact and Ludovico needed every friend he could find. He even gave Leonardo a vineyard as a present – half of which passed into the young Salai's hands at Leonardo's death. (Salai was now nineteen.)

In another letter of the period, Leonardo describes himself as 'ten men', organizing feasts, painting and sculpting, singing and

142

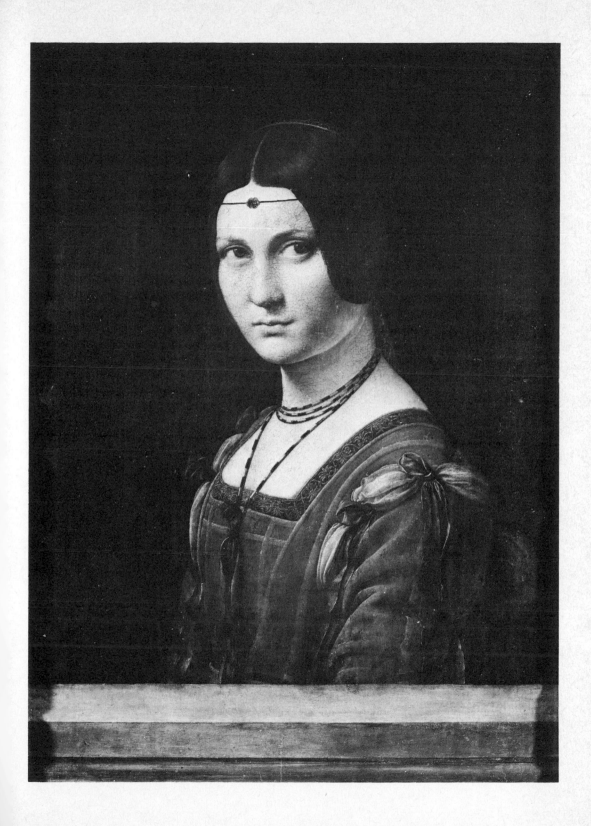

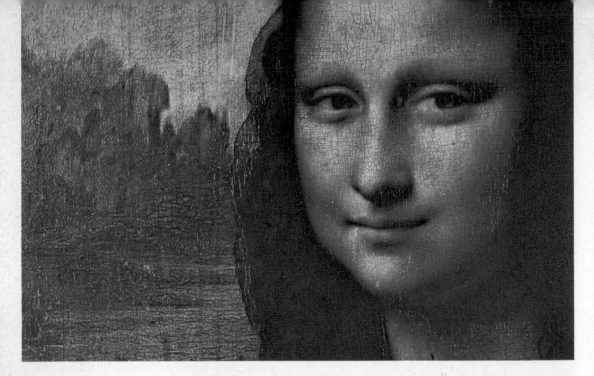

ABOVE A detail from the
Mona Lisa.
RIGHT Isabella d'Este,
sister-in-law of Ludovico
Sforza and one of Leonardo's
greatest admirers.

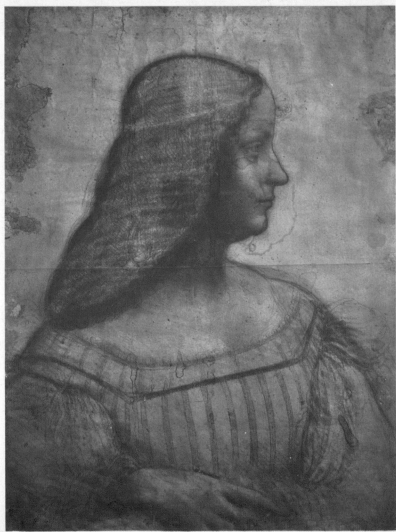

playing, studying mathematics and optics and making the river between the Brivio and Trezzo navigable. This last operation meant digging a new river bed through rock, and stabilizing the land all round. He made a new friend, Ippolito d'Este, who was to become Archbishop of Milan. It was lucky for him that Ludovico paid him when he did, since by September of the same year he was no longer Duke. Only Maximilian stood by Ludovico in these last months – and he was not strong enough to hold the throne for him. Ludovico took the precaution of sending his family to Innsbruck, under Maximilian's protection, in view of the fact that the new French King, Louis XII, was asserting his claims to both Naples and Milan. Ludovico played a double game, and actually invited Louis into Italy in the hope of keeping Milan to himself. The French army approached, and Ludovico's general Sanseverino fled. He put the Rocchetta in the hands of one of his

A diagram by Leonardo showing the proportions of the human body derived from *De Architectura* by Vitruvius.

145

least trustworthy officers, Bernardino da Corte, and went off to join his family, hoping to re-enter his city later. The French army, commanded by Trivulzio, entered in September 1499, after Bernardino had opened the gates to them. Meanwhile Ludovico was enlisting fresh Swiss mercenaries. It was not the sort of situation that appealed to Leonardo. He left the city long before the French arrived, and stayed at the Vaprio villa of his old friend Melzi, whose son Francesco became his pupil (without him much of Leonardo's manuscript work would today be lost).

Leonardo did not scruple to return to Milan when he heard that the French were in secure occupation. Besides, he wanted to go on

Pope Alexander VI, father of Cesare Borgia.

146

working on his flying machine. King Louis saw *The Last Supper* and announced that he would like to take it off to France. Leonardo described the King – a thin and narrow-shouldered man, his face deeply furrowed in a rather unpleasant way, a *bon bourgeois* if ever there was one, a quite ordinary man. But during the audience Leonardo was struck by a fascinating young Italian. His way of holding himself and looking about him captured the attention in the strangest way, apart from his good looks (not yet ruined by syphilis). His name was Cesare Borgia. He was the son of the Pope, Alexander VI. They met: certainly Borgia had heard of him. Politically he too was in Ludovico's situation of nearly twenty

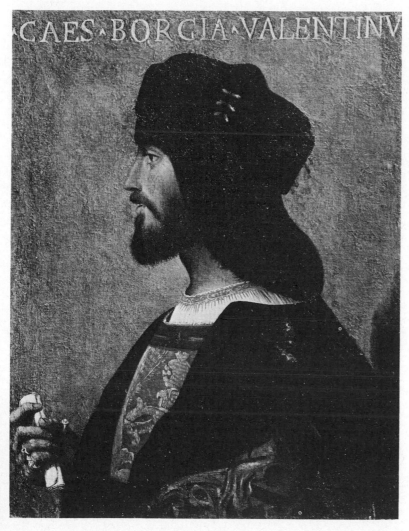

Cesare Borgia, the strikingly handsome son of Pope Alexander VI, who offered Leonardo a post as his chief military engineer.

147

years before: he needed artists and thinkers because they fascinated him, and also for the social prestige. He offered to take Leonardo on as his chief military engineer. Leonardo promised a decision later. He no doubt wanted to see where the dice would fall, as far as Ludovico was concerned.

He went to stay at Mantua, guest of the loyal Duchess, who had still failed to get her portrait. He did it unwillingly, perhaps coldly. The drawing of her in the Louvre attributed to him hints at a passionate and captivating personality, but the right sleeve and arm are so badly done, with the smallest sense of foreshortening, that we must make a personal choice as to whether those who claim it for Leonardo are right. Such a piece of gaucheness at this period in his life would have been incredible. The other arm is lifeless. The work is clearly unfinished and there is no evidence that his cartoon of it was: he would not have given it to her in the state of this Louvre drawing, nor would she have asked for an oil to be made from it. The Louvre work could possibly be a copy by another hand from his original, perhaps from the second drawing of her he is said to have taken to Venice. More likely it is the work of one of his assistants (and even then no one as gifted as Boltraffio), with Leonardo touching it here and there: certainly there is his touch in the profile, and perhaps the hands.

Isabella now pampered him as she had wanted to do for years. He promised her an oil painting later but it never came about, though she was not slow to remind him of his promise later. She hated long sittings, and he hated to work under limiting conditions. That alone would not have made him reluctant to paint her. He thought the stable of thoroughbreds belonging to her ugly husband Francesco Gonzaga the finest he had ever seen, and seems to have preferred their company to hers.

Her interest in Leonardo was stronger than he could bear perhaps. That would have been enough to send him away, and keep him away – the thought that her interest was an erotic one. It is difficult to refuse a duchess. By March of that year, 1500, he was in Venice. Ludovico, at the head of his mercenaries – fresh but no more reliable than the previous lot under Sanseverino – had entered Milan again in February. He decided to engage the French. It happened at Novara in April, and luckily for him the Swiss mercenaries on the French side refused to fight as well. But there was little hope of his winning a battle, or even of getting out alive. One day he disguised himself as a monk and escaped from the lines. The French caught him, and he was recognized. In his note-

book Leonardo simply wrote, 'The Duke lost his land, his possessions and his freedom and he never completed a single one of his projects' – even the casting of a monument to the Sforza family, he might have added. The clay model had remained in the courtyard of the Rocchetta, and Gascon archers had used it for target practice. Now there was nothing left of it. That in itself was not disastrous for Leonardo, who still had his small wax *bozzetto* of the horse, which could be cast at any time. And indeed he suggested to Ludovico's worst enemy later on that the work be adopted to the glory of Marshal Trivulzio, though nothing came of the project.

It was of course the end of Ludovico. He was placed in an iron cage and taken to a French fortress at Loches, close to the palace where Leonardo was to spend the last years of his life. French, Swiss and Venetian troops laid waste to the country all round Milan. The Castello was flooded, and the stores were ruined. Meanwhile Leonardo was travelling about like a prince, with Fra Luca Pacioli and the intolerable, the lovable Salai. Mantua was not quite rich enough for him, perhaps. He would go to Venice. He hoped to allure the Serenissima as he had once allured Ludovico, by talking to them about machines of war. And he felt they were rich enough to afford him.

4 The Search

Murianu

for the Perfect Patron

VENICE, QUEEN OF THE ADRIATIC, was at this time in her glory. During the century that was beginning now, she produced her most arrogantly self-satisfied architecture, and her aristocracy – who were also her politicians and naval commanders and diplomats – began to conceive land-ambitions that, together with the shift of trade from the Levant to the Atlantic, and the increasing importance of the powers north of the Alps, proved her undoing. For the moment, the Republic was probably the richest state in Italy. In fact, she seemed to be less connected with Italy than with the Aegean and the eastern Mediterranean. Her empire stretched far down the Dalmatian coast, and included Crete. She had two million colonial subjects, apart from her own tiny population of between one and two hundred thousand.

As Leonardo noted in his manuscripts, the Serenissima boasted that she could spend 'thirty-six millions in gold ducats in ten years of war with the Emperor, the Church, the King of Spain and the King of France'. Every Italian state seemed to want to rule Italy – and it would certainly have been possible for one of them had the Church been less powerful. She effectively prevented Italian unity for centuries. For she cut across the various states with her influence. It was not simply a matter of power. The rulers of both Venice and Florence were rather defiantly disposed towards the Pope. Lorenzo de' Medici had even fought him. They hardly took his threats of excommunication seriously. But their peoples did. The interdict of excommunication was applied twice to Venice during the thousand years of her republic, and once to Florence under Lorenzo. Nothing divided the people from their rulers more. And usually the rulers had to climb down. Yet papal policies seemed remote from Venice: what she called her 'inquisitors' were a secret political trio who kept dossiers and could arrange murders. Going to Venice was like visiting a foreign country. She seemed impregnable. Her moat was her shallow lagoon, navigable only to those long familiar with it. Leonardo had high expectations.

What he overlooked was that the Venetians were a mercantile people, and that mercantile people spend much of their time thinking about money and how not to spend it. Above all, they suspect the imagination. Venice had let Petrarch's marvellous

PREVIOUS PAGES A view of Venice by Breydenbach, c. 1480, in Leonardo's day at the height of its glory.

LEFT The Grand Canal in Venice today. The Republic declined steadily after the important trade-routes switched to the Atlantic, following the discovery of the Americas.

153

library petrify under the stifling 'leads', as her roofs were called: after two centuries of neglect only a few volumes were readable. Venice regarded painters as servants of the state, and treated them as important precisely in proportion to their zeal. The huge walls painted by Tintoretto and Veronese are far from Florentine in their flamboyance. Venice's ruling men were on the whole gracious and amiable, and courageous, but rather philistine. They had no doubt heard of Leonardo. But he was a 'foreigner' (the word applied to Italians as well as others): and therefore, for a mercantile people, not quite serious: nor quite above-board. Venice's little army of private agents watched newcomers closely, and the law forbade patricians to entertain them in their homes.

No doubt Leonardo gave the agents food for work when he began proposing new methods of disabling an enemy ship from below, and designed mine ships, ramming ships and a submarine piloted by one man who breathed through a leather tube running to the surface, and worked out a system for destroying the entire Turkish fleet. The Turks were at this moment invading Friuli – and they actually managed to reach the gates of Vicenza. He worked hard to attract the attention of the dour watchdogs of the Arsenal (where jobs were inherited at birth). His schemes were costly. That was probably the first argument against them. And secondly they took little account of the fact that Venice already had a fleet,

Reconstruction from Leonardo's notebooks of two designs for warships.

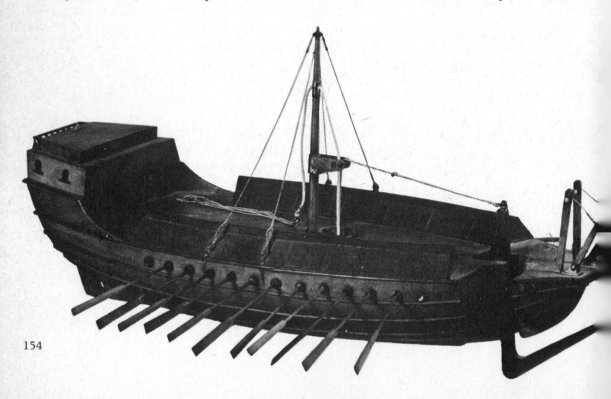

and an Arsenal that was a closed shop to new ideas as well as foreigners. It was hopeless to try to break through all this. And Venice did not even record his visit. He did become friendly, it is said, with the great printer Aldous, and the Venetian collector Cardinal Domenico Grimani, whose Flemish masters (at that time in vogue in Venice) he saw and whose Greek *Leda* in marble he almost certainly sketched. A maker of harpsichords, Lorenzo Gusnasco da Pavia, an old friend of his from the Milan days, visited him and wrote to Isabella of Mantua that Leonardo had shown him her portrait, 'which is extraordinarily like you: it is scarcely possible that it can be so well done'. Leonardo also met Stefano Chigi, and found time to study cosmography.

More than anything, the fact that a 'foreigner' could not move into Venetian society made it hard for him. And he had to earn his living. Though rich, the Venetians held their purses tight. They did make an estimate of the probable cost of his scheme for fortifications on the River Isonzo, and found it more than they could afford. Leonardo went to Venice in March 1500 and left again the following month – for Florence.

But one thing he had accomplished. The Comte de Ligny had been made governor of Pavia by Louis XII and had received Ludovico's sword. Now he invited Leonardo to settle in France. The two men had met at Pavia, and once again in Venice. So there

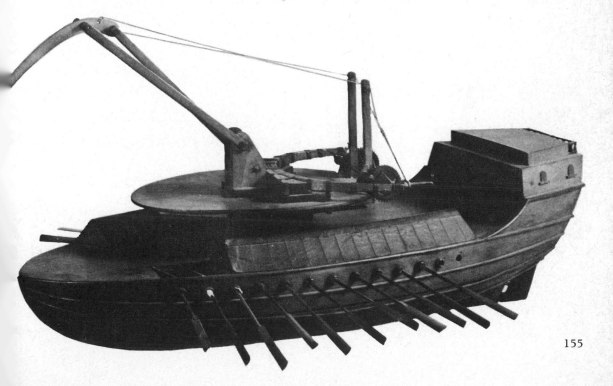

was a home waiting for him – among those who seemed to value not simply his work but the quality of his mind. He did not accept at once, but returned to Florence. It needed several more discouraging experiences – and the death of another patron – to send him north across the Alps.

Florence was definitely an interim choice. The fact that the Medici family were no longer in power was probably a matter of little regret for him. But what was there in its place? Certainly not a comparable system of patronage. Lorenzo de' Medici's son had drowned in the River Garigliano as a soldier, after a few absurd attempts at governing Florence. His place had been taken by the most persistent enemy of Medici power, the priest Savonarola. The city had become bankrupt. It even seemed to be asking for a long period of eclipse, after the Medici glories. The women ceased to wear jewellery, and for the new puritan régime painting was close to books and neo-platonic thinking, namely on a level with the jewellery. But still, Savonarola had been burned at the stake on 23 May 1498: he had turned his puritan fire on Rome, and the time had come for him to be liquidated. Florence never really won a quarrel with the Pope. But she never really wanted to. That was what had given Savonarola so much power – the fact that the politicians and painters and scholars he sneered at from the pulpit took him seriously. Even Lorenzo de' Medici took care to find out

Fra Girolamo Savonarola, who was born in the same year as Leonardo. His fiery denunciations of the rich and their neo-platonic favourites led to the burning of many books and paintings. RIGHT A detail from an anonymous painting of the burning of Savonarola in 1498, after he had recklessly incurred the anger of the Pope Alexander VI.

156

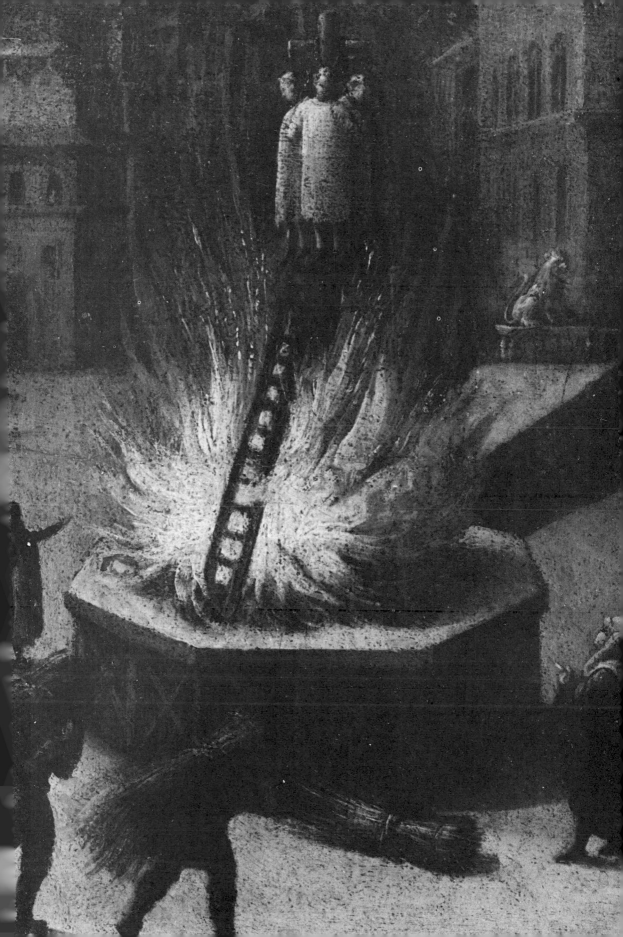

what he said in his sermons. He could have had him removed from Florence without much difficulty, but at most he sent him a friendly warning now and then, to curb his adjectives. Botticelli became an ardent supporter, and destroyed all his early work. Pico della Mirandola, after a youth feverish with new ideas, abandoned his platonism. Savonarola's sermons had the raw sound of the truth. Boccaccio's books had been burned with the fine laces and brocades. Florence had put on sackcloth and ashes. Nowhere in the town was there a workshop like Verrocchio's, gay and lively and warm. It was as if Florence had thought too much and too boldly, and painted too well, and enjoyed herself too brilliantly, and was now running back into the narrow but safe arms of the Church. The city had become rather sad.

But quite possibly Leonardo thought of Florence as a stopping-place on the way to meet Cesare Borgia. He was looking for a patron. And the patron did not need to be an angel. 'The pen must of necessity keep company with the knife,' he wrote. And, moreover, useful company, 'for one can do nothing without the other'. His realism had saved him from suffering from Ludovico's downfall: on 14 December 1499, about four months after Ludovico left Milan for the first time, promising to return, he had lodged a letter of exchange for six hundred gold florins with the monastery of Santa Maria Nuova in Florence, which shows that he meant to visit his home-town some time. On arrival there he cashed fifty of those florins: the transaction was dated 24 April 1500.

He met some of his old friends but many – including Toscanelli and Vespasiano da Bisticci – were dead. So were Lorenzo's Court – Marsilio Ficino, Poliziano, Pico della Mirandola. The two Pollaiuoli were dead, so was Ghirlandaio and, above all, for Leonardo, Verrocchio. Botticelli seemed depressed, having witnessed Savonarola's burning, after giving up his life to his doctrines. Fra Bartolommeo was working, so was Lorenzo di Credi, but they seemed in no better mood. Filippino Lippi was working too. He had just been given a commission by the Servite monastery to do a fresco for the Annunziata. He generously handed this over to Leonardo. According to Vasari, Leonardo stayed with the monks to do his work, together with Fra Luca Pacioli and his servant Salai, and his usual assistants. He was certainly not in want, but lived in some splendour, with servants.

Isabella d'Este wrote to the Vicar-General of the Carmelites, Fra Pietro da Nuvolara, on 3 April 1501, a year later, enquiring about Leonardo's activities (and no doubt wondering when she was

going to get her oil painting based on the cartoon – which her husband had given away). She asked Fra Pietro to persuade Leonardo to do 'a little picture of the Madonna, devout and sweet, as is his wont', and also something for her study at the palace in Mantua (which contained pictures by Mantegna and Perugino). 'I have had the letter of your Excellency,' Fra Pietro replied, 'and I will do with all haste and diligence that which you write to me. But, so far as I can gather, the life of Leonardo is extremely variable and undetermined, so that he seems to live from day to day. Since he has been here in Florence, he has made only a sketch in a cartoon.' He goes on to describe what is clearly a study for *The Virgin and Child and St Anne*, for the Servite monastery. 'And this sketch is as yet unfinished. He has not executed any other work, except that his two assistants paint portraits, and he, at times, lends a hand to one or another of them. He gives profound study to geometry, and grows most impatient of painting.'

There are several cartoons on the *Virgin and Child and St Anne* theme – at the National Gallery in London, at the Accademia in Venice, at Windsor, and there is the unfinished oil painting in the Louvre, usually dated 1508-10. There is disagreement about Fra Pietro's account of the cartoon he saw: he describes the figures as turned towards the left-hand side, and it all depends on whether we take his left-hand to mean that of the sitters or that of the spectator. He also describes St Anne as restraining her daughter from discouraging the Child as he grasps the lamb (meaning that the Church did not wish the Passion to be prevented). And in the Louvre painting she seems to be simply a watching and detached grandmother. It is possible that St Anne's hand was originally conceived as lying on her daughter's sleeve, and was cancelled – the Virgin's sleeve was painted over it – as an afterthought. But it is also possible that the cartoon described by Vasari, where St John as a little child plays with the lamb, and the Virgin (with the Child in her lap) gazes at him with tenderness, is the one in the National Gallery, since St John figures there too. Leonardo may have done his unfinished picture (in the Louvre) some years later, after the commission for the Servite friars had fallen through. As it turned out, that commission was taken over by Filippino Lippi, who died before he could complete it.

According to the 'anonymous Florentine', Leonardo did his portrait of Ginevra d'Amerigo Benci during this period, and he is supported in this by Vasari. The picture in the National Gallery, Washington, of a lady with a bush of juniper behind her, is thought

Two sketches by Leonardo
of female heads; they
are possibly preliminary
sketches for paintings.

160

to be this, especially as there is a sprig of juniper painted on the reverse of the panel, with a laurel wreath round it. Ginevra Benci was married in January 1474, and some think that the portrait was painted to celebrate her marriage. By 1500 she would be matronly, certainly no longer the young girl in the portrait. So we have a choice: either it is not Ginevra, and was painted in 1500, or else it is Ginevra, and Vasari and 'the anonymous Florentine' were wrong.

The records show that Leonardo signed a receipt for the rent of his vineyard outside Milan in July 1501, and that Manfredo de' Manfredi came to see him on Isabella d'Este's behalf. But Leonardo neither returned to Mantua nor did anything for her. There is evidence that he was in Florence the following year, in March, as Francesco Malatesta consulted him there about the value of some vases he wished to buy for his wife. But probably he was by now in Cesare Borgia's service, and happened to return to Florence from the Duke's camp. Cesare Borgia's actual patent was not issued until August 1502, so it is equally possible that Leonardo remained in Florence until about then. The patent authorized him to inspect Borgia's installations:

Cesare Borgia, by the grace of God Duke of Romagna, to all our lieutenants, castellans, captains, *condottieri*, officials, soldiers and subjects . . . we constrain and command, that to the bearer, our most excellent and well beloved servant, Architect and Engineer in Chief, Leonardo Vinci, whom we have appointed to inspect strongholds and fortresses in our dominions, to the end that according to their need and to his counsel we may be enabled to provide for their necessities, they afford a passage absolutely free from any toll or tax, a friendly welcome both for himself and his company, freedom to see, examine and take measurements, precisely as he may wish, and for this purpose assistance in men as many as he may desire, and all possible aid, assistance and favour, it being our will that in the carrying out of any works in our dominions every engineer shall be bound to confer with him and to follow his advice. Given at Pavia 18 August 1502.

He seemed destined to serve *parvenus* and tyrants. Borgia (with Arab and Castilian blood in his veins) already had a lively reputation for luxury, cruelty, crime and intelligence, not to say an eye for other men's gifts, and some real taste and erudition. And he loved taking his poets and musicians and painters to war with him. Like Ludovico he dreamed of making himself king of Italy, and his motto read 'Either Caesar or nothing' – and fate in the end chose the latter. He murdered the Pope's favourite Perotto, and later his

162

A preparatory sketch, possibly for *The Virgin of the Rocks*.

own sister's husband, Alfonso da Biscaglio, just as he executed one of his own governors for falling in love with her. He had his own personal assassin, called Grifonetto. And he was busy creating a kingdom for himself in the Romagna. The duchies of Forlì, Faenza, Imola, Rimini, Urbino and Pesaro had already surrendered to him. In June 1502 he had the brothers Manfredi of Faenza strangled and flung into the Tiber close to the castle of Sant'Angelo. They got in the way of his Romagna ambitions, charming as they were. 'Valentino', as Borgia was sometimes called, was now about to invade Umbria with the help of the tyrant of Città di Castello, Vitellozo Vitelli, who like him had syphilis.

Leonardo went first to Piombino on the coast, then to Siena and Perugia. At Piombino he noted 'the breaking of the wave upon the shore, and the laws which govern it'. At Siena he noticed the bell of the duomo. At Urbino (which had already surrendered to Borgia) he saw 'the dove-cot and the palace steps'. All this seems

163

to have happened before Cesare signed him on, as they had not yet met in their new relationship. He went to Cesena to advise on the need for bastions at the tower of Porto Cesenatico, and made a number of maps of central Italy, with the rivers and towns and contours clearly marked.

After Leonardo had joined Cesare, he went everywhere with him in the duchies, sketching the archers, musketeers and Swiss halberdiers of the Borgia army. He did some research on cannons, and consulted with foundries in Brescia on the casting of new ones. It must have been pleasant to be taken quite seriously for the first time outside the field of painting. He surveyed vast areas of southern Tuscany and the Romagna. By chance he met Macchiavelli in an inn at Nuvolara and offered to share his room with him when the innkeeper insisted on Macchiavelli's surrendering his to a famous courtesan. Leonardo did a sketch of the bony, aquiline, thin-lipped ambassador of the Florentine treasury, as Macchiavelli was at that time. They travelled on to Fano together, where Leonardo was to meet up with the Duke, and when they arrived, he invited Macchiavelli to join him in his splendid apartment close to Cesare's palace. Cesare intended to make a centre of the letters and the arts in Fano, and was said to be spending nearly two thousand ducats a day (in the tradition of papal 'nephews'). He was an inscrutable creature, strangely serene, and used to walk about in a mask. He went to bed at five in the morning and breakfasted at four in the afternoon. He was fascinated by Leonardo's maps, and began to think of him as something of a war-wizard – which indeed he was. On his side Leonardo must have seen enough to fill a lifetime. Cesare had Don Ramiro del Lorqua, his own governor of the Romagna, seated at Cesena, executed, officially for being an extortionist – but actually because he fell in love with Cesare's sister, Lucrezia, who had just married. He strangled and hanged his former captains, including Vitellozo Vitelli and Paolo Orsini, at Senigallia, after they had formed a secret alliance against him which was no secret at all: he met them at the gates of the town and embraced them warmly, then had them arrested. Leonardo sketched 'the most brutal madness of war', as he called it.

He was back in Florence by March 1503. His period with Cesare had never been considered a permanent one – not that that word could be associated with Cesare anyway. There was an officers' rebellion against Cesare in October 1502 which kept him busy and prevented much engineering work being done. Quite possibly

OPPOSITE Niccolò Macchiavelli, author of the famous *The Prince*. Leonardo met him quite by chance when Macchiavelli held the post of ambassador to the Florentine treasury.

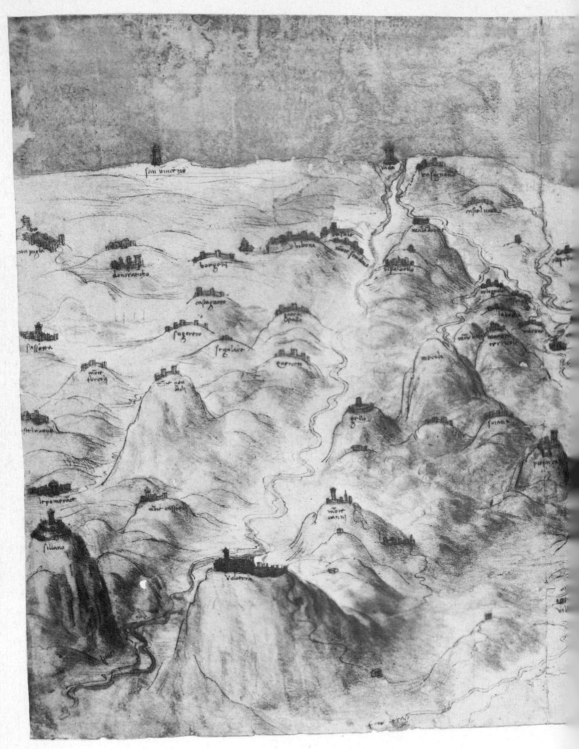

A map of Tuscany by
Leonardo showing the
important cities of
Pisa and Volterra.

Leonardo left him as soon as trouble brewed. All we know is that he drew fifty florins from his account at Santa Maria Nuova on 4 March 1503. Pope Alexander VI died (some say from poison) and Cesare, back in Rome, also fell ill – and recovered after being immersed in the steaming entrails of a mule. According to Macchiavelli, it was only his father's death, and his own illness, which prevented him from extending his rule throughout Tuscany to Florence, not to say beyond.

Leonardo's plan to control the waters of the Arno and thereby starve Pisa into submission.

In his manuscripts Leonardo noted a loan to Attavante, the miniature painter, of four gold ducats, and on 23 July 1503 he entered the service of the Signoria as a military engineer. For the first time Florence really needed him – for its war against Pisa which it looked for a time like losing. He had himself enrolled once more as one of the city's painters, as if intending to settle down. He was now fifty-one. Michelangelo (twenty-seven at the time) and Raphael were then the coming painters, and rather critical of Leonardo for his unfinished works and his obsessive perfectionism. Yet he got a great – a venerable – welcome from Florence. And he quickly produced a scheme for cutting off the course of the Arno in such a way that Pisa could be starved into submission. This job may have been due to Macchiavelli, who certainly came to see him. With the help of Giovanni Cellini (father of the famous Benvenuto), he began charting the Arno, planning to build powerful dykes, with an excavating machine and a crane of the type used today, only worked by hand. Locks were to link the two water-levels, and models of these can be seen today, like those of the excavator and the crane, at the little museum in Vinci. Two thousand workers started on the project.

The mayor of Florence, Piero Soderini, also asked him to do an epic fresco for the Grand Council hall of the Signoria, which Leonardo – ignorant of the fact that Michelangelo (who did not hide his dislike of him) had been asked the same – agreed to do. He chose as his theme a famous Florentine victory back in 1440 over the Milanese *condottiere* Piccinino, called *The Battle of Anghiari*. Here again Macchiavelli's friendship had proved useful. Michelangelo chose a deliberately different theme, from the recent Pisan wars – an incident where a group of soldiers was surprised while bathing in the nude. Michelangelo began work a little later than Leonardo (who started in October 1503, using the papal hall of Santa Maria Novella as his studio). His minute studies of the horse in every state of action and repose from the Milan days, came to serve him now, and he began a series of studies for this 'fight for the standard' (for that was to be the picture's central story) which are all we have today of a work which probably represented the climax of his powers, the sum of everything he had learned about the human figure, the horse and how to convey a moment of intense action with still forms. Rubens's drawing, taken from the central group in Leonardo's picture, together with many other sixteenth-century copies, the Leonardo study for the head of one of the soldiers (at Budapest) and a drawing in the British Museum

169

from a portion of the picture, testify to the extraordinary thing
that picture must have been, in which not a fraction of the
surface did not originate in a fact of nature, not a moment in the
action did not relate to the meaning of the whole, and not a facial
expression did not argue the strain and terror of that moment.
Clearly, painting would never be the same again. Had the painters
of the period that followed him and Michelangelo shared his
powers of thought and study, there would have been better work
to look at today, and less of the empty and melodramatic poses
that are most of what we mean by the word 'baroque'.

But Leonardo decided that we should be robbed of his work
precisely as he had decided to rob us of his *Last Supper*. He wanted
to try something new (probably in the hope that we should see
his work better than we see the usual tempera frescoes). He applied
oil again on a special stucco. According to the 'anonymous
Florentine', the upper part dried too dark, the lower part melted.
A copy of the result in the Uffizi today shows that at first the ruin
was not too disastrous. Leonardo hoped to heat the oil dry, but
when burning braziers were brought into the hall he found that
they were insufficient to dry even the horses' hoofs. The oils
started to drip. Michelangelo's taunt – that he ought to be ashamed
of himself for having left his horse unfinished – must have rung
in his ears. He had planned the picture with such grateful ingenuity
and concentration – grateful to be getting at last a commission
from his home town in which he could prove his powers.

You must make the conquered and beaten pale [he wrote to himself],
their brows raised and knitted, and the skin above their brows furrowed
with pain, the sides of the nose with wrinkles going in an arch from the
nostrils to the eyes, and make the nostrils drawn up and the lips arched
upwards to discover the upper teeth; and the teeth apart as with crying
out and lamentation. And make one man shielding his terrified eyes with
one hand, the palm towards the enemy, while the other rests on the
ground to support his half-raised body . . . You would see some of the
victors leaving the fight and issuing from the crowd, rubbing their eyes
and cheeks with both hands to clean them of the dirt made by their
watering eyes, smarting from the dust and smoke.

Apparently Raphael came from Siena to see the result.

There were the usual difficulties over the contract, and the
usual delays. It was not until 4 May 1504 that the Signoria pro-
vided the contract duly signed. The cartoon was to be finished by
the following February (1505), and Leonardo was to get fifteen
gold florins a month, to start from 20 April 1504. If he failed to

PETRVS SODERINI

meet the deadline he was to repay the entire sum. The cartoon was clearly finished in time, since there is a record of payments by the Signoria for scaffolding to be erected for the actual painting in the Grand Council hall. The record mentions other payments for plaster, oil and colours continuously until 30 August 1505.

On 30 May of the following year he asked to leave the city for a period of three months on condition that if he did not present himself within the stipulated time he would pay a fine of 150 gold ducats. Leave was granted, and from that time *The Battle of Anghiari* was never touched again. It seems that perhaps only the foreground battle of the standard was finished, and this was what Vasari saw 'flaking from the wall'. Vasari himself overpainted what was left of Leonardo's work, in 1565.

For a long time the two cartoons, one by Leonardo and the other

by Michelangelo, hung in different places – the first in the papal hall of Santa Maria Nuova, the Michelangelo in the Palazzo Medici. Benvenuto Cellini wrote in his autobiography in 1558 that these works 'were the school of the world' and everyone came to see them. They both disappeared. Michelangelo's was cut to pieces in 1516, while Leonardo left his behind when he went away to France, and no one knows what happened to it after that. His scheme for diverting the Arno was abandoned, probably because it had proved too expensive. Suddenly the treasury cut off payments in October 1504. The Pisans then destroyed all the engineering work that had been done so far.

Leonardo may, by this time, have begun to feel impatient with Florence, and to decide finally that he must make a home elsewhere. He must have been thinking hard of the French: indeed,

A copy of Michelangelo's cartoon of the great Florentine victory over the Pisans, the *Battle of Cascina*, showing Pisan soldiers disturbed while bathing.

OVERLEAF Another copy of Leonardo's *Battle of Anghiari* which is now lost to us because of the failure of his experimental technique, probably more accurate than Rubens's.

this was why he wanted to leave Florence for three months – to undertake some work for Charles d'Amboise, lord of Chaumont-sur-Loire and at present the governor of Milan. The Mayor of Florence was certainly no patron. Leonardo thought him mediocre and unbearable – and Soderini was called by his wife Argentina 'my little mouse'. And equally Leonardo was less popular than he had once been in Florence. His style of living, which had never been restrained by a period of puritanism as Florence's had, was defiantly aristocratic. When the seasonal flooding of the Arno came, many peasants died of a kind of plague from the infectious swamp, caused by his engineering work. His father died in 1504 at the age of eighty. He was engaged in a lawsuit against his step-brothers over the property he had inherited from his uncle. They accused him of being an atheist and of having betrayed Florence by serving under her enemy Cesare Borgia. And he 'practised magic' and was a homosexual. It was not a good climate for him, this increasingly provincial city which would soon be a backwater controlled by new 'ducal' Medici (backed by the Spanish). Only the Duchess of Mantua, of his old friends, continued to offer him a helping hand. But she was a friend he did not seem to want. She visited Florence – and he fled to Fiesole for the day, and did not see her.

For some years now, since his earlier return to Florence, he had been working on what was to become the most famous portrait in the history of painting. Mona or Madonna Lisa Gherardini, from a noble family in Naples, had married Francesco del Giocondo, a Florentine, in 1495 – at the age of sixteen or eighteen (hence the portrait's other name, *La Gioconda*). Mercifully he took it to France with him, where it passed into the collection of Francis I, so that today it is in the Louvre. Francesco del Giocondo was a rich silk merchant, nearly twenty years older than Lisa. His first wife had been Camilla from the famous Rucellai family, which like his traded in silk manufactures. Camilla had died in childbirth. According to Vasari, Leonardo undertook the portrait for Mona Lisa's husband, but whether it was a commission we do not know. He took no hurry with it, and the fact that he took it away with him indicates that no money passed between him and Giocondo. The portrait had possibly, in the four years of its execution, become something he could not bear to part with. It captured in a single work all that he had been trying to achieve in portraiture, particularly in his portraiture of women – and we may include the angels and the madonnas. And what we see today is

180

little – compared with what Vasari saw. This is his description:

In this head, whoever wishes to see how nearly art is able to imitate nature, was readily able to comprehend it; since therein are counter-feited all those minutenesses that with subtlety are able to be painted: seeing that the eyes had that lustre and watery sheen which are always seen in the living creature, and around them were all those rosy and pearly tints, together with the eyelashes, that cannot be depicted except with the greatest subtlety. The eyebrows, also, by reason of his having represented the manner in which the hairs issue from the flesh, here more thick and here more scanty, and turn according to the pores of the flesh, could not be more natural. The nose with its beautiful nostrils, rosy and tender, seems to be alive. The mouth with its opening, and with its ends united by the red of the lips to the flesh tints of the face, appeared, indeed, to be not colours but flesh. Whoever intently observed the pit of the throat, saw the pulse beating in it. And, in truth, one could say that it was painted in a manner that made every able artificer, be he whom he may, tremble and lose courage. He employed also this device: Mona Lisa being very beautiful, while he drew her picture, he retained those who played or sang, and continually jested, that they might make her continue merry, in order to take away that melancholy that painters are often used to give to the portraits which they paint. And in this picture of Leonardo's, there was a smile so pleasing, that the sight of it was a thing more divine than human; and it was held to be a marvel, in that it was not other than alive.

That is not a description of what we see today. But the character-istic landscape background remains, so deeply in contrast with the easy, domesticated yet tenderly detached figure of Mona Lisa. Behind her, wild nature has its ease and repose, and certainly its detachment. At this time Leonardo was drawing some of the finest sketches of plants that had ever been seen. There never was an artist so devoted to the miracle of natural life, nor one who translated this devotion into such tireless work with the brush. The clouds, the streams, the rocks are not simply a scene: they have a function, they came into being, they grew, and they are changing all the time – the clouds into water, the sun-scorched rocks into hot air that draws winds from the sea, in an endless interdepend-ence, a life that is never for a moment inactive, and of which Mona Lisa – her flesh, her hair and nails and eyebrows and fingers – is a part, like a landscape of another kind. Perhaps the smile simply grew, and Leonardo – had he heard Vasari's praise – might have felt more gratitude for what he said about those eyebrows and the nose 'that seems to be alive' and 'that lustre and watery sheen which are always seen in the living creature', than for the 'divine

smile' which he himself took for granted. But that smile was a
support and guarantee of everything he stood for: if you paint
the truth, which can come only from the most precise study and
thought, the 'divine' element will come of its own accord, quite
naturally. Leonardo would perhaps have said of the lesser artist
that he lacked not the sense of the divine, but simply the power
to work.

He is said to have entertained Mona Lisa with six musicians,
and installed a kind of musical fountain which he had invented,
where the water played on small glass spheres. He put a greyhound
bitch near her for her to play with, and also a white Persian cat.
It was not simply to keep a smile on her face: he never went to
a picture that intellectually. More likely it was to keep her sitting
for longer hours than most girls could stand, so that he might
observe all the more minutely every pore of her lovely face. She
came to him in the late afternoon, with her sister Camilla, who sat
apart with her missal. It may be that he was unwilling to leave the
portrait in Florence unfinished. Each new work was a fresh ex-
ploration for him, and he needed to get to the end of that particular
voyage, whether or not the work was 'finished' from the public
point of view. He could not overcome his fascinations, especially
with what was untried and challenging: this, more than anything,
destroyed his work.

He was much absorbed in these years with the Leda theme. He
shared the fascination with all the Courts of Italy, though his way
of depicting Leda's love affair with the swan was different from
most others. In Milan he had made many sketches of the swans of
the moat round the Castello, which the Duchess Isabella of Mantua
had given to Ludovico. Together with these sketches he had done
at least eight St Sebastians, unharmed by arrows – his 'andro-
gynous' image. And something of the same 'androgynous' interest
went into his Leda theme. Again, the painting has been lost. The
'anonymous Florentine' refers to it. And Cassiano del Pozzo saw
it in Fontainebleau, in the royal collection, in 1625, when he
accompanied Cardinal Francesco Barberini's mission to France:

> A standing figure of Leda almost entirely naked, with the swan at her
> feet and two eggs, from whose broken shells come forth four babies. This
> work, although somewhat dry in style, is exquisitely finished, especially
> in the woman's breast; and for the rest the landscape and the plant life
> are rendered with the greatest diligence. Unfortunately the picture is in
> a bad state because it is done on three long panels which have split apart
> and broken off a certain amount of paint.

182

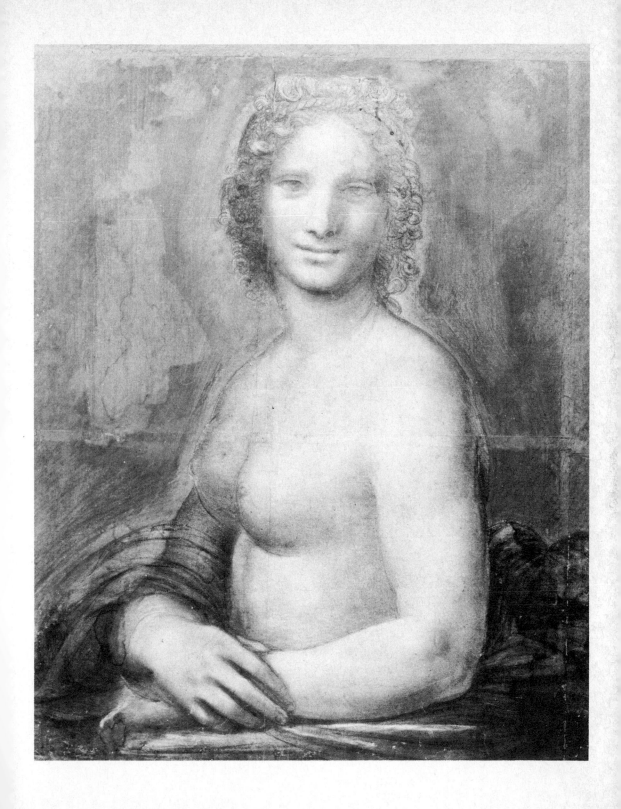

By the eighteenth century the work had disappeared. But we know more or less what it looked like from Leonardo's drawings of the head and bust of Leda, now at Windsor, from Raphael's famous drawing which must have been done before 1504, a red chalk drawing now in the Louvre which may have been done by one of Leonardo's assistants, a picture by Bugiardini which was painted on the basis of the first Leonardo cartoon around 1504, another copy perhaps by Francesco Melzi on the second cartoon, dated about 1508, and the copy by another pupil, Cesare da Sesto (at Wilton, in England) which is said to be the closest likeness to Leonardo's final piece.

Since most of the copies are from Milanese artists, and dated after his departure from Florence, it seems likely that his drawings over the years culminated in a picture during his last stay in Milan, as Charles d'Amboise's guest. Leda seems to recoil from the swan, at the same time as she is tenderly (but not madly or even ecstatically) attracted to it. We return to the theme of sexual reluctance in the woman which was perhaps close to his own attitudes, as it was also responsible for that feeling of close identity with the female to which his portraits and his madonnas testify. She is the passive and patient witness of a necessary act, for which children are the divine compensation. In a woman of powerful personality like Isabella d'Este it may have been the very opposite of these qualities that made him recoil from her. Although Leonardo is credited with the homosexual's interest in lovely boys, there is nothing in his work to compare with his portraits of women. They included far more the sum-total of his feelings about the body and particularly the sex-function than the rest of his work. His St Sebastian too became a figure almost without sex, or rather with the qualities of both sexes; this perhaps was his motive in doing eight versions. He was now fifty-four, and both the *Mona Lisa* and the *Leda* (the latter conceived in the most fertile landscape of flowers and grass he had painted since his workshop days) were the memorials of his own now exquisite detachment.

OPPOSITE A preliminary sketch for *Leda and the Swan*, a painting now lost to us.

185

5 The Las

Years

LEAVE WAS GRANTED for Leonardo to visit Milan in May 1506. He conquered the French. And Charles d'Amboise offered him a pension that looked like being secure for the rest of his days. He had found his patron, so it seemed, and his days with tyrants and usurpers were over. Francesco Melzi, the son of his friend at Vaprio, joined him in Milan as his pupil, together with Giovanni Boltraffio, as before, and the extravagant Sodoma. Salai was still with him – now a painter too, under the name of Andrea Salaino. Among the other pupils were Cesare da Sesto, Giampietrino, Marco d'Oggiono, Luini. As far as we know, Leonardo was in a peaceful mood these days, after the Borgia storms. On 27 May 1507 Louis XII made his official entry into Milan, and possibly Leonardo helped to devise the celebrations for this. According to Vasari he made a vast lion for the occasion, 'which came forward several paces, and then opened its breast which was found full of lilies'.

His plan to transform the Sforza horse into a Trivulzio horse came to nothing, though he continued to make drawings, and it is possible, though no one can prove it or give the smallest evidence for it, that the so-called Ferenczy horse is a *bozetto* of that intention.

He quietly returned to his old pursuits. In the dissection room he was joined by a pupil from whom he learned a great deal – the twenty-six-year-old Marco Antonio delle Torre, who had already made a reputation for himself as an anatomist.

He overstayed his leave, and d'Amboise wrote to the Signoria of Florence to ask for an extension. Piero Soderini replied in a complaining tone and said that Florence could not do without him. D'Amboise referred the matter to his sovereign, and Louis XII wrote as well, which was a polite kind of ultimatum. So Leonardo had a tacit understanding that he would continue with the French. He did return to Florence in September of that year (1507), armed with another letter from Louis XII recommending that the lawsuit be finalized as quickly as possible. Not that it helped. Ippolito d'Este also sent a letter to the same effect, so did d'Amboise. It looked as though he would have to settle in Florence for some time. But he was now virtually a prince. D'Amboise's letter to the Signoria had spoken of 'the master, Leonardo da Vinci, painter to the most Christian King, to whom with the greatest difficulty we have given licence on account of his being under promise to execute a panel-picture for his Most Christian Majesty, came thither wishing to end certain differences, which have arisen between him and his brothers'.

He lived in the apartment of the sculptor Giovanni Francesco

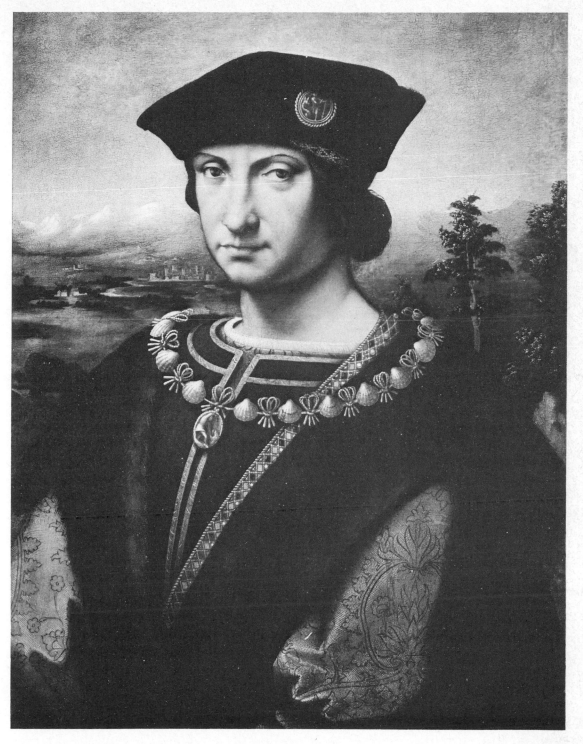

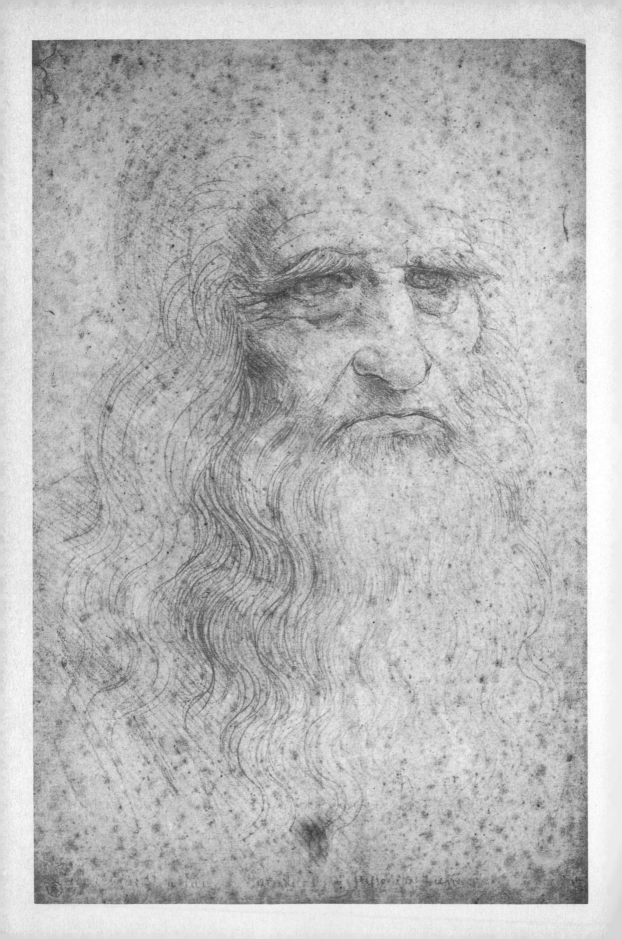

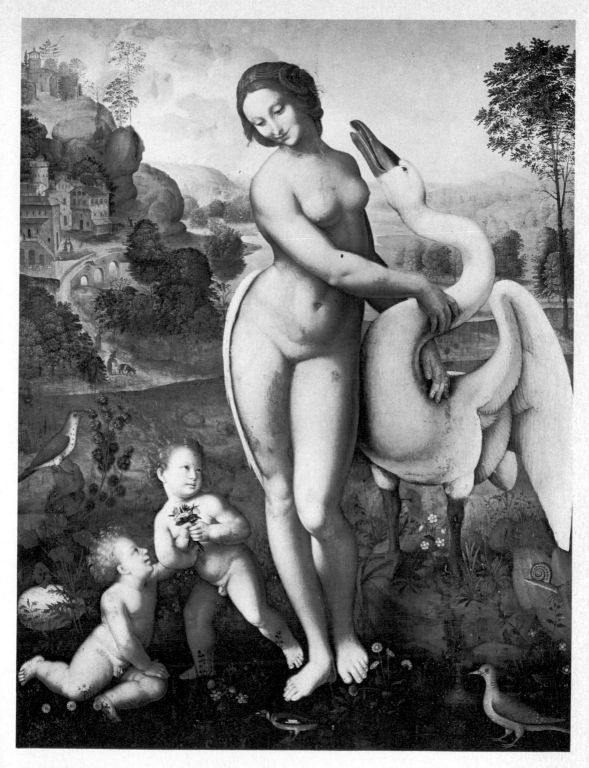

LEFT A portrait of an old
man which some believe
to be a self-portrait
of Leonardo.

ABOVE Of the many copies
of Leonardo's *Leda and the Swan*,
now lost, this is probably
closest to the original.

Rustici in the Via de' Martelli (Rustici had been a pupil in the Verrocchio workshop). The house belonged to his old friend Pier di Braccio Martelli, with whom he had often stayed in the past. In the spring of the following year he wrote to d'Amboise, 'I send Salai to inform your Excellency how I am almost at the end of my litigation with my brothers, and how I hope to be there by this Easter, and to bring with me two pictures, in which are two madonnas of various dimensions, which I have begun for the Most Christian King, or for whomever shall please you.' One of the madonnas he mentions may be the original of the so-called *Madonna Litta* by Bernardino de' Conti (at the Hermitage in Leningrad), as there is a drawing of the Child at suck in the British Museum manuscripts and, in the Louvre, a study of the head of the Virgin, both from about 1508.

His *Battle of the Anghiari*, which the Signoria of Florence hoped to see finished, was drawing such big crowds that a barrier had to be placed in front of it. Eventually not only the lawsuit with his brothers but the long-standing argument with the friars of San Francesco from twenty-five years before over the *Virgin of the Rocks* altar-piece, were settled — both by the good offices of Louis XII. The French King received the original of this picture from Leonardo, which is why it is in the Louvre today.

He returned to Milan in 1508, and remained there until 1512. During that time Charles d'Amboise died, on 10 March 1511, and the city was placed under the command of two military men, Gian Giacomo Trivulzio and Gaston de Foix. After losing a battle at Ravenna on 11 April 1512, where Gaston de Foix was killed, the French decided to pull out of Lombardy. The previous year Swiss troops had set fire to Desio not far from Milan, and Leonardo had sketched the smoke rising. It seemed he was not to be left in peace for long, but for the moment he decided to stay on and wait events. In June 1512 Ludovico's son Massimiliano, whom Leonardo must have known well, entered Milan with a strong alliance composed of the Emperor, the Pope and Venice behind him. Chasing the French out of Milan was indeed quite frequent during this century.

As to Massimiliano's feeling that Leonardo had been disloyal to his father by serving the French, an artist at that time was expected to have no more loyalties of this kind than a mercenary captain. He was looking for a patron again, and Massimiliano was not even a Ludovico. He waited to see what would happen. The following year, on 11 May 1513, Giovanni de' Medici, one of Lorenzo the Magnificent's sons, was made Pope, as Leo X, and it

looked as if Leonardo might be invited to Rome, through the good offices of his admirer Duke Giuliano de' Medici (now the Prince of Florence, with Spanish troops behind him, and brother of the Pope).

Four months after the Pope's coronation Leonardo went down to Rome in the Duke's company. 'I departed from Milan for Rome,' he wrote in his notebook, 'on the 24th day September, 1513, with Giovan' and Francesco de' Melzi, Salai and Lorenzo, *il Fanfoia.*' He was given splendid apartments in the Belvedere of the Vatican, and it looked as if an old dream of his – to live in the city where, so to speak, Italy's heart beat – would come true. Above all, Rome was now the city for artists. Michelangelo and Raphael were there. Bramante was busy tearing down ancient Rome to build a Renaissance one. The Vatican began to take on its present look of architectural order and a certain serene splendour too; the covered bridge which joins it to the fortress of Castel Sant'Angelo (a useful hiding place for harried Popes) was constructed.

Leonardo did not like Leo x. For one thing the Pope was fat, and stank, and had a double chin, and for another he had the kind of Latinist interests which tended to exclude a man of his temperament. While even more of a patron than his father had been, Leo never took Leonardo up. He unashamedly preferred Raphael, as much for the fact that he did what he was asked – and did it on time.

Leonardo found Rome's climate heavy, the streets intolerably dusty. And for all the artists crowded together in it, Rome was not at all an artistic city in feeling. It was raw and vulgar and self-indulgent. The cardinals lived in jewelled splendour these days. New palaces were being built for them round the Vatican. One of them, a gambling cardinal called Raffaello Riario, had once cowered at the altar of Florence's cathedral during the Pazzi attack, a mere boy. He had escaped hanging by the skin of his teeth, and it is said that for the rest of his life he continually put his hand to his throat and stroked it reminiscently. Leonardo must have known his face, and remembered.

For a 'northerner' like Leonardo, only Rome's throbbing, ancient presence, as if her gods were in hiding only for a time, worked its fascination – and his fellow artists were busy removing the last outward signs of that. The city's great families were debauched and philistine. The Pope failed to give him an audience for a very long time. But Leonardo enjoyed himself – clowning much of the time, if we are to believe Vasari. Perhaps Rome's

Castel Sant'Angelo in Rome.
Leonardo found Rome
vulgar and dusty during
his three-year stay from
1513, and was a victim
not only of the Pope's
indifference but a whispering
campaign against him which
culminated in a papal ban
on his dissecting of corpses.

almost brutal simplicity elicited this. One of the peasants who looked after the vineyard of the Belvedere brought him a lizard shaped rather strangely, and Leonardo fastened wings made out of other lizards' scales to its back with a mixture of quicksilver. The wings quivered when the lizard walked. He made special eyes for it, and horns, and a beard, and kept it as a pet, frightening his friends with it when they visited him. He inflated the guts from a bullock and obliged his friends to crowd into a corner of the room as they expanded. 'He made an endless number of these follies, and gave his attention to mirrors, and tried the strangest methods in seeking out oils for painting, and varnishes for preserving works when executed.' It is strange to hear of him 'flaying lizards' scales' to make wings for his pet.

But this was how his researches looked among the Romans – like hearty clowning. 'He formed a paste of a certain kind of wax,' Vasari wrote. 'As he walked he shaped animals very thin and full of wind, and, by blowing into them, made them fly through the air, but when the wind ceased they fell to the ground.' The 'bullocks' guts' are described at the beginning of Vasari's narrative as 'a dragon' with which 'he delighted to frighten his friends'. The 'mirrors' Vasari refers to are clearly Leonardo's little experiments in optics.

The only references in Leonardo's own notebooks to his work at this time are to his various researches, and a treatise called *De Ludo Geometrico* was completed on 7 July 1514, he tells us, in a special study that 'the Magnificent Giuliano', his patron, had provided him. Not that Leonardo was ever a sombre creature. '*Nel parlare*', the 'anonymous Florentine' said, 'in his way of talking he was most persuasive.' And he loved to surprise, particularly in a city which by ancient tradition asked for display. So there may have been an element of jest in some of his experiments for friends.

A mirror-maker whose workshop was also in the Belvedere, a German aptly called Giovanni degli Specchi, was responsible for a lot of the stories about him – presumably because he was jealous of Leonardo's influence with Duke Giuliano. Leonardo wrote the Duke several complaining letters: 'He has hindered me in anatomy, blaming it before the Pope, and likewise at the hospital: and he has filled the whole Belvedere with workshops for mirrors and workmen, and he has done the same in the chamber of Maestro Giorgio.' This 'Maestro Giorgio', also a German, was Leonardo's assistant, and joined with Giovanni-of-the-mirrors to launch a whispering

196

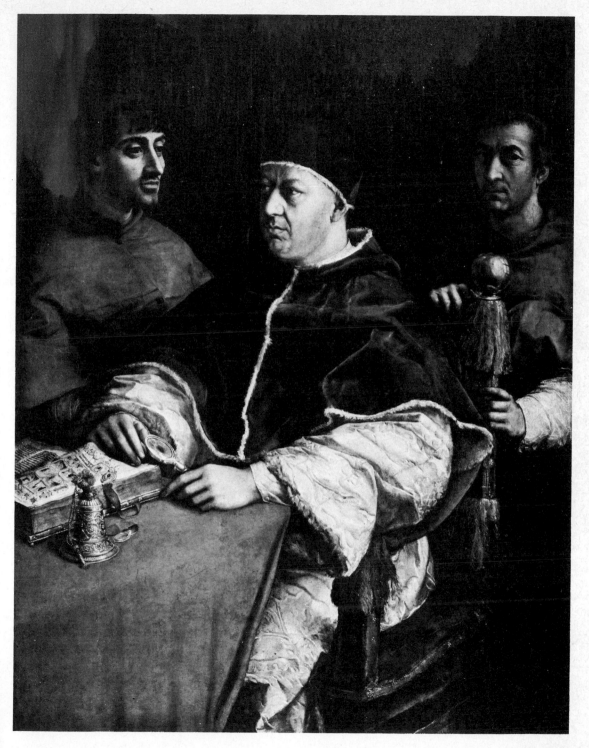

197

A fight between a dragon and a lion. The mixture of mythical animals
and real ones is characteristic of Leonardo's style.

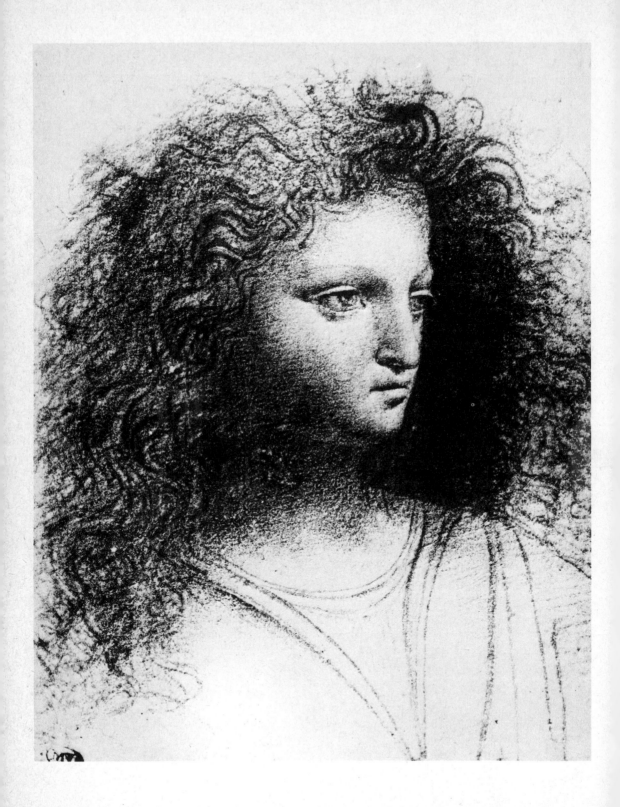

campaign against him. Giorgio also refused to learn Italian, was always complaining about his pay, failed to follow Leonardo's drawings and was in the habit of joining his friends in the Swiss Guards for shooting parties among the city's ancient ruins. In his letters Leonardo made the Rome period sound harassed and uneasy.

Of course these were only tiresome setbacks which his powerful friends could easily set to rights. But he was not getting the recognition he was used to – that inner recognition which is essential for the artist. There were too many painters about, too much competition. He continued to do his sketches for the *Leda*, and people did flock to see his *Mona Lisa*. Among his friends was the collector he had met in Venice, Cardinal Grimani, whom he now sketched.

He did get one commission from the Pope, as an engineer. He was to suggest how best the Pontine Marshes could be drained. It involved going down into the Campania, which despite the malarial dangers was a relief to him: then, as now, the Campania conveyed more sense of ancient Rome than Rome itself. And there were no Florentines tearing down the ruins to make a new Rome.

He worked out a plan for draining the marshes by canalizing the River Afonte. Other commissions did not follow. Francesco Melzi loaned him money (though this may not have been a sign of distress, only an incidental need, for he was still in Duke Giuliano's household, and Melzi was still his pupil). But Leonardo was perhaps aware more of his failures than his glories at this moment – his smashed Sforza horse, his rotting *Last Supper*, his unfinished and peeling *Battle of Anghiari*, his flying machine which had not flown, his numberless 'books' – over a hundred of them – which he had not completed. He did do two paintings for Baldassare Turini da Pescia, a papal official, first a *Virgin and Child*, then *A Boy* (the latter described by Vasari as 'beautiful and graceful to a marvel'). The first picture soon deteriorated, 'whether through the fault of whoever covered the panel with gesso, or by reason of his so many and capricious mixtures of grounds and colours', no one knows. Like *The Boy*, it was later lost. The Pope also gave him a small commission for a painting: Leonardo at once began distilling oils and herbs to make the varnish, which – so the story goes – made the Pope say, 'Ah me! He will never do anything, for he begins by thinking about the end, before the beginning of the work.' A few steps from his own quarters would have taken the Pope to the *Mona Lisa* – but Leonardo's disastrous inclination to follow every twist and turn of his mind, at whatever cost to his

OPPOSITE A sketch of a young boy's head.

201

work, laid him open to this kind of remark. And perhaps it was the thing to say about Leonardo these days. Michelangelo called Leonardo 'the lyre-player from Milan' – and, having finished the Sistine ceiling in four years, he was listened to with some awe.

There had already been an incident between them, in Florence, described by 'the anonymous Florentine':

Leonardo, passing one day, in company with Giovanni da Gavina, near Santa Trinità, by the bench of the Spini, where were gathered together a number of men of repute who were discussing a passage of Dante, they called Leonardo and asked him to explain the passage to them. And by chance Michelangelo passed by at that moment, and, having been called by one of them, Leonardo replied, 'Michelangelo will explain it to you.' At which Michelangelo, thinking that he had said it in order to make jest of him, replied in anger, 'Explain it yourself, you who made a model for a horse in order to cast it in bronze, and was not able to cast it, and to your shame abandoned it!' And, having said this, he turned his back on them and went away: and at those words Leonardo, who remained there, grew red.

Leonardo, quite apart from his temperament, which enjoyed thought and enquiry rather than elbowing for recognition in an army of artists, was also not the age to take up the struggle of his early years again, under another rather indifferent Medici. That family had never brought him good fortune. They were, after all, a banking family, and liked to see returns for anything that appeared in their debit column. To the business-man intangible glories are non-existent ones: the glory of Leonardo's presence was not enough for them, as it was for the French, and, before them, for Ludovico. It was natural that his thoughts should turn to the French again (his connections in that country were another thing that rankled with the Pope). Louis XII had talked at length about Leonardo to the Florentine ambassador, Pandolfini, mentioning 'his perfection and other qualities'. He had wanted Leonardo as his Court painter – had virtually ordered the Florentine government, through Pandolfini, to put Leonardo at his service: 'He is a good master and I wish to have several things from his hand – certain small panels of Our Lady and other things as the fancy shall take me, and perhaps I shall also cause him to make my own portrait.'

The French, too, saw in Leonardo's flying machines and geometrical puzzles and schemes for protecting a man underwater with special diving suits, not simply the engineer gone mad, for there were many people devising similar schemes (and of course

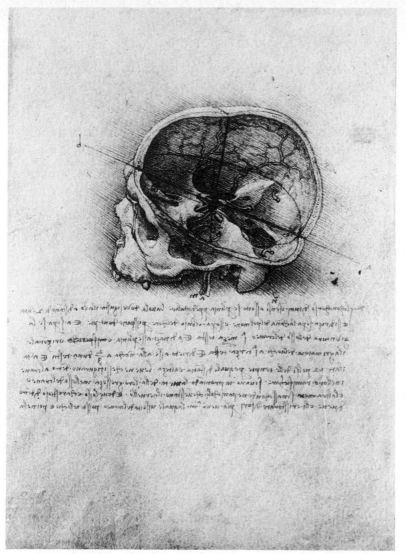

A sketch of a skull.
Leonardo's interest
in anatomy continued
all his life, during which
he dissected thirty corpses
always with the assistance
of the Church.

society took up their schemes), but also the activity of a fervently curious mind – a mind more likely to be found in France or Burgundy at that time than Italy. For the Italian, Leonardo was if anything rather old-fashioned, a medieval creature, who pursued medieval interests, not modern 'Grecian' ones. No one was really shocked by his researches or his experiments, least of all the Church. For the ferment of the new thought went on inside the Church, and through the Church alone. Leonardo dissected in the hospitals of the Church, and got assistance from the Church. In his life he dissected over thirty corpses, always with ecclesiastical

Leonardo's interest in
anatomy was shared by
many others: a contemporary
painting of an anatomy
lesson in progress.

assistance, and no one stood in his way until a German mirror-maker started spreading superstitious stories about him.

He was forbidden to use the hospital in Rome again – and the ban was confirmed by the Pope. But that was not due to any horror of dissection, least of all to any disapproval of his thoughts. The Pope was a modern man, in the sense of the time: so far from Leonardo's being regarded with defensive resentment by old-fashioned clerics, it was they who felt they were carrying the times forward (as they were), and to this movement Leonardo was an outsider. That, perhaps more than any other single factor, worked against him all his life. Michelangelo was, if anything, less gregarious than he was, but he was socially recognized: he was a 'reformer', and at the Vatican reform was not yet a dirty word; the Inquisition had not yet turned its attention to the humanists, the German movement of protest against Rome had not yet started, Spanish zeal had not yet transposed itself into the Jesuit order and what the historians have called the Counter-Reformation, designed to bolster the Church up again after the terrible schisms of the mid-sixteenth century. These problems were sublimely uninteresting for Leonardo.

In January 1515 Duke Giuliano de' Medici married Filiberta of Savoy. The following month, as Francis I looked like being as troublesome as the two French kings before him, the Duke took a papal army north to forestall any new attempt on Milan, or other places in Lombardy where he had governing rights. We do not know if Leonardo accompanied him. The Duke was taken seriously ill on the way and stopped at Florence. From that moment Leonardo had no further need to be in Rome: he could hardly stay there without a great protector. Some say that he felt Michelangelo's competition keenly, and that Rome was too small for both of them. But life then, as now, was a practical affair, and men – especially artistic men – tended to go where they were best looked after.

He was offered not only a pension by the new French king but a home, a palace of his own, the château of Cloux near Amboise on the Loire – a few miles from the prison fortress where Ludovico had died in May 1508. Francis I was vigorous, gracious, a young man of striking intellectual curiosity. Physically he was quite different from his two predecessors – tall and fine-looking, with a fair beard – and Leonardo did like to have patrons who knew how to bear themselves, and were more or less healthy.

Probably Leonardo accompanied the Duke Giuliano's arrogant brother Lorenzo for a time, as a member of his household, at least

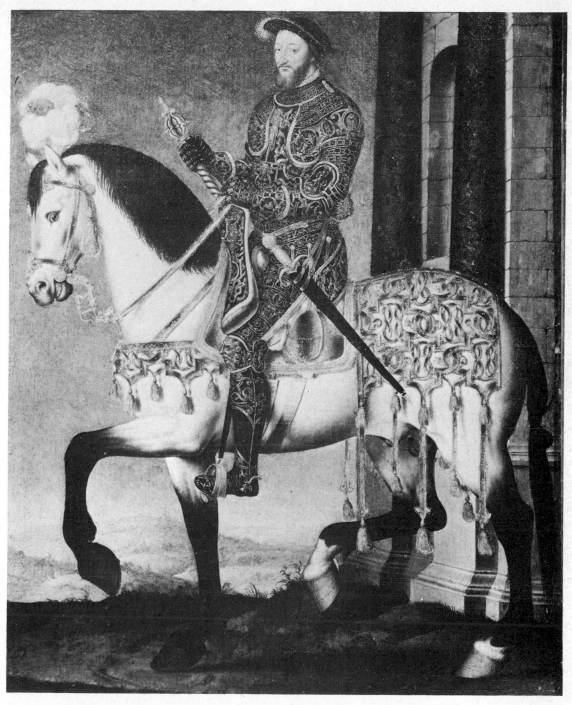

Francis I, who was King of France from 1515 to 1545 and gave Leonardo a palace of his own, a pension and a position as 'first painter, engineer and architect to the King of France'.

as far as Piacenza. He was now sixty-four. And he seemed to have chosen the winning side again. The French beat the imperial army at Marignano, and Leo X was obliged to take a journey to Bologna to meet Francis and talked it all over. Some say that Leonardo was in Bologna too, and met the King there. However that may be, he was quite as relieved to find that the King was the perfect patron as Francis was spellbound by him. Leonardo began to feel the old grace of life again, after the hot Roman sleep. And if he *was* in Bologna, it must have been a wry satisfaction for him to see Leo X saying Mass in the King's presence, at the cathedral of San Petronia.

He was to be Francis's official painter. After the King left Italy, Leonardo returned for a time to Vaprio. Then he and Francesco Melzi left Italy together. He was to be called 'The First Painter and Engineer and Architect to the King of France in France' as well as 'State Technician', with a pension of seven hundred écus. They crossed the Italian border on 6 January 1516, going by Lake Verbano and Lake Leman to Geneva, then on to central France. In March the Duke Giuliano died at Fiesole.

The little palace of Cloux had large, high-ceilinged rooms, and its serenity seemed the setting reserved by destiny for his last years. He could think as much as he wanted here, and take as long as he wanted on his painting. He had his books and instruments. A subterranean passage joined his palace to the royal castle. Francis came across to see him frequently. Leonardo was enchanted. There was a small Italian colony – the potter and the gun-maker and the gardener were Italian. The King talked with him in Italian, and the whole Court began to wear long hair like Leonardo's. Once more he was the deviser of feasts and processions and masques. Marguerite de Valois adored him. He visited the castle at Loches, and saw Ludovico's cell, with his scratchings on the wall, and his designs. Ludovico had once tried to escape in a cart full of straw but lost his way and was caught again. It seemed better to be an artist than a prince.

He made plans for the Romorantin canal for the Queen Mother's residence near by, and had locks constructed. His palace in fact belonged to her. Visitors came from Italy. One of these, accompanying the Cardinal of Aragon, described how they saw

LEFT The palace of Cloux, near Amboise on the Loire, which Francis I gave to Leonardo and which was joined to the King's castle by an underground passage.

OVERLEAF Two sketches for the *Virgin and Child and St Anne*, one of the three pictures of Leonardo's which greatly pleased the Cardinal of Aragon.

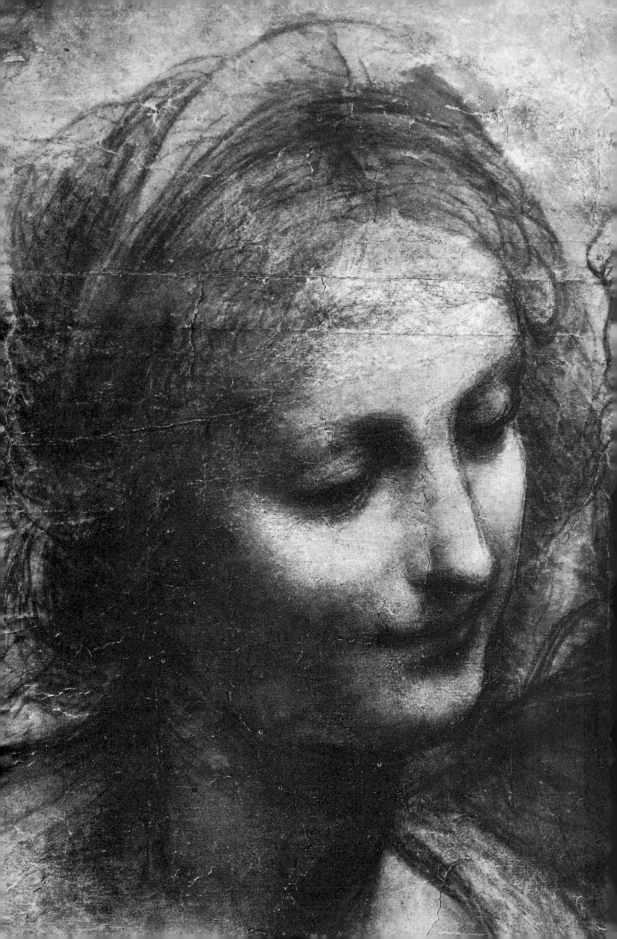

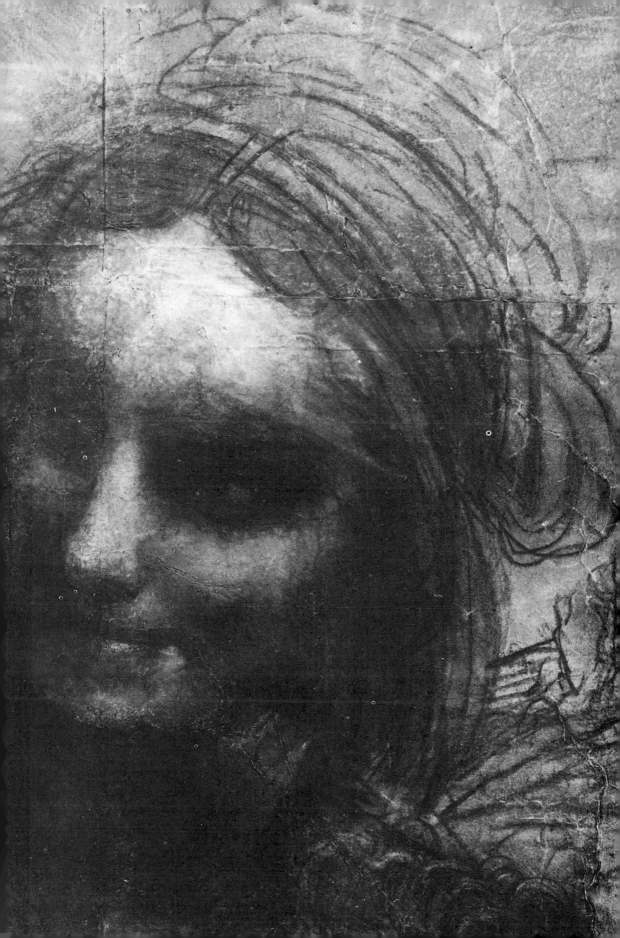

Leonardo, the Florentine, who showed the Cardinal three pictures, one of a certain Florentine lady, done from the life at the instance of the late Magnificent, Giuliano de' Medici, the others of St John the Baptist, as a Young Man, and of the Madonna and the Child, which are placed in the lap of St Anne, and all of them most perfect: but indeed, on account of a certain paralysis having seized him in the right hand, one cannot expect more fine things of him. He has well instructed a Milanese disciple, who works excellently well, and although the aforesaid Messer Leonardo is not able to colour with that sweetness which he was wont, nevertheless he works at making designs and giving instructions.

It is possible that Leonardo had caught malaria in Rome, or at least fallen ill after his stay in the Campania. His paralysis was the result of another fever, brought on this time during the surveying of the marshes of the Sologne. He always drew with his left hand, but for painting he needed both.

As to the pictures he showed the Cardinal, the *Virgin and Child and St Anne* and the *St John the Baptist as a Young Man* are in the Louvre today. The portrait of 'the Florentine lady' could have been the *Mona Lisa*, except that of course Giuliano de' Medici had not commissioned it – but then the Cardinal's secretary might easily have misheard something Leonardo said, or construed the matter for himself.

The famous *St John* is perhaps the one great work of Leonardo's that is still not prized. It goes together with the *Mona Lisa* as a wonderfully conclusive piece, containing the essential quality of all his previous angels, even his smiling women, and his 'andro-gynous' creatures too, his St Sebastians: the pointing attitude of St John is similar to that of several Angels of Annunciation that he did in his last years. In these the angel is doing something quite revolutionary. Instead of looking at the Virgin, he is looking at us. We for the moment are the Virgin, faced by a smile so unearthly, so frightening and ecstatic at the same time, so forbidding and inviting, that our shudder is an acceptance and a refusal in one.

It is this same gaze, and this same attitude, that makes our response to *St John* a divided one too. The smile is almost too familiar. The upward-pointing hand is almost too much of a sign-giving. He is saying that someone will come after him. He is pointing to Christ. That is, he is pointing to Christ's actual presence, then and there, with the promise that we are going to have *the divine honour of a visit*. This promise is in the tenderness of St John's gaze, in his smile that is at one and the same time a tender assurance of Christ's nature and a sad recognition that the visit will be misused,

212

and the flesh despised. It is one of the most marvellous ideas ever rendered in painting, to make St John an announcing angel for us, to have him looking reflectively in our eyes, as if he knows both our need and the vengeance we shall take for having the need satisfied. Here is detachment, or rather the proof of a lifetime of struggle towards detachment, realized at last. St John, really, is neither a man nor a woman. The sex-function has gone entirely.

And this 'little St John', as Francis I called it, was remarkably close to Leonardo's drawing of a seated *Bacchus* with crossed legs (probably done in France). The St John is not entirely free of that same look of almost self-indulgent promise – for Bacchus too is pointing. The figures are indeed so close that the one subject may have been changed for the other: the '*Bacchus-St John*' in the Louvre is the result of a St John being overpainted as a Bacchus. Leonardo never forgot the element of the natural, the enjoyment, the ecstasy that touched the flesh. And so in the St John there is something sensuous too – the promise of a divine visit is the promise of a divine earth!

Leonardo made a sketch for a new royal palace at Amboise. He was responsible for Chambord, a royal pavilion in the forests of the Sologne. He organized the festivities for the christening of Francis's son in April 1517, and in May of the same year for the marriage of Lorenzo de' Medici, now Duke of Urbino, to Madeleine de la Tour d'Auvergne, which took place at Amboise. For the wedding he is said to have designed a special triumphal arch in the main courtyard with tribunes all round, for the jousts, and a mock fortress which fired balloons.

There are two portraits of old men from this period which we may regard as self-portraits or simply as his reflections on two alternative ways of getting old, two moods of old age. He had a home at last. He had respect with security, after a lifetime in which one or the other was invariably missing. His last years were very much in the terms of his ideal: a powerful and discerning prince, an orderly Court and splendid surroundings, a place where envy would not deny him the simplicity of life he enjoyed most. He had his workshop on the ground floor of his palace, his sitting-room and library upstairs. Climbing upstairs one day on Francesco Melzi's arm, he collapsed. That winter was a hard one. On 23 April of the following year, 1519, he dictated his Will. His body was to be buried in the church of St Florentin, attached to the royal palace, and four High Masses and thirty Low Masses were to be celebrated in the churches of St Florentin, St Denis and the Franciscan church

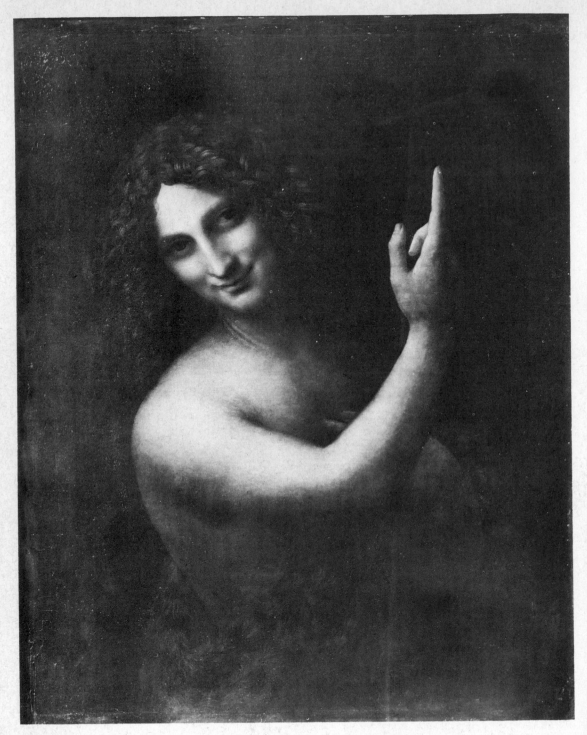

Two of the last works
by Leonardo which bear
interesting similarities.

ABOVE *St John the Baptist*,
perhaps the one great work
of Leonardo's still not
widely prized.

RIGHT *Bacchus*, the result
of overpainting an earlier
version of *St John the Baptist*.

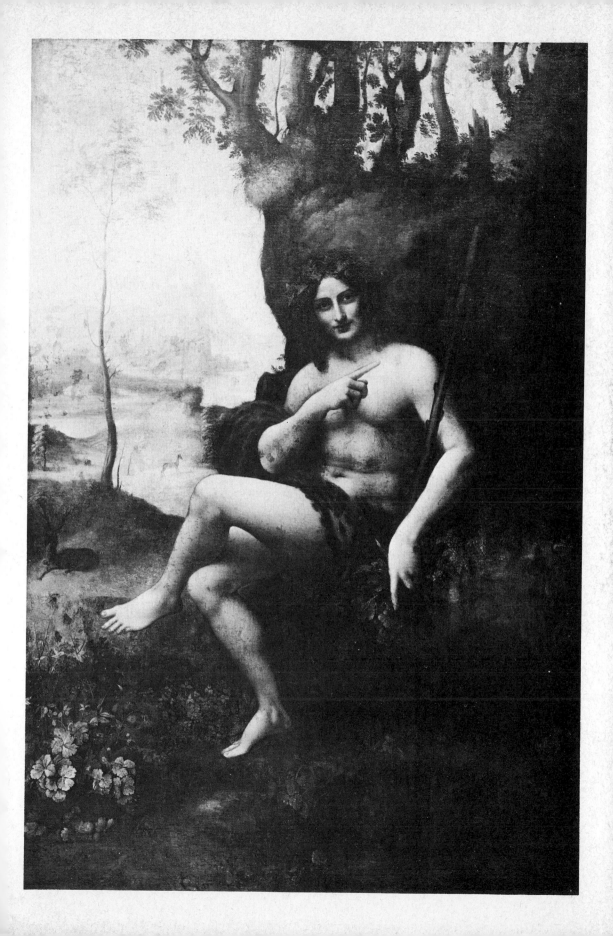

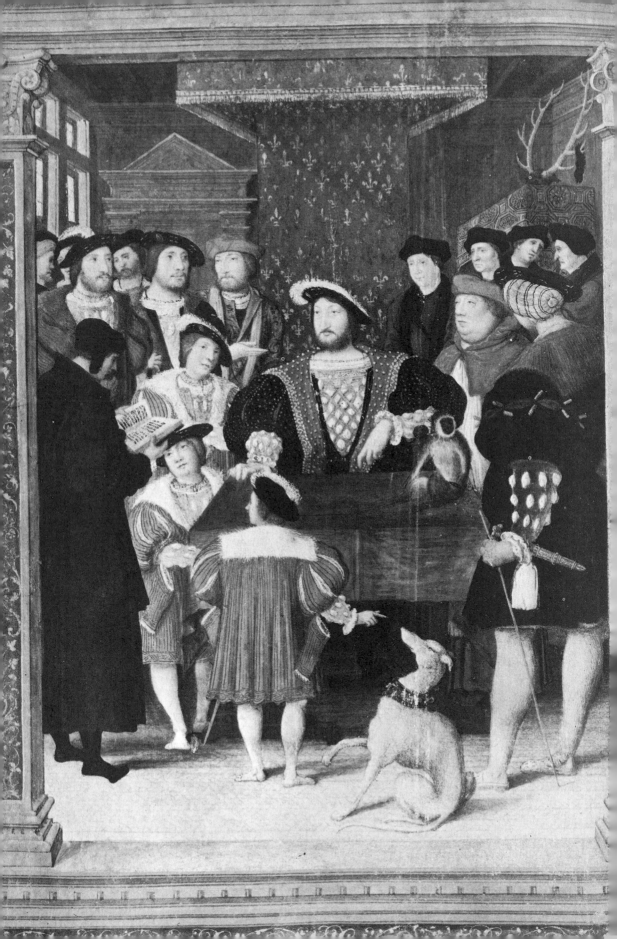

in Amboise. 'To Messer Francesco de' Melzi, gentleman of Milan, in remuneration of the services graciously rendered by him in the past, all and each of the books which the said testator has at present, together with all other instruments and notes concerning his art and industry as a painter.' To Salai and another servant called Battista de Villanis he bequeathed one half of his vineyard outside Milan each. To his waiting-woman Matturina went a fur-lined cloak, a gown and two ducats. And to his brothers he left his account deposited with the chamberlain of the hospital at Santa Maria Nuova in Florence, as well as his vineyard at Fiesole. Which was surely one of the many detached acts of his life.

According to Vasari the King often visited him during his illness, and Leonardo would raise himself in order to receive him, and sit on his bed. He asked to receive the Holy Sacrament, 'supporting himself on the arms of his friends and servants'. He confessed and was penitent, 'with many sighs'. During the King's last visit he remarked how 'he had offended God and mankind in not having laboured at his art, as he ought to have done', then was seized by a paroxysm, and died in the King's arms. The story is doubted because the King signed a decree at the birth of his second child at St Germain en Laye on 1 May. But Leonardo may have died some days before his departure, if indeed he did die on Easter Day, which in 1519 was 24 April, namely the day after he dictated his Will. He was sixty-seven. Francesco Melzi, writing to Leonardo's brothers, said that he had died on 2 May. And he did not mention the King's being present. Again, we may take our choice, as with almost everything we know, or fail to know, about Leonardo da Vinci.

OPPOSITE Francis I and his court. During Leonardo's last illness the King was a frequent visitor. According to Vasari Leonardo died in the King's arms on Easter Day, 24 April 1519, the day after he had dictated his Will.

Chronology

15 April 1452	Leonardo da Vinci was born, the illegitimate son of Ser Piero di Antonio, notary, and Caterina.
1457	A tax return made by Leonardo's grandfather Antonio recorded the fact that the child was living with his father, now married to Albiera di Giovanni Amadori.
1468	Leonardo's grandfather Antonio died at the age of ninety-six.
1469	Another tax return showed Leonardo still living in the Vinci household at the age of seventeen. In the same year Leonardo's father and his uncle Francesco rented a house in Florence, in what is now Via dei Gondi. The house belonged to the Merchants' Guild (Francesco was registered as a member of the Guild of Silk Merchants).
1470	Leonardo's father worked as a notary for the Signoria, and as Procurator for the convent of the Annunziata. During this year (perhaps in 1469) Leonardo become an apprentice in Verrocchio's workshop.
1472	An entry in the register of the painters' guild (the Company of St Luke) shows Leonardo to have been in debt to the company for his fees and an 'offering' on St Luke's day, 18 October 1472.
5 August 1473	This was the date written by Leonardo (now twenty-one) on a landscape-drawing which survives today as his first known work (in the Uffizi, Florence).
8 April 1476	An anonymous denunciation or 'tamburazione' was made against a seventeen-year-old Jacopo Saltarelli for homosexuality. Among those named as his lovers was Leonardo.
7 June 1476	The second tamburazione in which Leonardo was described as a homosexual. He was acquitted.
10 January 1478	He was commissioned by the Signoria of Florence to paint the altarpiece of the St Bernard chapel in the town hall. He wrote in his notebooks that he had begun work on two Virgin Marys.
29 December 1479	Bernardo di Bandini Baroncelli, who murdered Lorenzo the Magnificent's brother Giuliano in Florence's cathedral, was hanged, and a drawing of this, together with notes on the murderer's clothes, is attributed to Leonardo.
March 1480	Leonardo received a commission from the monastery of S. Donato a

the Signoria granted. An argument developed in the autumn about *The Battle of Anghiari*, which was still not finished: the mayor of Florence asked for the 150 gold florins as compensation.

1507 The Florentine ambassador in Milan wrote to the Signoria on 12 January that the King of France wished to retain Leonardo. Louis XII also wrote on the 14th of the same month. The Signoria agreed on the 22nd. On 27 April Leonardo was given back his vineyard near Milan, which had been confiscated after the capture of Duke Ludovico. 26 July Louis XII again wrote to the Signoria, this time ask them to expedite the lawsuit between Leonardo and his brothers over the inheritance from his uncle Francesco. He was paid in Milan the first instalment for his *Virgin of the Rocks* on 26 August.

1508 Leonardo returned to Florence where he worked on *St Anne*. He was back in Milan in Spetember. The *Virgin of the Rocks* was paid for in full in October. He began to receive a pension from the King of France in July.

1511 The son of Ludovico, Massimiliano, invaded Lombardy, and Leonardo was once more in Florence, now that the French were driven out of Milan.

1512 During this year Leonardo may have returned to Milan for a time, or stayed with the Melzi at Vaprio.

1513 Crowds came to see *The Battle of Anghiari* in Florence, and the Signoria was obliged to erect a barrier in front of it on 30 April. Leonardo was definitely in Milan this year with his household, which now included Francesco Melzi. On24 September he left for Rome, where he lived in the Belvedere (the Vatican) in rooms prepared for him by the Pope's brother, Giuliano de' Medici. He stayed in Rome for three years.

1514 He undertook various journeys – to Parma, Bologna, Florence. He made studies for the draining of the Pontine Marshes, on a commission from the Pope. He painted a *Leda*.

1515 Giuliano de' Medici left Rome and Louis XII died. With the departure and later death of Giuliano, Leonardo was again without a protector.

1517 He was invited by the French King Francis I to take up residence in the Château de Cloux. He arrived in May.

1518 Leonardo began receiving a pension of ten thousand *scudi* from the French king. There were various celebrations during the year – for the christening of the king's son, and the marriage of Lorenzo de' Medici to the king's niece.

1519 23 April Leonardo drew up his will. He died on 2 May.

Chronology

15 April 1452	Leonardo da Vinci was born, the illegitimate son of Ser Piero di Antonio, notary, and Caterina.
1457	A tax return made by Leonardo's grandfather Antonio recorded the fact that the child was living with his father, now married to Albiera di Giovanni Amadori.
1468	Leonardo's grandfather Antonio died at the age of ninety-six.
1469	Another tax return showed Leonardo still living in the Vinci household at the age of seventeen. In the same year Leonardo's father and his uncle Francesco rented a house in Florence, in what is now Via dei Gondi. The house belonged to the Merchants' Guild (Francesco was registered as a member of the Guild of Silk Merchants).
1470	Leonardo's father worked as a notary for the Signoria, and as Procurator for the convent of the Annunziata. During this year (perhaps in 1469) Leonardo become an apprentice in Verrocchio's workshop.
1472	An entry in the register of the painters' guild (the Company of St Luke) shows Leonardo to have been in debt to the company for his fees and an 'offering' on St Luke's day, 18 October 1472.
5 August 1473	This was the date written by Leonardo (now twenty-one) on a landscape-drawing which survives today as his first known work (in the Uffizi, Florence).
8 April 1476	An anonymous denunciation or 'tamburazione' was made against a seventeen-year-old Jacopo Saltarelli for homosexuality. Among those named as his lovers was Leonardo.
7 June 1476	The second tamburazione in which Leonardo was described as a homosexual. He was acquitted.
10 January 1478	He was commissioned by the Signoria of Florence to paint the altarpiece of the St Bernard chapel in the town hall. He wrote in his notebooks that he had begun work on two Virgin Marys.
29 December 1479	Bernardo di Bandini Baroncelli, who murdered Lorenzo the Magnificent's brother Giuliano in Florence's cathedral, was hanged, and a drawing of this, together with notes on the murderer's clothes, is attributed to Leonardo.
March 1480	Leonardo received a commission from the monastery of S. Donato a

Scopeto for an *Adoration of the Magi* which was to be completed within thirty months.

1481	The contract for his S. Donato commission was signed, and he was paid one lira and six soldi in firewood for the 'painting of the clock'.
1482	Leonardo left Florence to enter the service of Ludovico 'the Moor' of Milan, who was looking for an engineer, a musician and an artist in one man. He left his *Adoration of the Magi* unfinished.
25 April 1483	A contract was signed between the Confraternity of the Immaculate Conception in Milan and Leonardo (in association with the brothers de Predis) for the painting of an altarpiece. His *Virgin of the Rocks* is usually dated this year. He may also have begun his sketches for the Sforza monument.
13 April 1485	Most probably he received on this date a commission from Duke Ludovico to paint a madonna for the King of Hungary.
1488-9	Payments were made to Leonardo for his designs for the cupola of Milan cathedral, though the commission finally went to others.
1489	He devised the decorations for the wedding of the young Gian Galeazzo Sforza and Isabella of Aragon. He was also writing notes on the human figure. In July of this year the Florentine Pietro Alamanno wrote to Lorenzo the Magnificent that Duke Ludovico was looking for another artist to do the Sforza monument as Leonardo did not seem likely to finish it.
23 April 1490	Leonardo wrote in his notebook on this date that he had begun work once more on the monument, after the extended wedding festivities (which had been interrupted by the death of the bride's mother). In June of this year he was sent together with a Sienese engineer and Antonio Amadeo to Pavia to help with the designing of the cathedral.
22-4 July 1491	Leonardo recorded the arrival of 'Salai', aged ten, in his household. From now on he constantly noted the boy's thefts.
1491-2	Leonardo and the de Predis brothers complained to Duke Ludovico that the *Virgin of the Rocks* commission needed re-arbitrating.
1492	Leonardo organized the celebrations for the wedding of Duke Ludovico with Beatrice d'Este.
13 July 1493	Leonardo recorded in his notebooks that his mother Caterina came to visit him in Milan on this date.
1495	He began *The Last Supper* for Ludovico. It is possible that his mother died during this year.
1496	Leonardo did a portrait of Lucrezia Crivelli, the duke's mistress, and also wrote to the duke complaining of arrears in salary.

29 June 1497	Perhaps as a result of this letter the duke instructed Leonardo to finish *The Last Supper*, and made certain payments to him.
1498	During this year *The Last Supper* was finished and further work done on the Sforza horse. On 26 April Isabella d'Este wrote to Cecilia Gallerani, another of the duke's mistresses, in connection with a possible portrait of herself by Leonardo. In October of this year Ludovico presented Leonardo with a vineyard.
May 1499	The French under Louis XII invaded Lombardy and Duke Ludovico escaped to Innsbruck under the protection of the Emperor Maximilian. Leonardo sent six hundred gold florins to Florence, to be deposited with the monastery of Santa Maria Nuova. He also left Milan, visiting Mantua (guest of Isabella d'Este), Vaprio (guest of the Melzi family), Florence and finally Venice.
March 1500	This was the month in which Gusnago wrote to Isabella d'Este from Venice saying that he had just seen Leonardo's portrait of her. But by August of this year Leonardo was back in Florence.
1501	Together with his household Leonardo was the guest of the Servites in Florence. He did the first cartoon for *St Anne*, and a madonna for Louis XII.
1502	Leonardo joined the court of Cesare Borgia and accompanied him to the Romagna. Borgia issued an official pass for Leonardo in Pavia on 17 August of this year.
1503	Ambrogio de Predis petitioned Louis XII to settle the *Virgin of the Rocks* dispute with the Confraternity of the Immaculate Conception. Between March and June of this year Leonardo was again in Florence, and may have started work on his *Mona Lisa* and *Leda and the Swan* at this time. During July he was occupied as an engineer in Florence's war against Pisa, and proposed changing the course of the Arno. In April he received a commission from the Signoria for *The Battle of Anghiari*, and in October rejoined the painters' guild, the Company of St Luke.
1504	The Signoria made several payments to him for *The Battle of Anghiari*, as well as providing scaffolding, turpentine etc for his preparatory work. Between 25 and 27 May Isabella d'Este wrote to Leonardo asking for an 'Infant Christ'. Leonardo promised to provide one. His father died on 9 July at the age of eighty.
1505	He continued working on *The Battle of Anghiari* and may have visited Rome.
1506	Leonardo returned to Milan, now that it was under French occupation, and promised to pay the Signoria of Florence 150 gold florins as an indemnity if he did not return within three months. On 18-19 August the French asked the Signoria for a prolongation of one month, which

the Signoria granted. An argument developed in the autumn about *The Battle of Anghiari*, which was still not finished: the mayor of Florence asked for the 150 gold florins as compensation.

1507 The Florentine ambassador in Milan wrote to the Signoria on 12 January that the King of France wished to retain Leonardo. Louis XII also wrote on the 14th of the same month. The Signoria agreed on the 22nd. On 27 April Leonardo was given back his vineyard near Milan, which had been confiscated after the capture of Duke Ludovico. 26 July Louis XII again wrote to the Signoria, this time ask them to expedite the lawsuit between Leonardo and his brothers over the inheritance from his uncle Francesco. He was paid in Milan the first instalment for his *Virgin of the Rocks* on 26 August.

1508 Leonardo returned to Florence where he worked on *St Anne*. He was back in Milan in Spetember. The *Virgin of the Rocks* was paid for in full in October. He began to receive a pension from the King of France in July.

1511 The son of Ludovico, Massimiliano, invaded Lombardy, and Leonardo was once more in Florence, now that the French were driven out of Milan.

1512 During this year Leonardo may have returned to Milan for a time, or stayed with the Melzi at Vaprio.

1513 Crowds came to see *The Battle of Anghiari* in Florence, and the Signoria was obliged to erect a barrier in front of it on 30 April. Leonardo was definitely in Milan this year with his household, which now included Francesco Melzi. On24 September he left for Rome, where he lived in the Belvedere (the Vatican) in rooms prepared for him by the Pope's brother, Giuliano de' Medici. He stayed in Rome for three years.

1514 He undertook various journeys – to Parma, Bologna, Florence. He made studies for the draining of the Pontine Marshes, on a commission from the Pope. He painted a *Leda*.

1515 Giuliano de' Medici left Rome and Louis XII died. With the departure and later death of Giuliano, Leonardo was again without a protector.

1517 He was invited by the French King Francis I to take up residence in the Château de Cloux. He arrived in May.

1518 Leonardo began receiving a pension of ten thousand *scudi* from the French king. There were various celebrations during the year – for the christening of the king's son, and the marriage of Lorenzo de' Medici to the king's niece.

1519 23 April Leonardo drew up his will. He died on 2 May.

Select Bibliography

E. M. Almedingen, *Leonardo da Vinci* (Bodley Head, 1969)

Luca Beltrami, *Documenti e Memorie Riguardanti la Vita e le Opere di Leonardo da Vinci* (Milan, 1919)

B. Berenson, 'Leonardo da Vinci', from *The Study and Criticism of Italian Art* (Bell, 1916)

K. Clark, *A Catalogue of the Drawings of Leonardo da Vinci in the Collection of His Majesty the King at Windsor Castle* (OUP, 1935, 2 vols)
Leonardo da Vinci (revised ed. Penguin, 1967)

Sigmund Freud, *Leonardo da Vinci and a Memory of his Childhood* (Standard ed. Vol 2, 1910)

Carlo Maria Franzero, *Leonardo* (W. H. Allen, 1969)

R. Friedenthal, *Leonardo da Vinci* (Thames & Hudson, 1960)

L. H. Heydenreich, *Leonardo da Vinci* (New York Macmillan, 1954, 2 vols)

K. R. Eissler, 'Leonardo da Vinci', from *Psychoanalytic Notes on the Enigma* (Hogarth Press, 1962)

E. MacCurdy, *The Mind of Leonardo da Vinci* (Cape, 1928)
ed., *The Notebooks of Leonardo da Vinci* (New York Braziller, 1956)

D. Merezhikovsky, *The Romance of Leonardo da Vinci* (New York Modern Library, 1955)

Carlo Pedretti, *Leonardo* (Thames & Hudson, 1973)

J. P. Richter, *The Literary Works of Leonardo da Vinci* (OUP, 1939, 2 vols)

E. Solmi, *Leonardo da Vinci* (Milan, 1900)

G. Vasari, *Lives of the Painters* (1568)

List of Illustrations

225

Picture research by Judith Aspinall

Index

229